WOMEN OF VISION

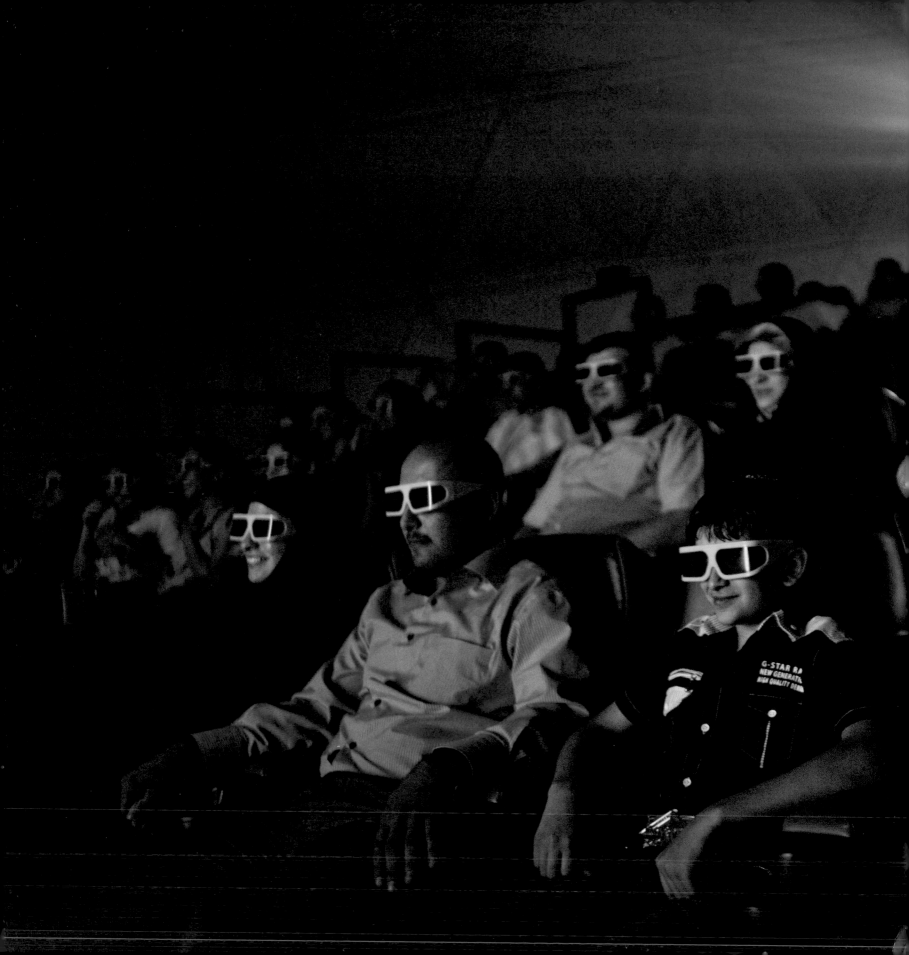

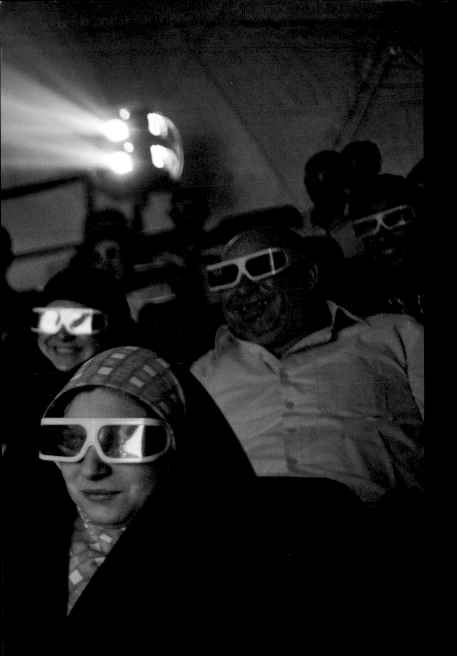

WOMEN
OF VISION

National Geographic
Photographers on Assignment

FOREWORD BY ANN CURRY

INTRODUCTION BY CHRIS JOHNS

CONTENTS

Foreword *8*

Introduction *16*

Amy Toensing *18*

Stephanie Sinclair *36*

Diane Cook *54*

Maggie Steber *72*

Jodi Cobb *90*

Erika Larsen *110*

Beverly Joubert *128*

Lynn Johnson *146*

Lynsey Addario *166*

Carolyn Drake *184*

Kitra Cahana *202*

Curator's Note *220*

Acknowledgments *222*

LYNSEY ADDARIO / Baghdad, Iraq, 2010 *Preceding pages: Moviegoers thrill to shaking seats and wind machines during a 3-D film at a theater closed during the war.*

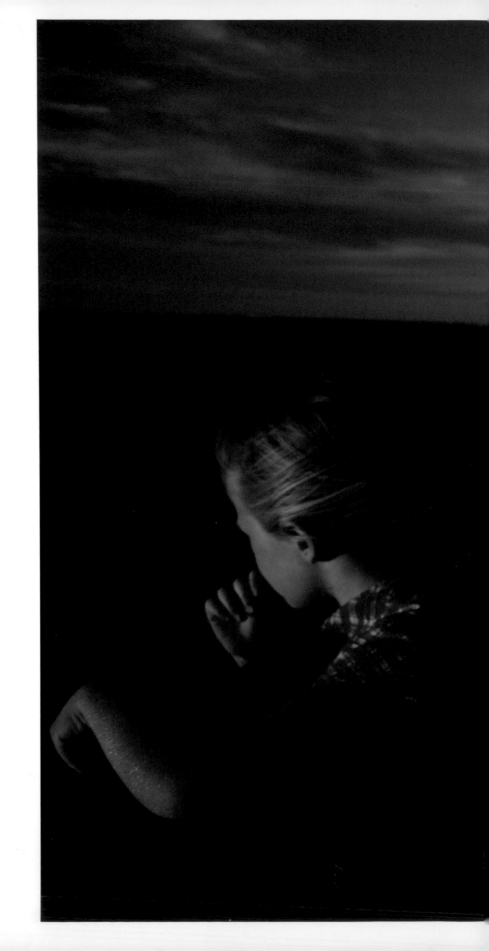

AMY TOENSING / New South Wales, Australia, 2008
Sisters ride in the back of the family pickup truck across their parched farm.

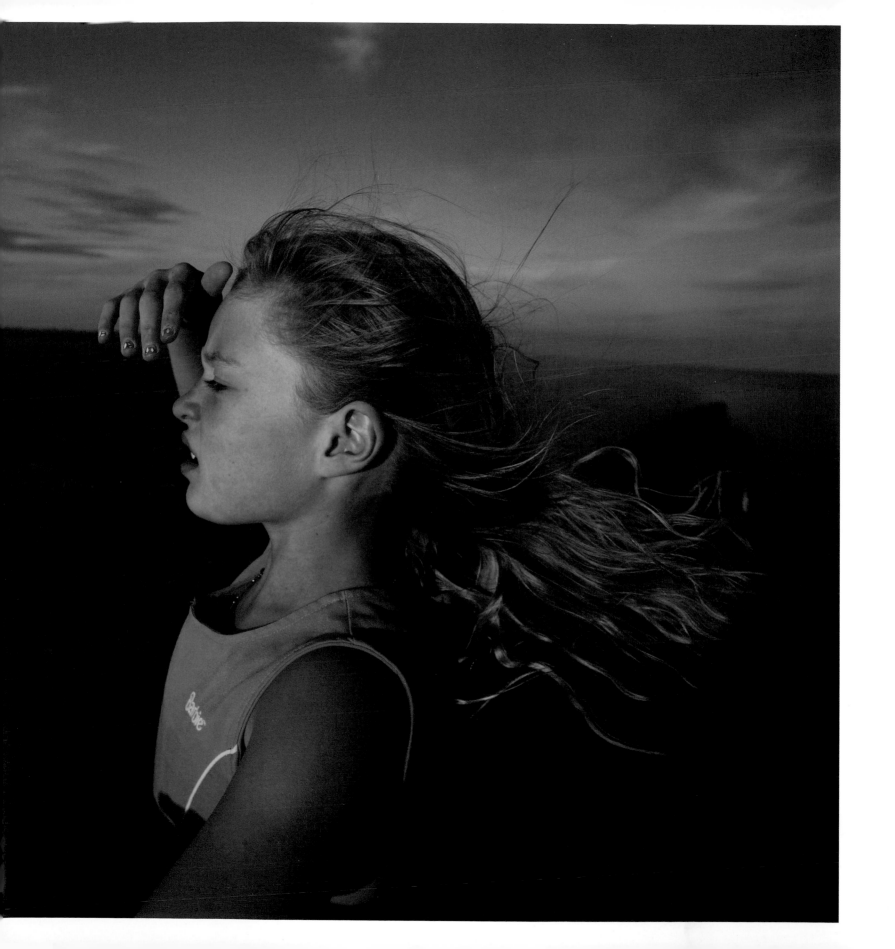

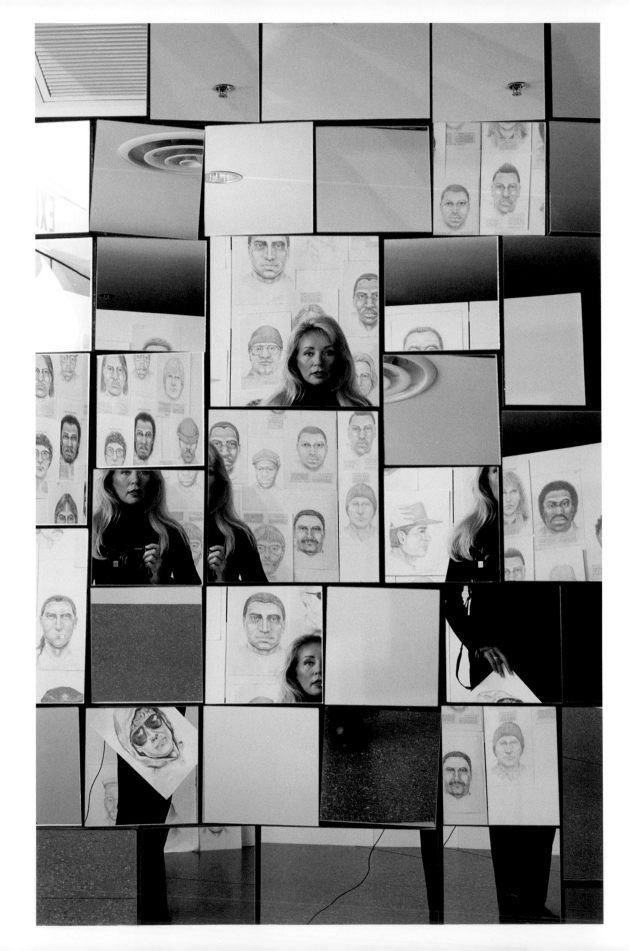

FOREWORD
Ann Curry

National and International Anchor/Correspondent, NBC News

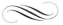

Henri Cartier-Bresson, considered the father of photojournalism, once coined the phrase "the decisive moment" to describe the split second when a photographer's eye, mind, and heart all come into focus together on an image that is compelling enough to inspire the click of the shutter. This idea suggests that beyond the geometry of composition and the joy of luck, a photographer's vision is influenced by experiences and emotions that plot a beautiful conspiracy, influencing ideas about what makes a good picture. In this way, each image can be seen as a kind of reflection of the person who made it.

Woe it is, then, that our ability to see back in time through photographs is limited by the absence, for so many years, of the visions of women. What did they see that we cannot find in the photographs of their time? I have often wondered what would emerge if more women had photographed wars, including the Civil War. If more women had photographed the New Deal's Work Projects Administration (WPA), would there be more images of women and children during the Great Depression, as exemplified by Dorothea Lange's picture of the migrant mother?

This new volume of 11 photographers—all celebrated, brave, and talented women, each with her own vision—gives us a chance to investigate how the X chromosome might influence Cartier-Bresson's "decisive moment." What is in women's hearts, minds, and eyes when they choose a subject to photograph?

As you look at the images on these pages, do any seem as though they could have been taken only by a woman? These beautiful photographs take their place alongside those before—and those yet to come—that have the power to stop time and document life. In them, we see our world today—and also, great love for our future.

MAGGIE STEBER / Scottsdale, Arizona, 2007 *Forensic artist Jeanne Boylan (left) mines buried images from trauma victims' memories.*

STEPHANIE SINCLAIR / Sanaa, Yemen, 2012
A lieutenant in the elite female counterterrorism
unit patrols the women's barracks.

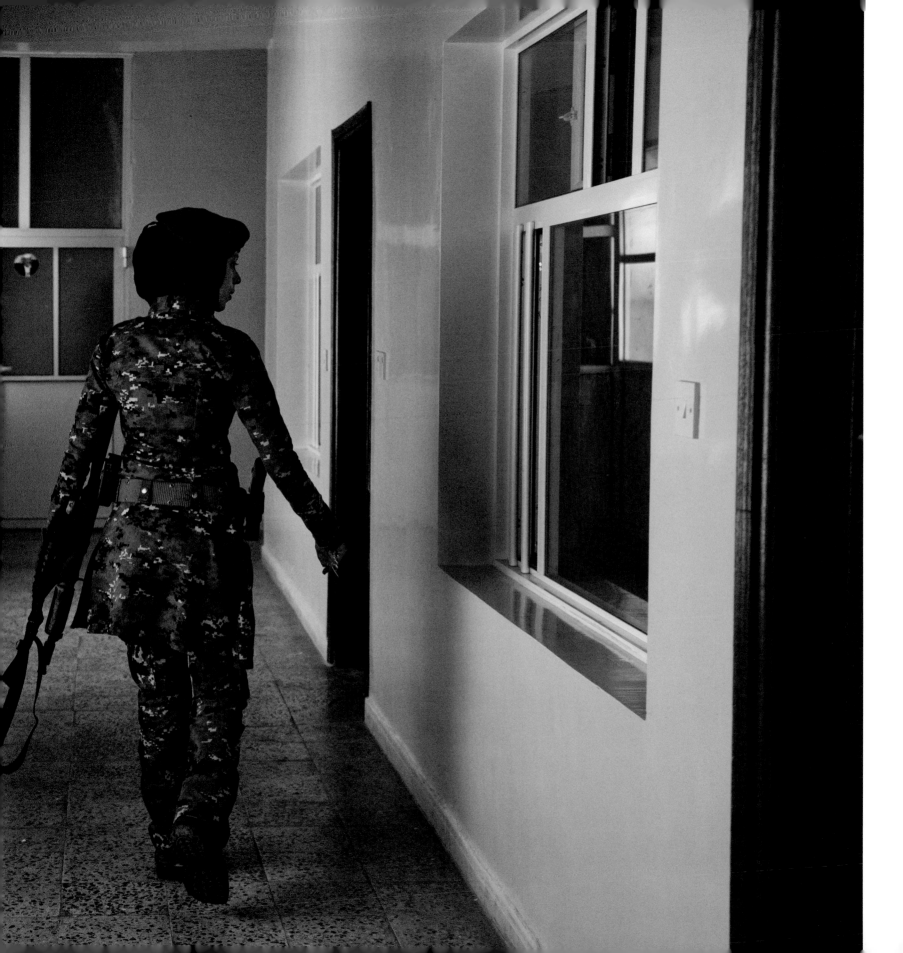

LYNN JOHNSON / Shiwa, Zambia, 2004
A chain casts its shadow on a man who once
killed animals for food but now leads tourists
on trophy hunts.

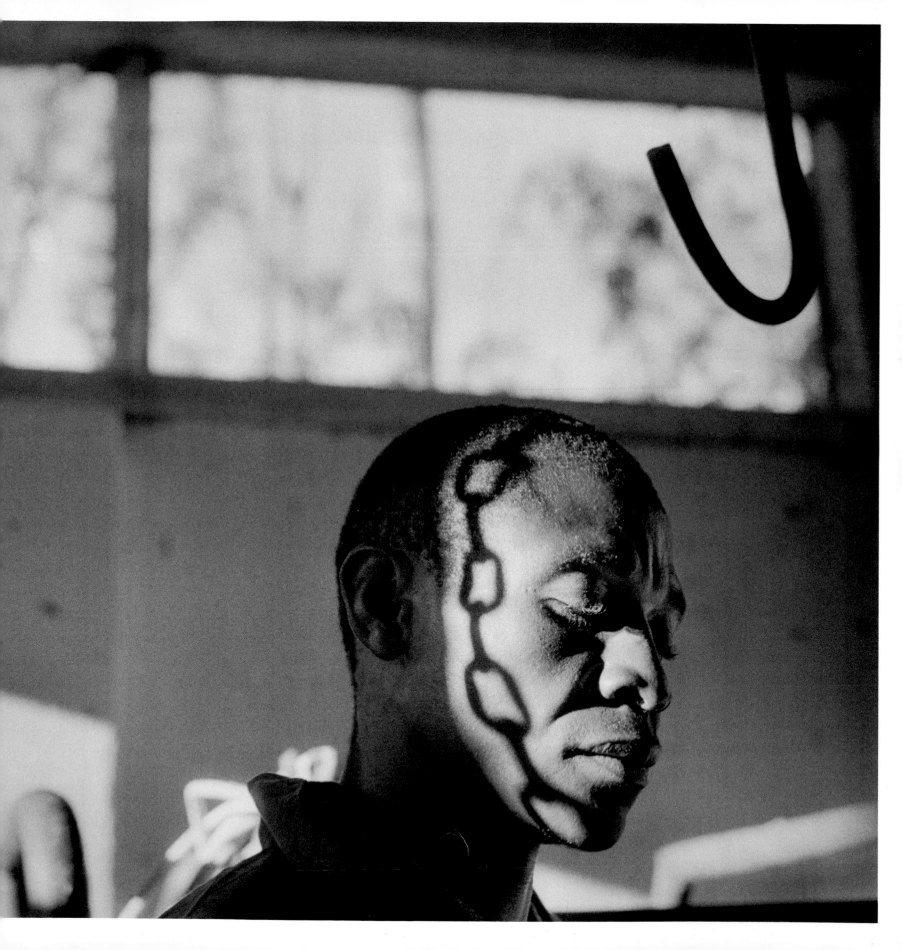

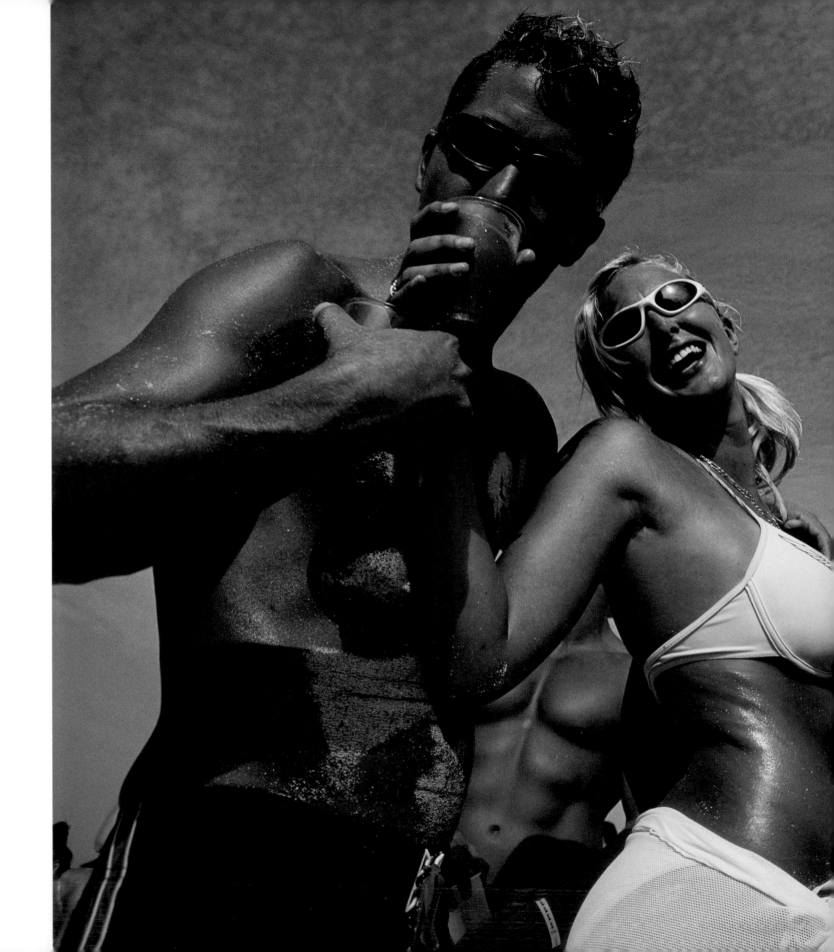

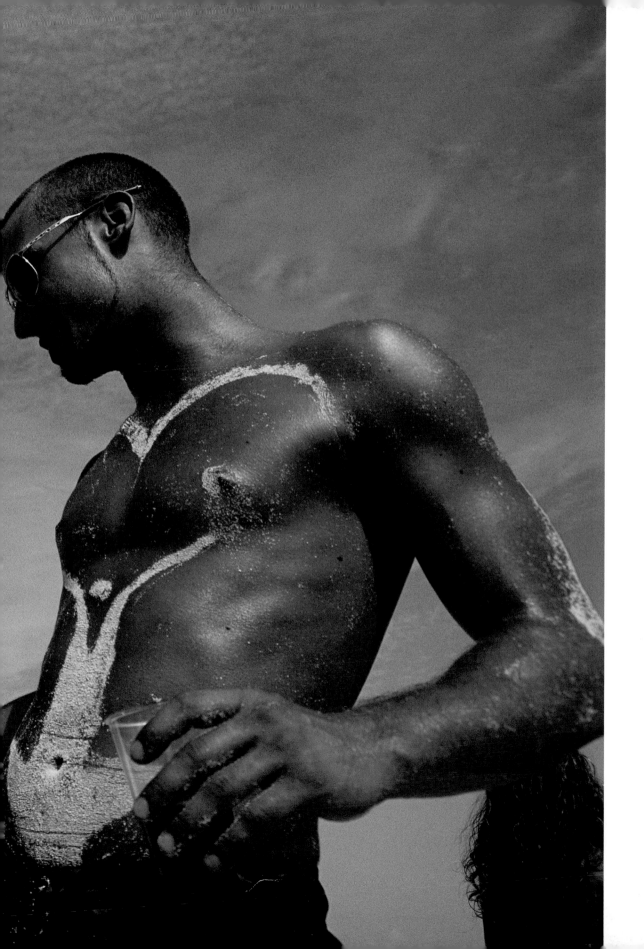

JODI COBB / Cancún, Mexico, 2003
*Sensuality and desire spark attraction
among spring breakers on a beach.*

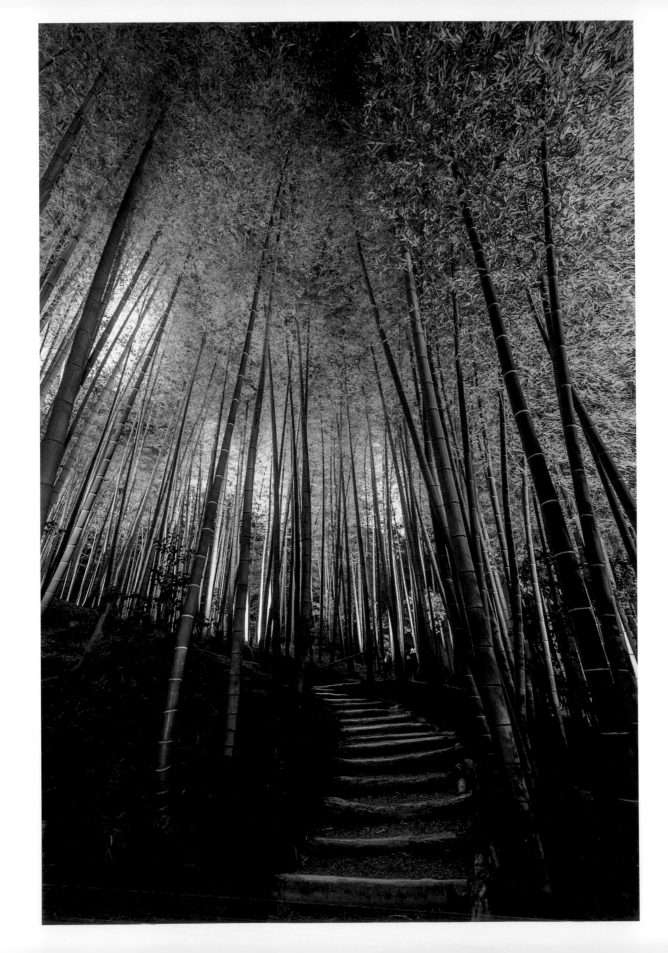

INTRODUCTION
Chris Johns

Editor in Chief, National Geographic Magazine

When I was studying photography in college, my hero was Dorothea Lange, the socially conscientious photographer who worked for the Farm Security Administration (FSA) and captured the face of Depression-era America in the iconic portrait "Migrant Mother."

Lange was a photographer in the 1930s and 1940s, when few women could—or would care to—choose that professional path. Those who did found the going tough and could expect to be patronized. Lange's younger FSA colleague, Marion Post Wolcott, was once chided by the agency's director to "behave like a lady." Back then, *National Geographic* was no exception. "If you find the going too tough, why not run over to Paris for a week and get some new clothes . . . I understand that is good for a woman's morale," the chief of the photographic lab advised Kathleen Revis, National Geographic's first female staff photographer when she was on assignment in England in the 1950s.

Fortunately, the gender divide has dissolved, as photo credits and bylines on the pages of *National Geographic* show. The work of women photographers published in the magazine is nothing less than stunning in its breadth and depth, and above all, in its ineffable humanity.

A photograph stands on its own. But in the images in this book, it is impossible not to imagine the woman behind the frame. There is a distinct point of view, and how that image is framed—the subject, the aesthetic—is affected by the photographer's experience, culture, and yes, gender. But not *just* gender. In short, it's about diversity. We gather and present readers with many different voices, and the magazine is infinitely better and more complete for it. And so, in this exhibition, we celebrate both photography *and* women.

The camera, the writer Eudora Welty reminds us, is "about wanting to know." The women in this book have explored the world with their cameras, wanting to know. Wanting to see. Wanting to show.

DIANE COOK AND LEN JENSHEL / Kyoto, Japan, 2012 *Bamboo Garden at Kodaiji Temple*

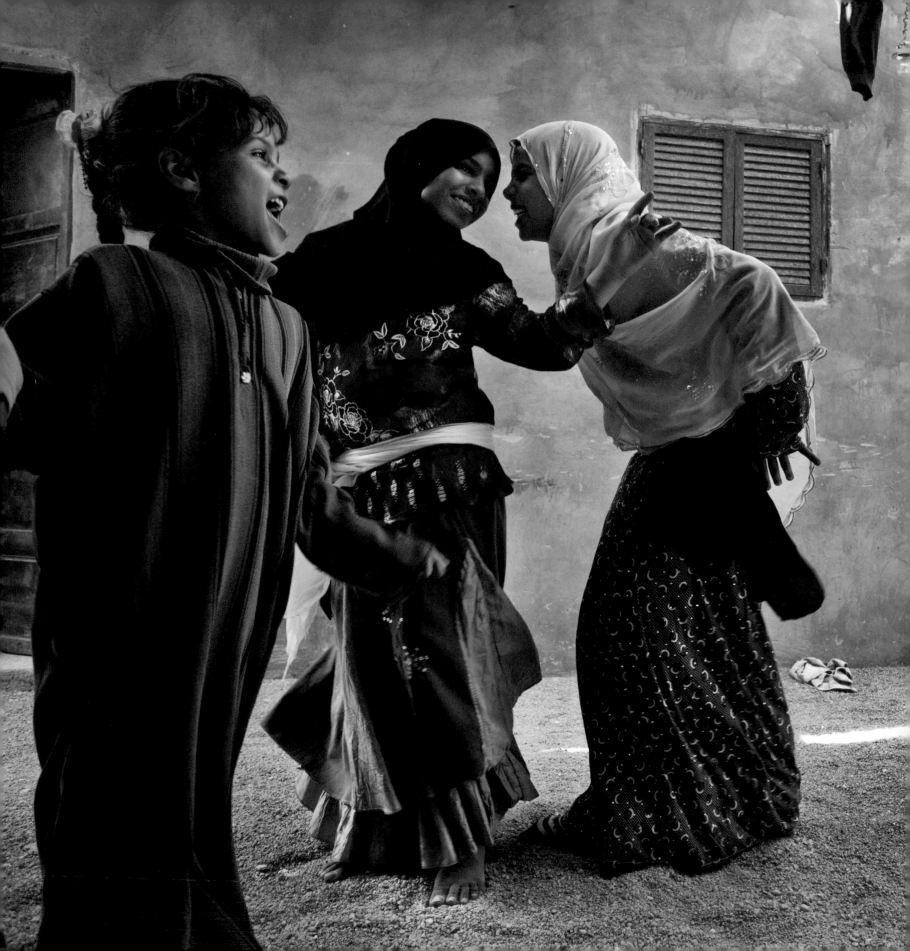

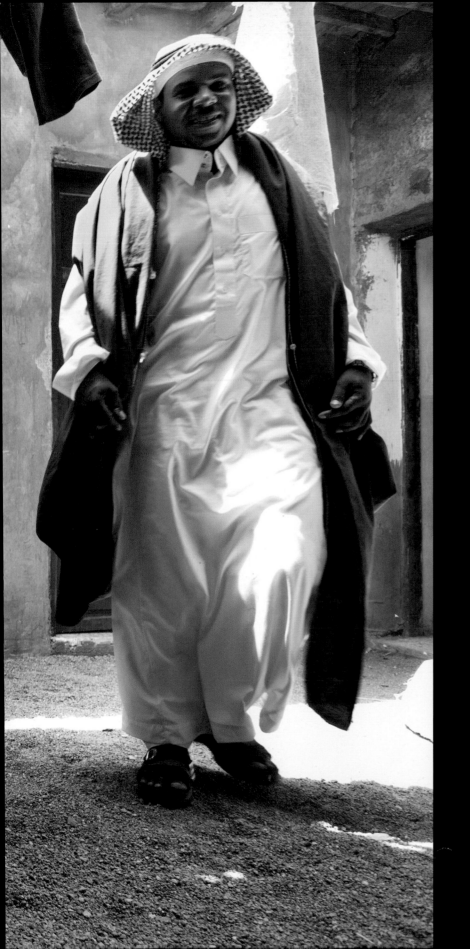

AMY
TOENSING

Seeing
From the
Heart

"The essence of photography is getting what's inside your heart out into the photograph."

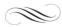

Fourteen years and fourteen *National Geographic* stories later, Amy Toensing still loves the first photo essay she created for the magazine during her internship in 1999. Her chosen subject was Monhegan Island, a small, exclusive community of painters and lobstermen about 12 miles off the coast of Maine. Through a poetic mix of witty, sensitive, and descriptive images, Toensing captured the people of the island—everything from their spirits to their personal habits.

Since then, Toensing has continued to illuminate the humanity of diverse places, including Australia, Papua New Guinea, and the Jersey shore. She prepares by reading novels, which she says provide a strong sense of place. Then she contacts potential subjects. Once she arrives in the field, the process is purely intuitive. "I can only plan 10 percent of my stories in advance. All the rest of it is serendipity. Being in the field is probably the most present that I feel in my life," she says. As she hunts for photographs, she looks for three things: relationship, story, and something beautiful. But, she adds, "A huge part of my process for making my images has to do with time. Spending time with people, or spending time with the story." One of her recent photographs was selected as one of National Geographic's 50 Greatest Photographs.

Growing up, Toensing always thought she would be an Outward Bound educator. It wasn't until her senior year of college that she discovered photography, during a semester at the Salt Institute for Documentary Studies in Maine, where she learned how to tell a story and how to use the darkroom. For her final assignment, she photographed the migrant broccoli pickers in northern Maine. "It was the first time I realized I could tell a story through a sequence of images," she recalls. The series won first place for documentary in the College Photographer of the Year awards.

Toensing feels strongly that what makes a photographer is "what they have to say, and how they see with their eyes, their mind, and their heart." This, she says, poses the greatest challenge. "The essence of photography is getting what's inside your heart out into the photograph."

Preceding pages: *Arrayed in embroidered garments, Bedouin girls dance at a wedding in Sinai, Egypt, 2008.*

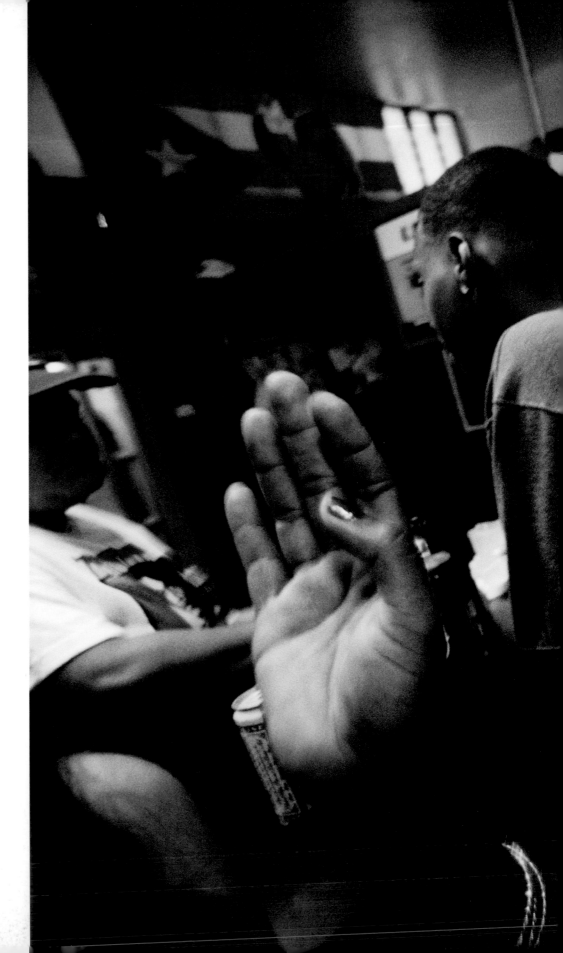

Identity Crisis ~ 2002

In 1952, Puerto Rico adopted a consti-
tution, ending U.S. colonial rule of the
island. Now a commonwealth, it exists
in a peculiar state of political limbo.
As Puerto Ricans look to the future,
they passionately debate whether they
should maintain the status quo, lobby
to become the 51st state, or seek full
independence.

*A woman in a Loiza bar sways to the drumbeats
of* bomba, *a music derived from African slaves.*

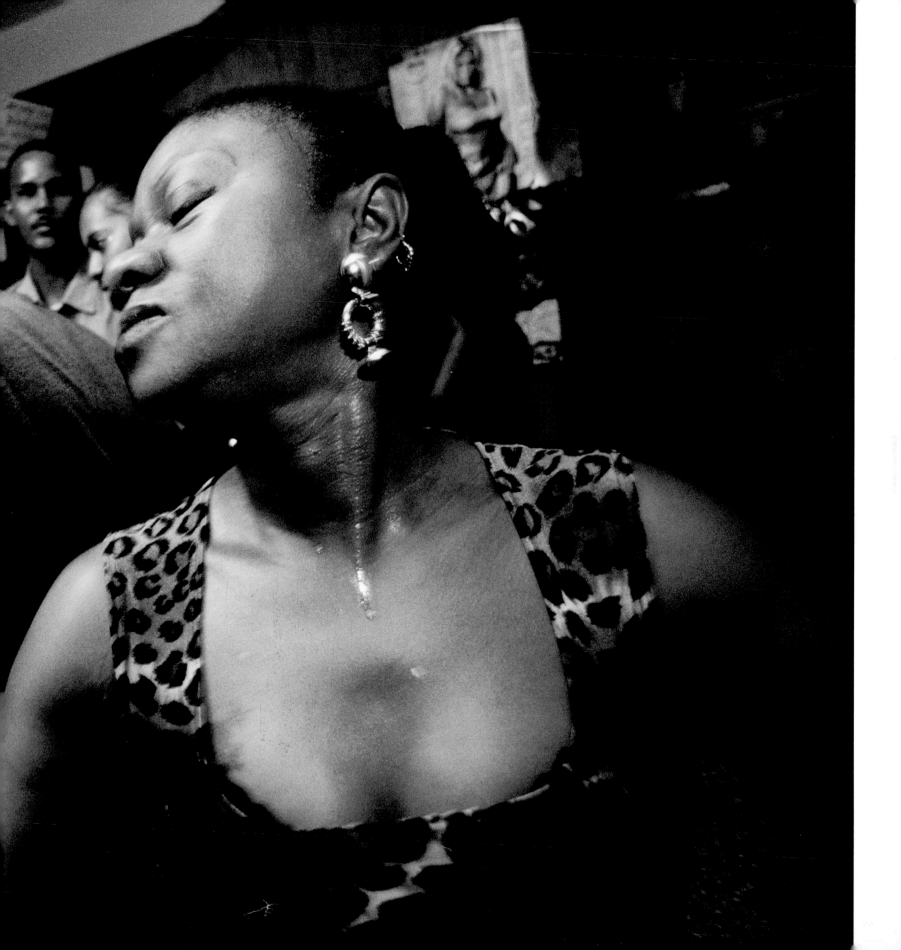

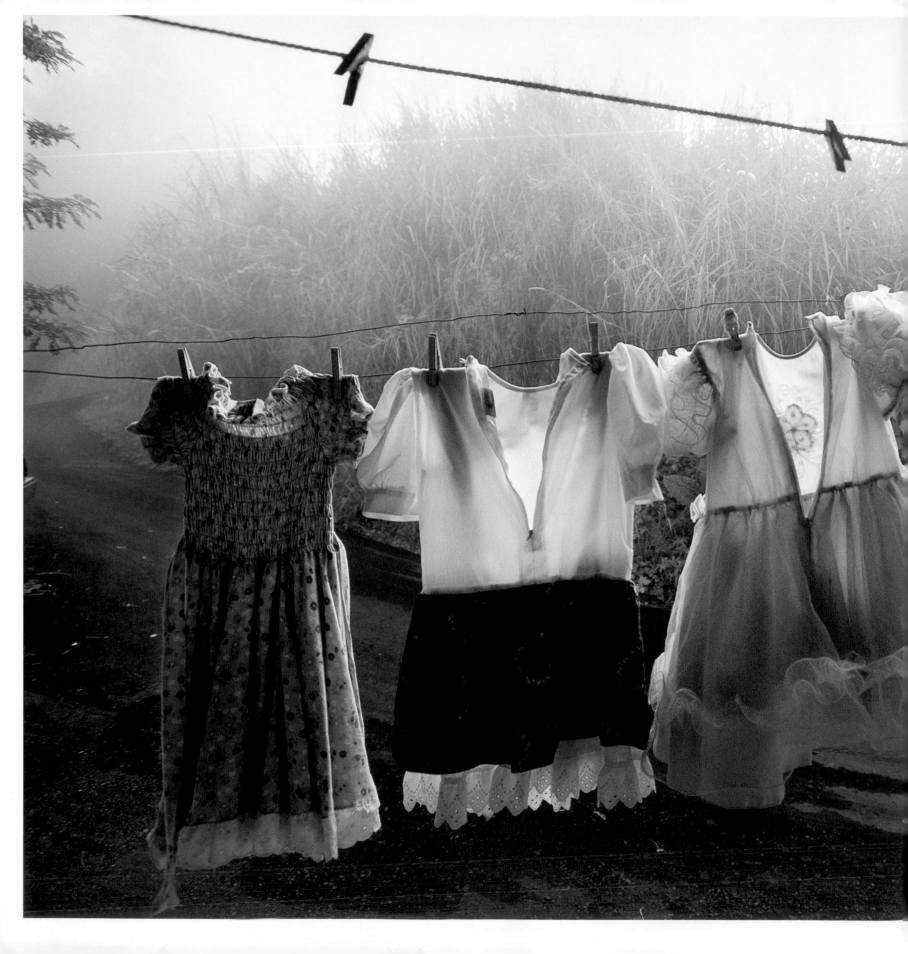

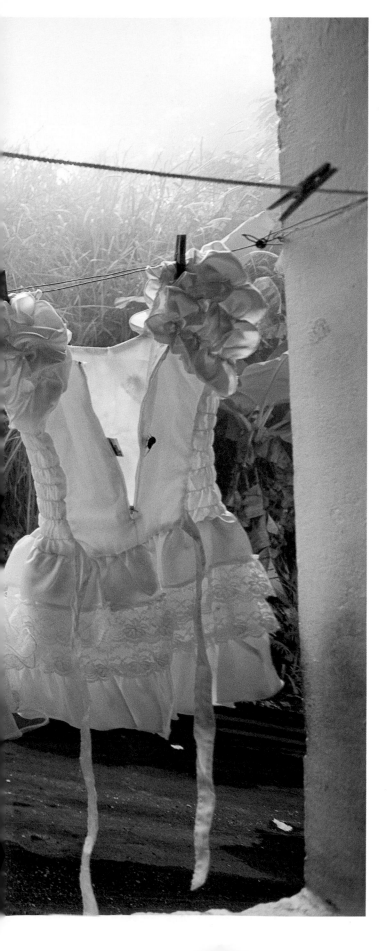

"The first step is understanding the story. And then it's finding the places where you think pictures might happen."

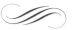

Dresses festoon a clothesline in Utuado, a lush mountainous region in central Puerto Rico.

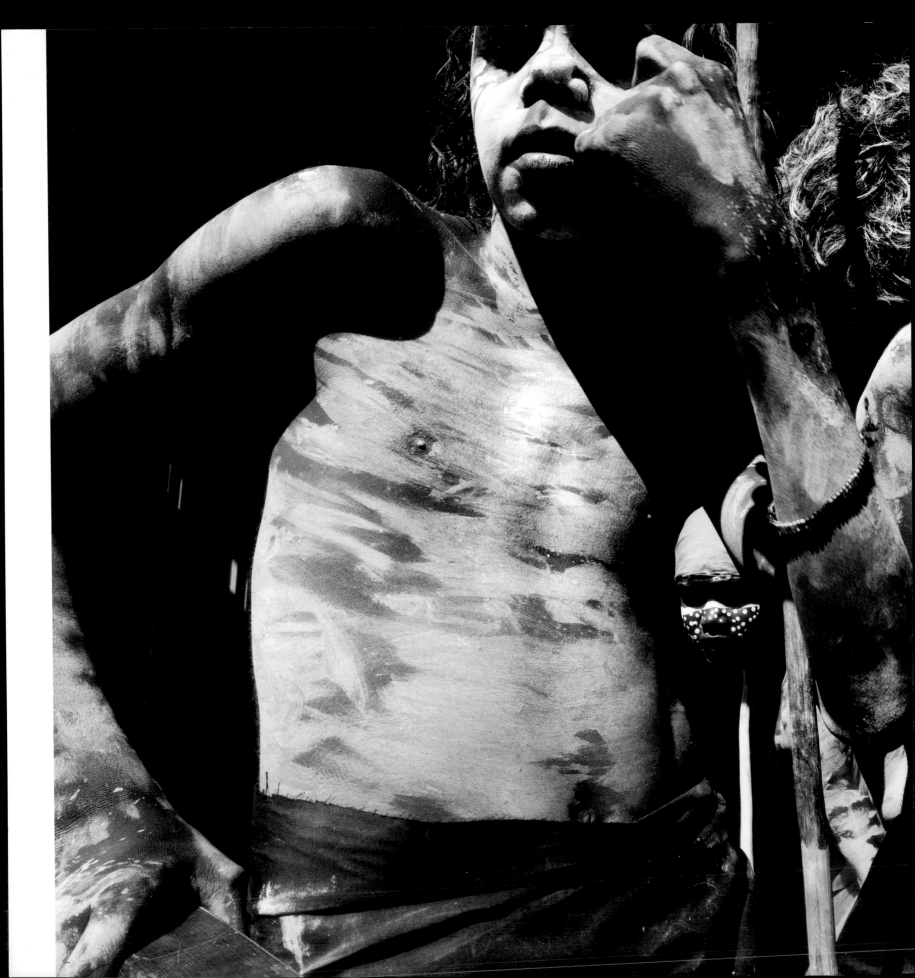

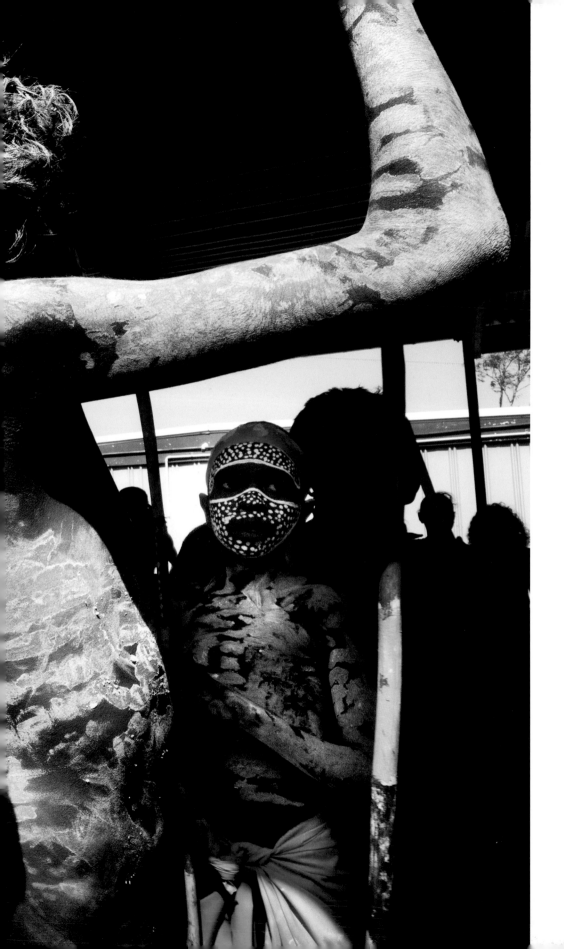

Preserving a Culture ~ 2010–2011

For at least 50,000 years, Aboriginals have inhabited Australia. But for the past 200 years, European settlement has challenged the very survival of the culture. Today the indigenous people, numbering roughly 670,000, make up less than 3 percent of the country's population. While most live in urban centers, it is in their ancestral homelands where connection to the land remains strong and their culture has endured.

Boys at a bush school in Northern Territory wear body paint as part of a tribal ceremony.

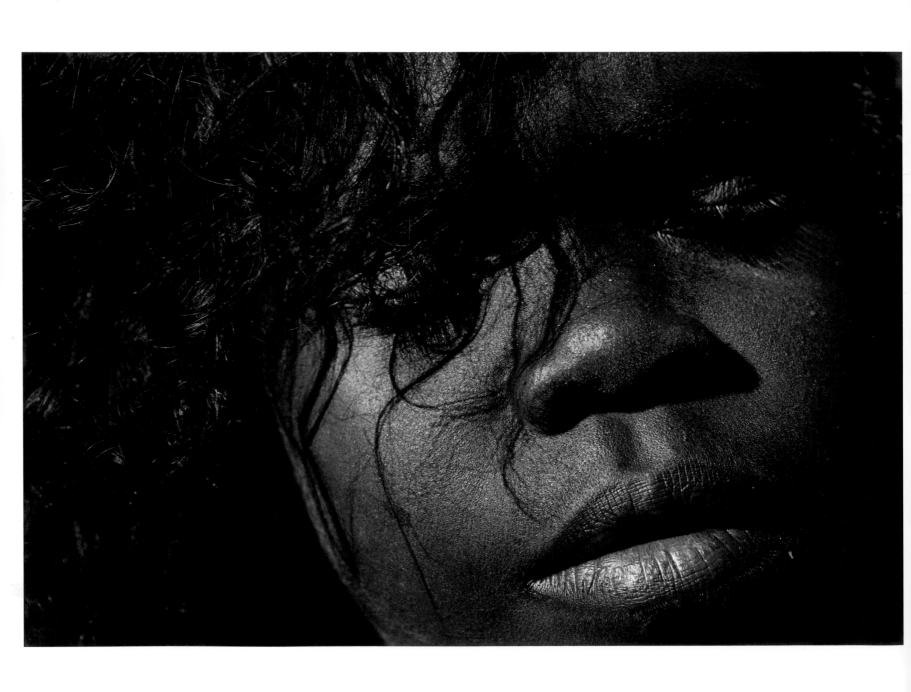

A pensive Aboriginal girl in a Northern Territory homeland is learning her cultural legacy.

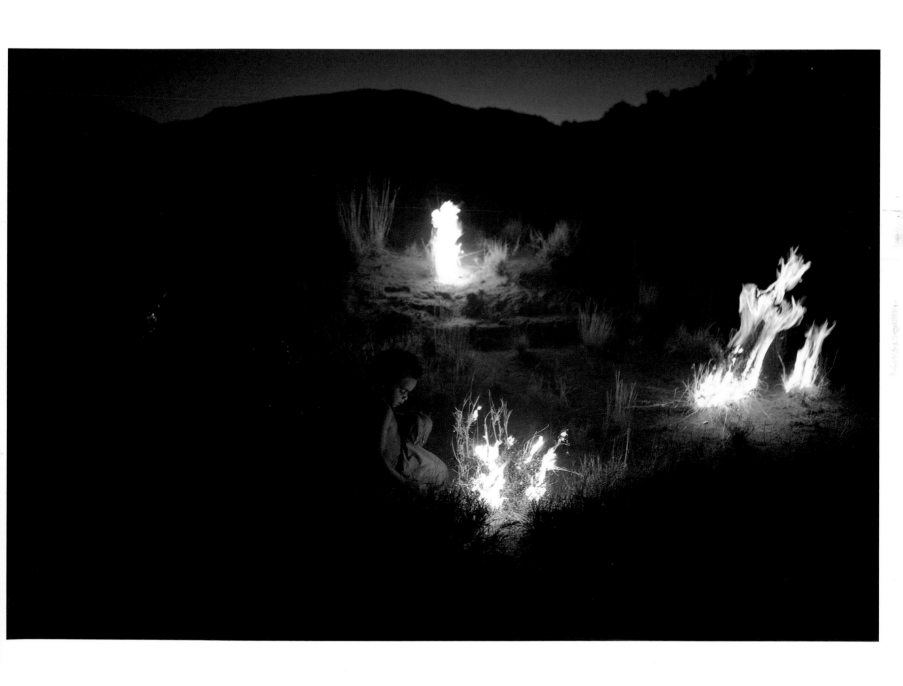

An Aboriginal boy tends fires on tribal lands in Australia's Great Victoria Desert.

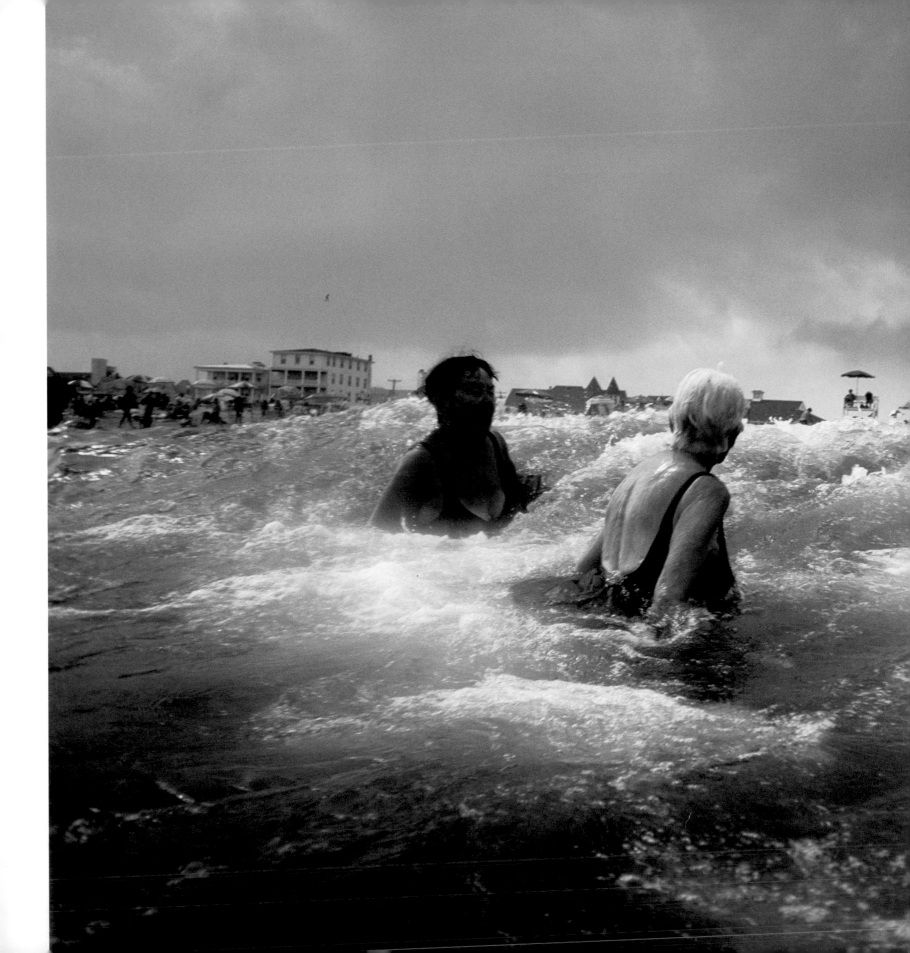

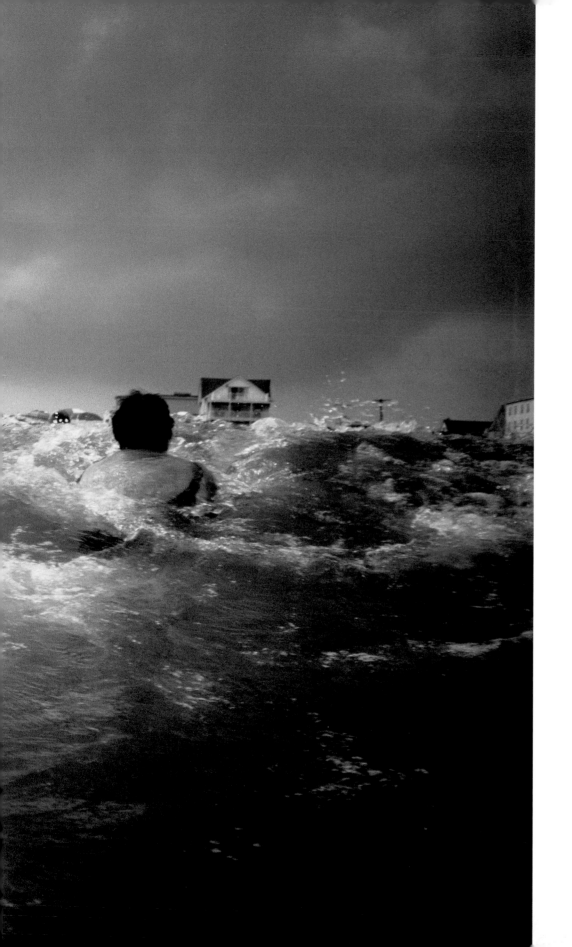

Anchored in Faith ~ 2000

Since 1869, worshippers have flocked to the seaside town of Ocean Grove, New Jersey, in search of spiritual renewal at Methodist camp meetings. Today, the modest resort—located 40 miles south of New York City—attracts as many tourists as pilgrims, though the beach itself is closed on Sunday mornings.

Longtime Ocean Grove visitors take a dip in the roiling Atlantic surf.

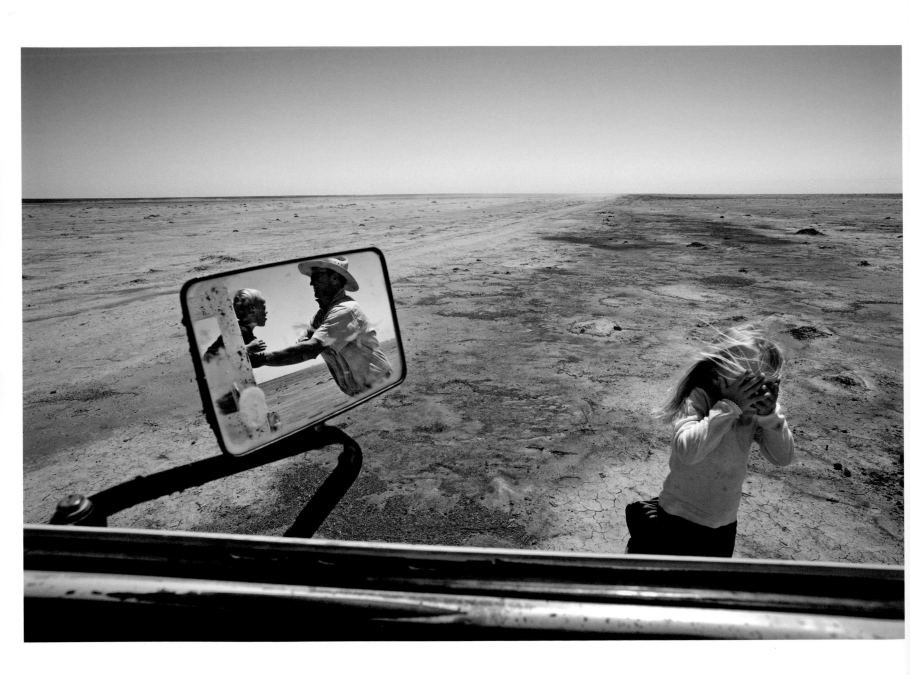

Drought-Stricken Australia ~ 2008
Record-low rainfalls in Australia led to unprecedented drought conditions in the southeast agricultural region.

Green fields turned to dust, devastating farmers and their livelihoods. Toensing captures a harsh beauty as well as the enduring spirit of the people.

"You really have
to listen with your heart.
It's not necessarily about words.
It's about tuning in."

A farmer and his children (left) play in a water-
starved field where his livestock once grazed.

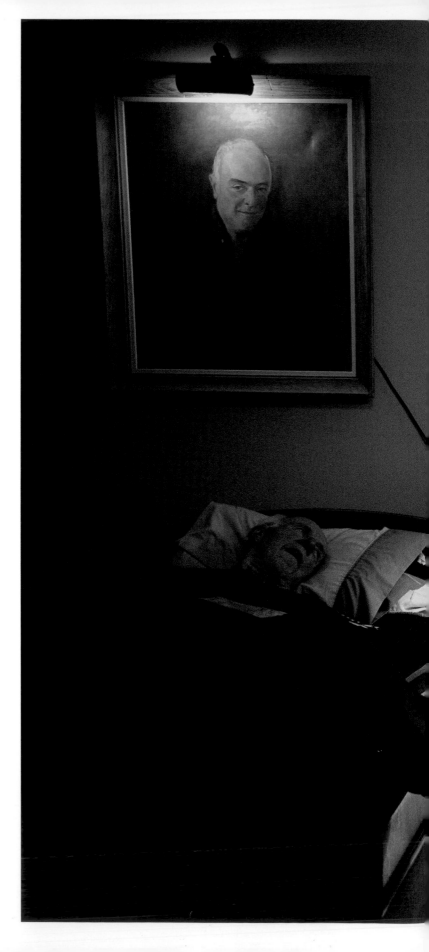

The Simple Life ~ 1999

Monhegan Island, 12 miles from Maine's coast and home to lobstermen and artists, has fewer than 80 permanent residents. Toensing chose the island as the topic of her first *National Geographic* magazine photo essay and still ranks it as one of her favorite shoots.

Harry and Doug Odom, now deceased, slept under each other's portraits in the bedroom they shared on Monhegan Island.

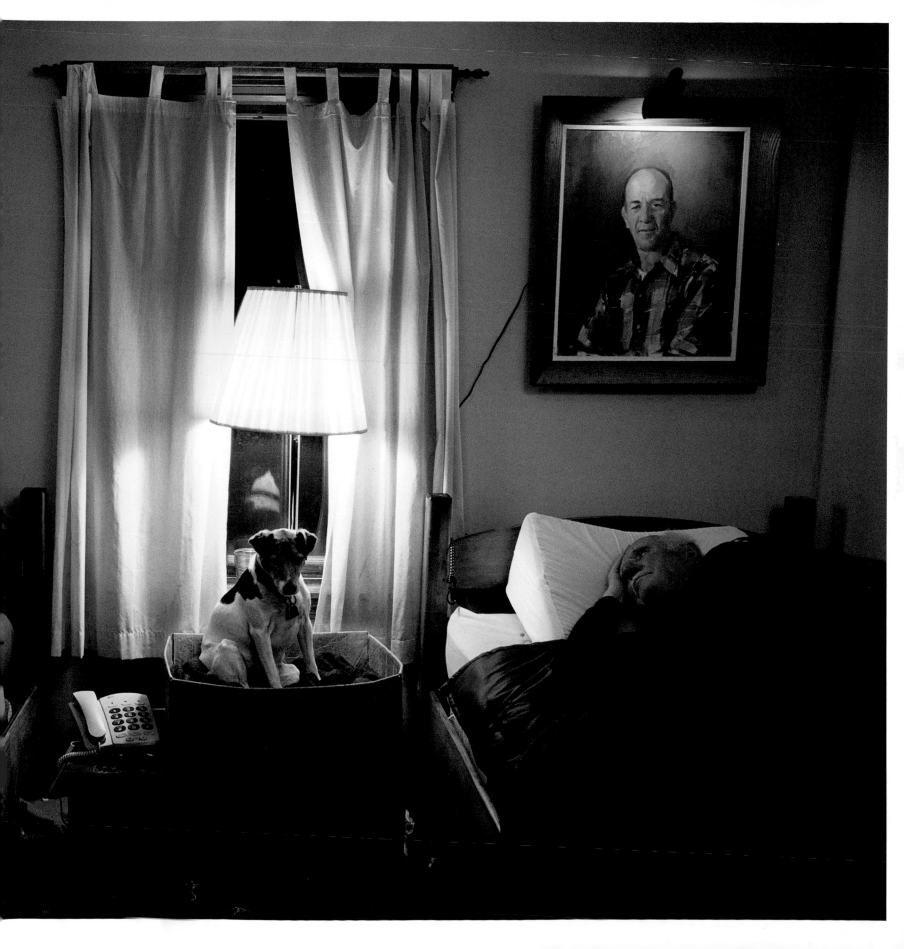

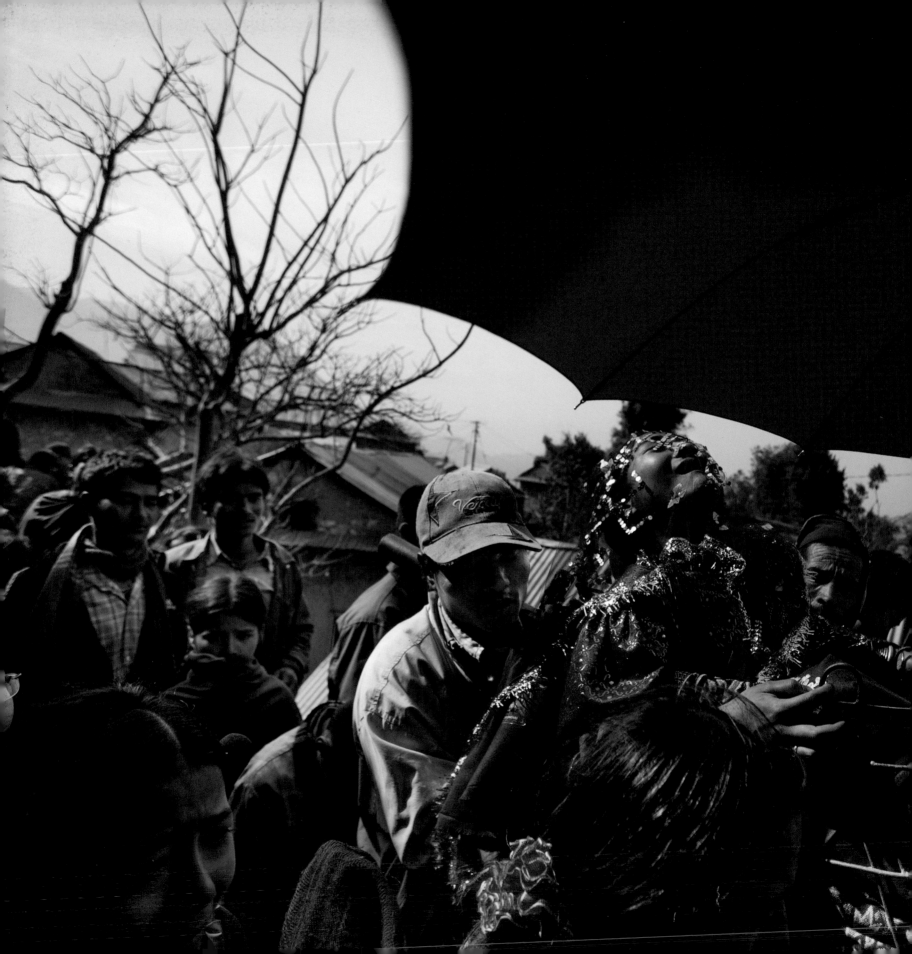

STEPHANIE SINCLAIR

Bearing
Witness

"Photography isn't about you or your feelings as the photographer. It's about what the subjects are going through."

Stephanie Sinclair has spent the last decade documenting some of the world's most controversial subjects, from Yemen's child brides to Texas's polygamists. But her goal is simple: to record what is in front of her and pass as little judgment as possible. "It's all too easy to make things black and white. But every issue is gray," she says. "You have to operate and communicate from that perspective."

After earning her B.S. in journalism from the University of Florida in 1997, Sinclair worked for the *Chicago Tribune* covering the Iraq war. For the next six years, she worked as a freelance photographer in the Middle East before moving back to the United States and joining the prestigious VII Photo Agency in New York as a full member in 2009. She currently contributes to *National Geographic,* the *New York Times Magazine, Time, Newsweek,* and other publications. "Being a female photographer definitely has its pluses," she says. "I think you get better access."

Sinclair has received critical acclaim for her work on child marriage and other human rights stories, including the Overseas Press Club's Olivier Rebbot Award, three Visa d'Or awards, and four World Press Photo awards. Her photo series "Self-Immolation in Afghanistan: A Cry for Help" was part of the Whitney Museum of American Art's 2010 Biennial in New York. "The story was heartbreaking," she says. "But you have to leave your ego out of it and understand that photography isn't about you or your feelings as the photographer. It's about what the subjects are going through."

Despite her record of courageous work, Sinclair, who is based in Brooklyn, New York, only recently felt a personal sense of reward. In 2012 the United Nations hosted a major exhibition of her work on child marriage. Both Secretary-General Ban Ki-moon and Archbishop Desmond Tutu attended the opening. To Sinclair, the exhibition symbolized action against the practice. "I feel like I've done as much as I can do," she says. "And that's a good place to be."

Preceding pages: A 16-year-old Nepali bride cries out in despair as she is carried in a cart to her new husband's village.

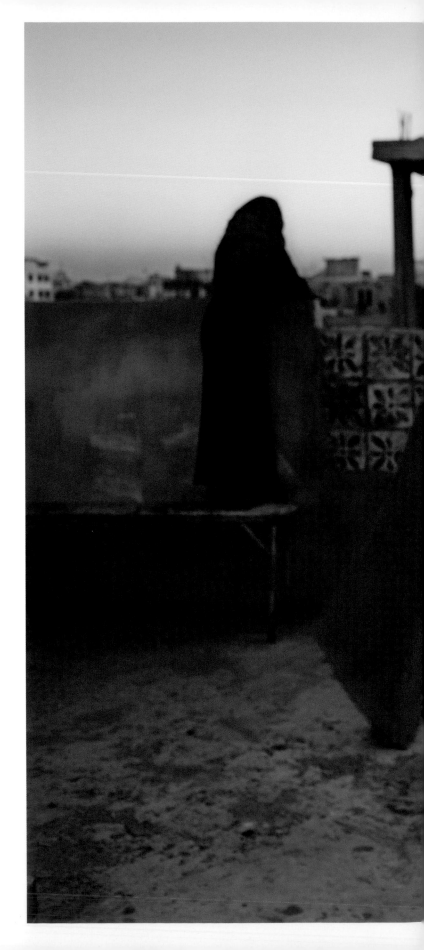

Child Brides ~ 2007-2010

Marriage should be a time of joy and celebration, but that is not the case for tens of millions of girls around the world who are forced to marry young, many before reaching puberty. Cast out of their homes and denied childhood and schooling, the girls usually face a future of poverty and abuse. Sinclair's searing images of such girls and other imperiled women pack an emotional punch.

Nujood Ali stunned the world in 2008 by obtaining a divorce at age ten in Yemen, striking a blow against forced marriage.

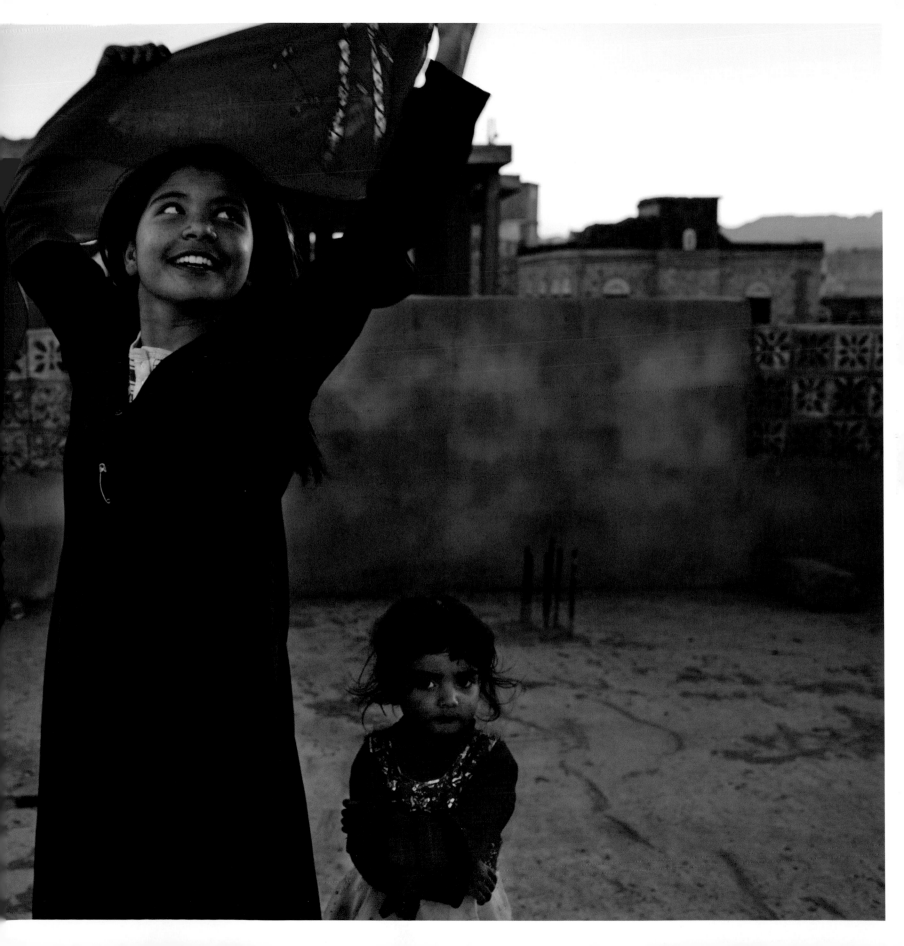

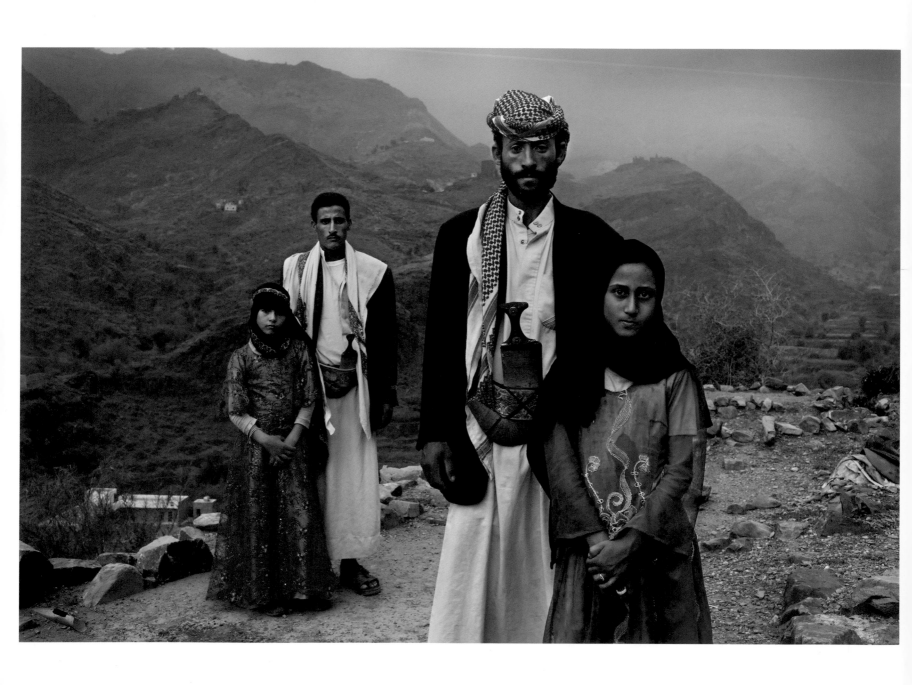

"Whenever I saw him, I hid," admits an eight-year-old Yemeni girl (above, in pink), with her husband, recalling the early days of marriage at age six.

In a combined ceremony in rural Yemen (right), young brides, ages 11, 12, and 13, marry each other's brothers and uncle.

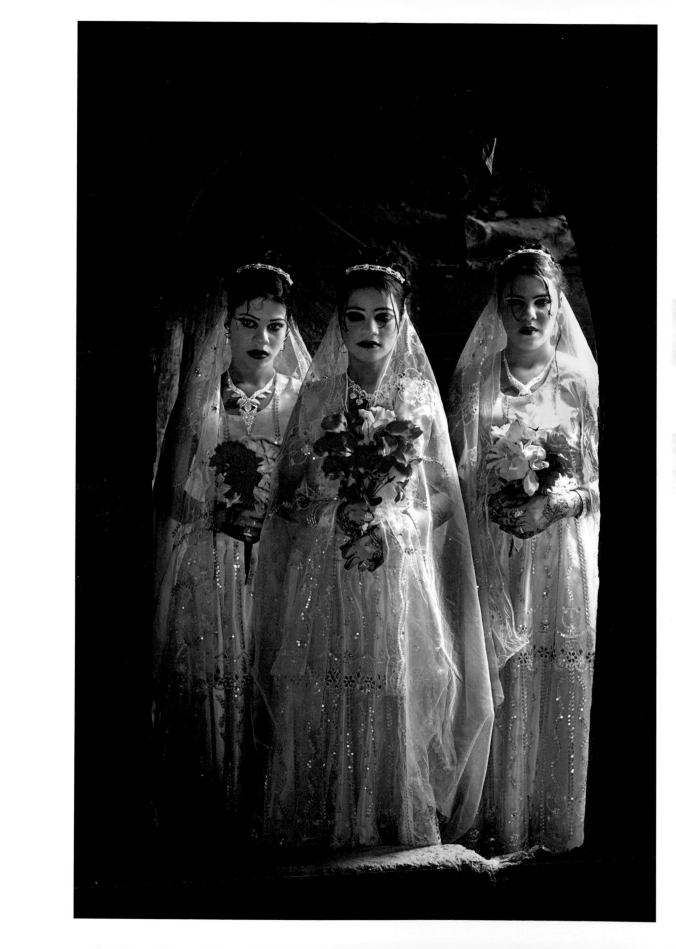

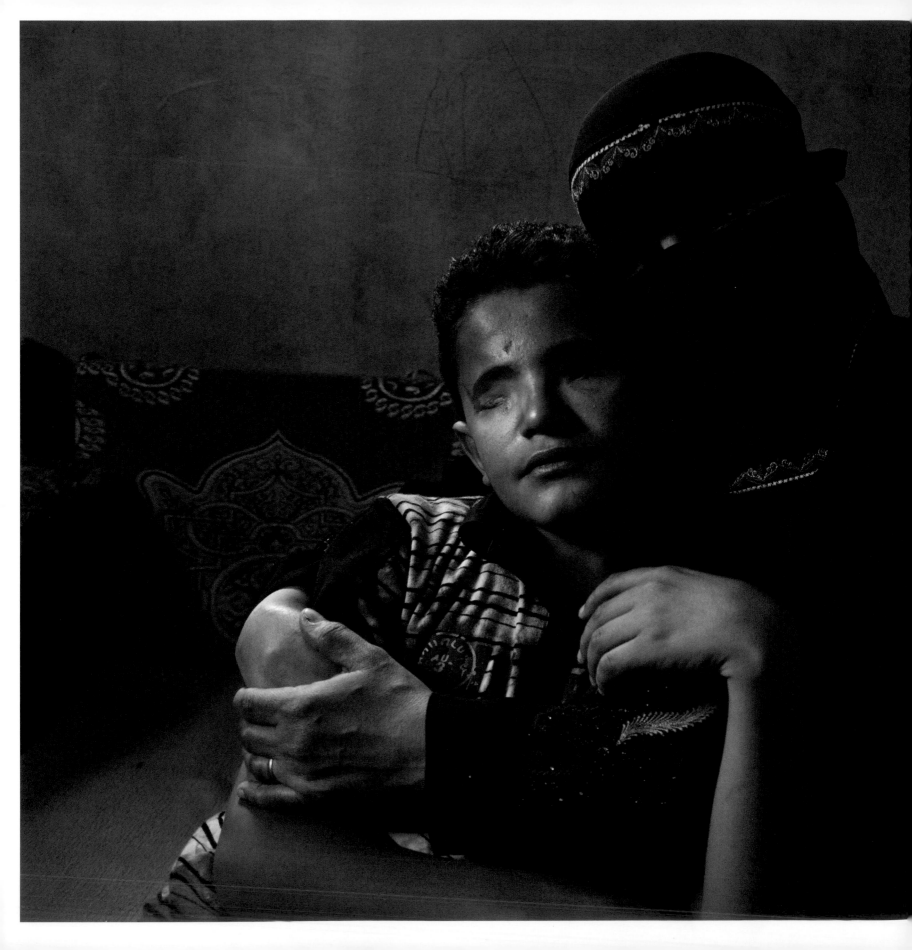

Yemen on the Brink ~ 2012

Inspired by the Arab Spring, Yemen launched a pro-democracy movement in 2011 that led to the resignation of its president. But like many of the Arab uprisings, Yemen's transition to equality and prosperity hangs in the balance. A formidable al Qaeda faction has established a foothold in the region, and clashes between government forces and insurgents have intensified. Amid the destruction of cities and families, democracy seems a distant dream.

A mother cradles her 12-year-old son, who lost both eyes to gunfire during a protest rally in Sanaa.

"The worst day is not when my safety is at risk; it's when I can't get the pictures I want. You have a chance to get voices heard, so every day counts."

Two boys chase a kite through the rubble of Sadah, an antigovernment stronghold near Yemen's northern border.

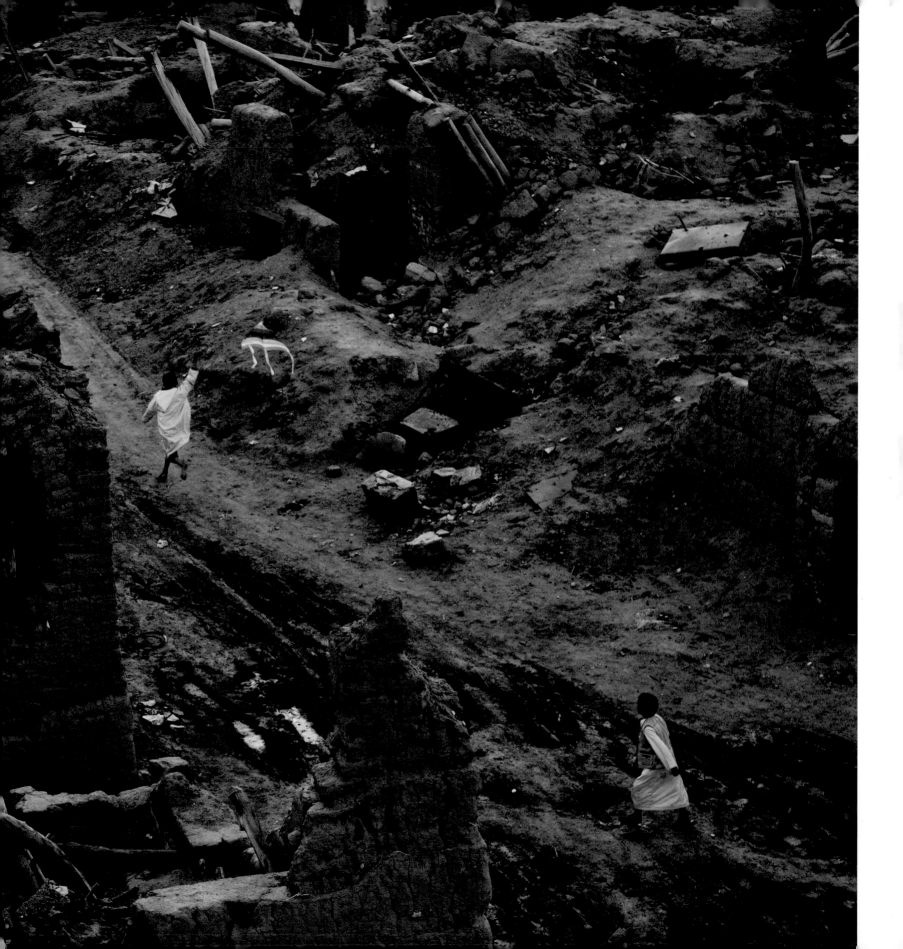

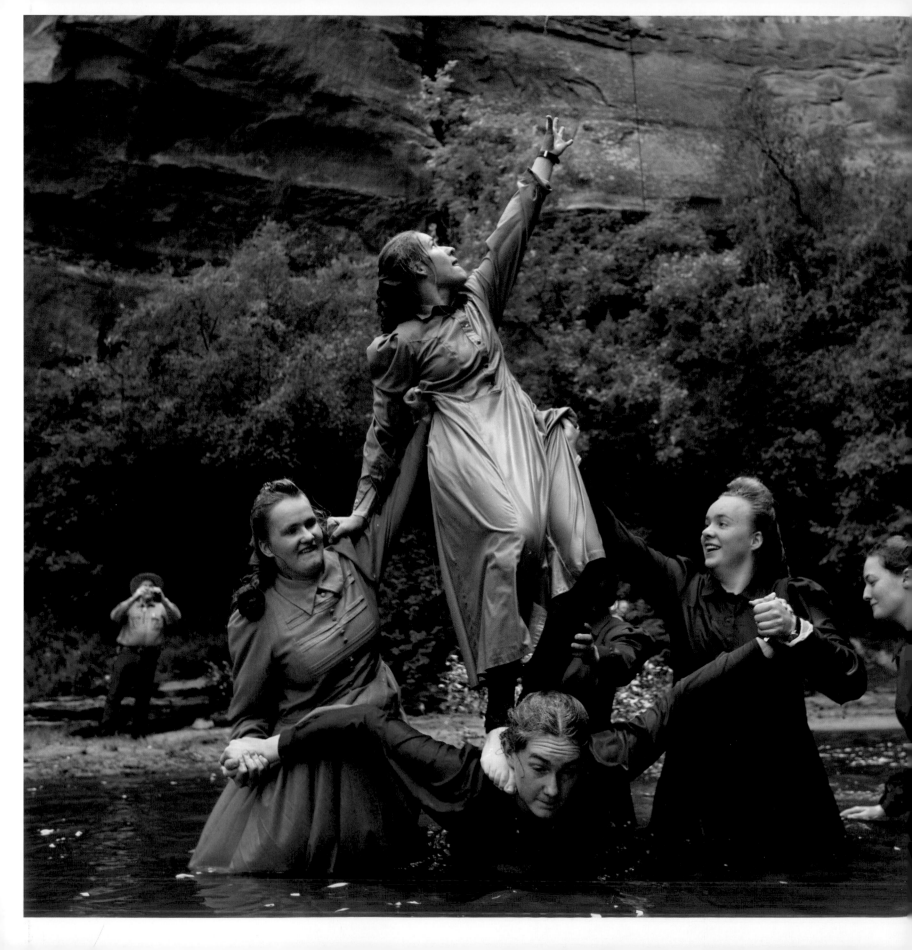

Sister Wives ~ 2008–2009

In 2008, when Texas authorities raided a fundamentalist polygamous offshoot of the Church of Jesus Christ of Latter-day Saints, a confounding question arose. Were women in the Mormon sect coerced into "spiritual" marriages? Arranged by church leaders, such unions usually pair young women, some underage, with older men in plural marriages. Few of the sister wives protest the practice or renounce the religion, but critics worry that psychological and social bonds prevent them from exercising their own free will.

Wearing homespun dresses, sisters splash in a pond near the fundamentalist Mormon settlement in Hildale, Utah.

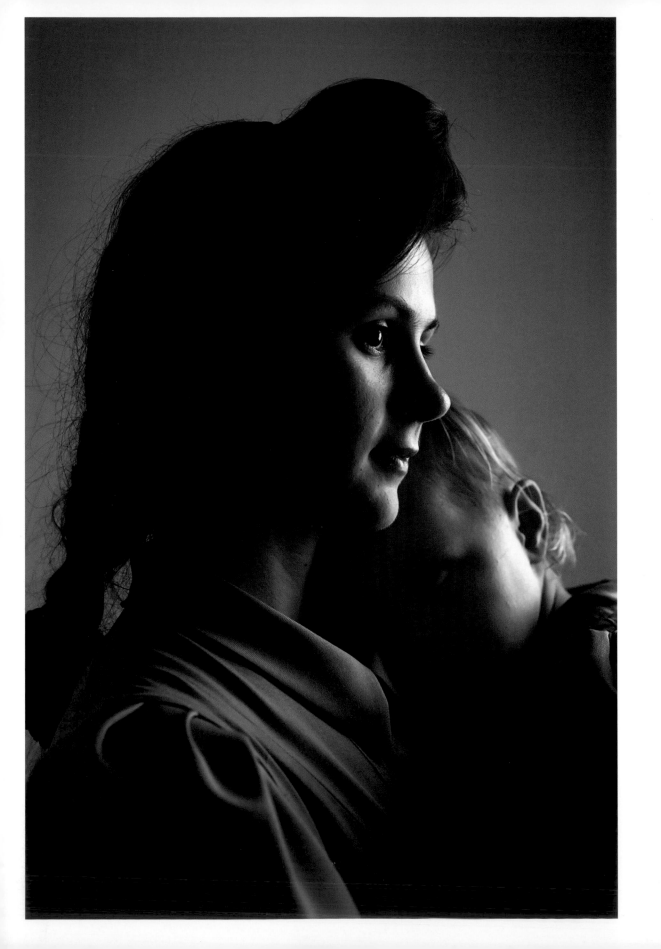

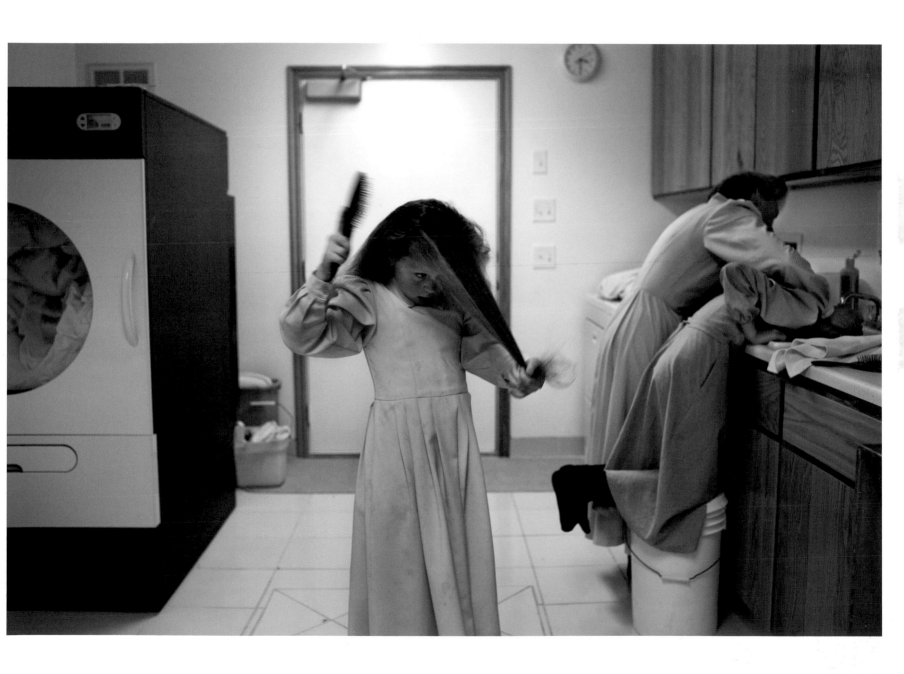

In a 2008 investigation of underage marriage, Texas officials collected DNA from Veda Keate (left) and her two-year-old daughter.

Merril Jessop's family members wash up in the polygamous leader's Texas home. He was later sent to prison.

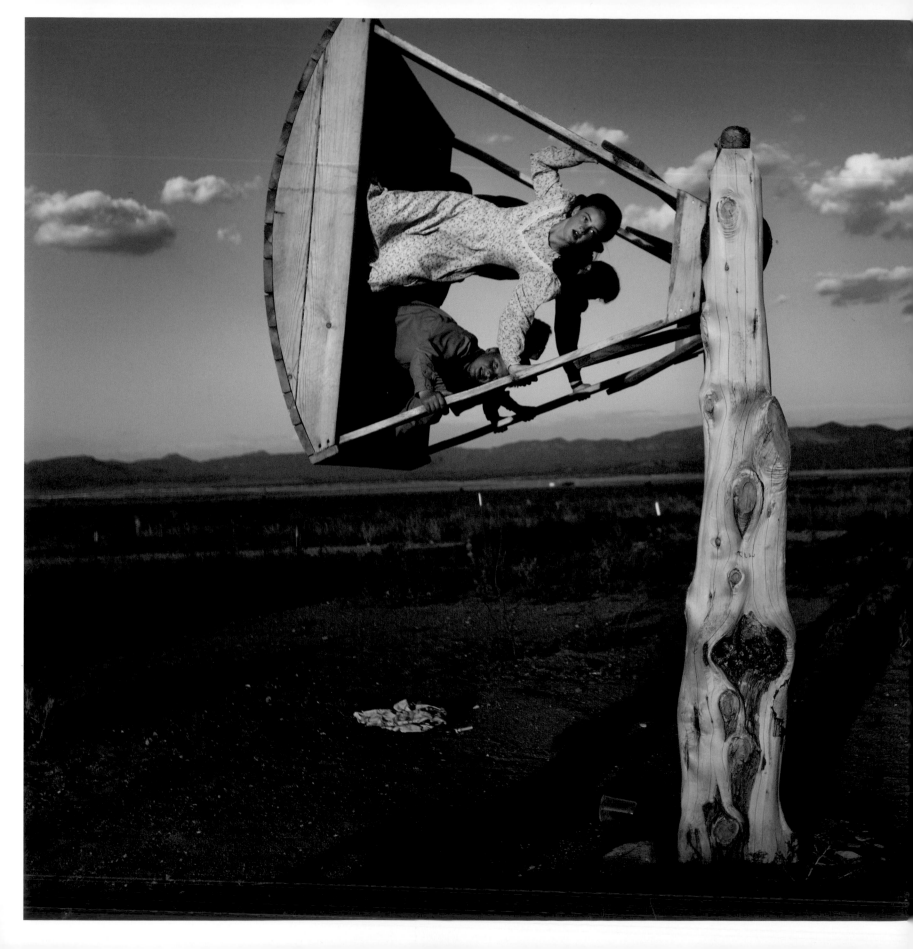

"I go in with
an open mind
and photograph
from that viewpoint."

*After working in the hay fields, girls play on a
homemade swing at their community's ranch in
Pony Springs, Nevada.*

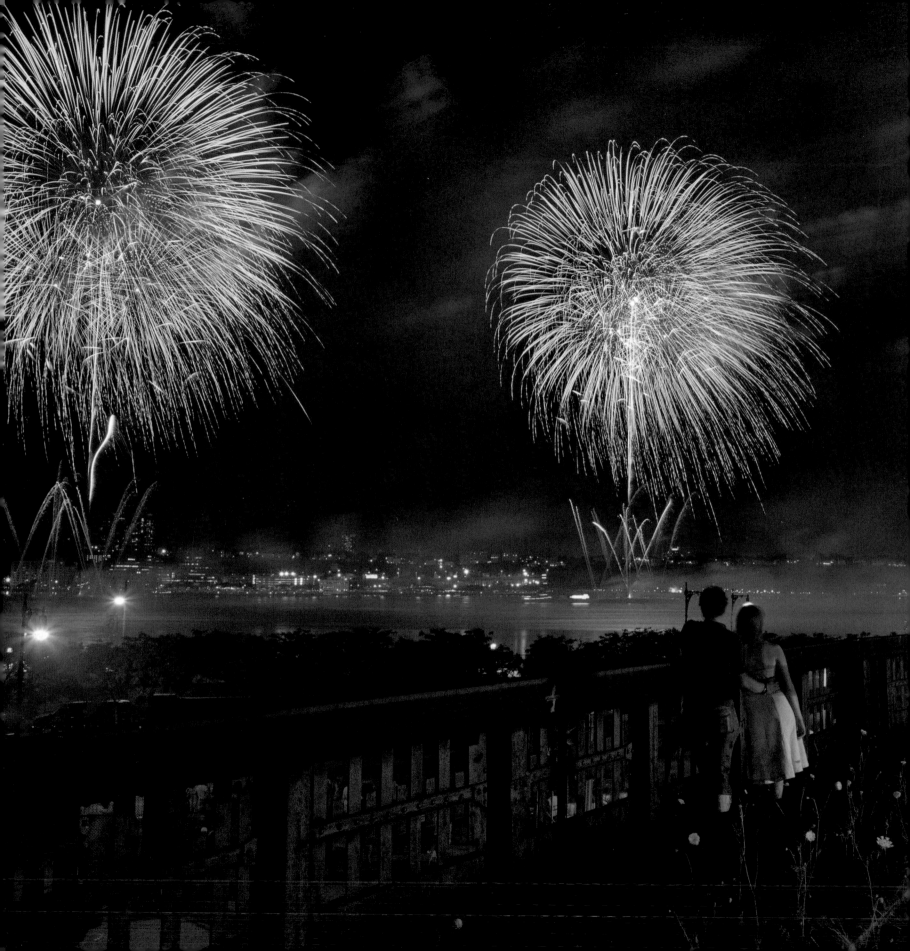

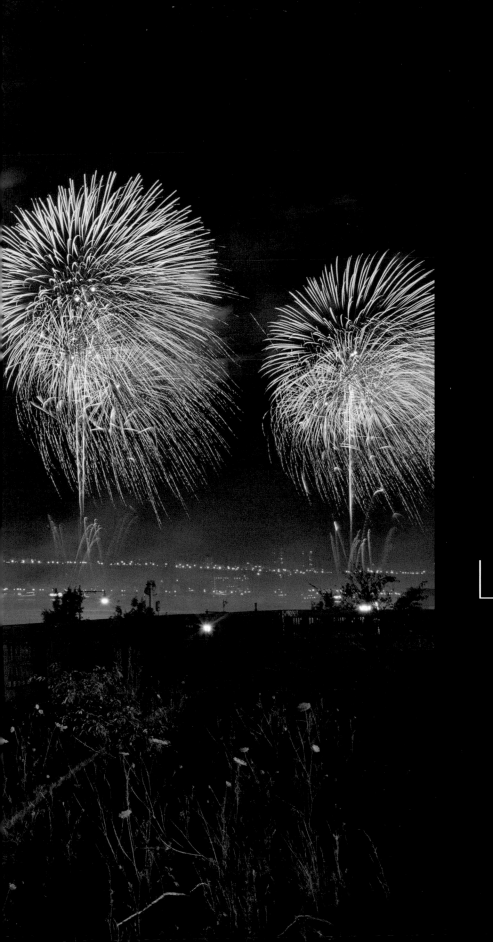

DIANE COOK

≈

Illuminating
Landscapes

"Taking pictures is not just pushing a button. Like a musician, you have to . . . respond in the moment."

Photographer Diane Cook prefers landscapes to people. After two decades documenting the world for *National Geographic* and other magazines, "I want my pictures to reconnect people who aren't connected to the landscape," she says. "And I want those who are connected to understand it better."

Cook, who grew up in Indiana, studied painting and art history at Rutgers. "I had the harebrained idea that to support my painting, I could earn a living as a photographer," she says. Her photography passion began long before college, when a family member took her into his darkroom. "It was magic to see light doing something to a piece of paper—to witness an image materialize in a tray of chemicals," she says.

She married photographer Len Jenshel in 1983, and the two began collaborating in the early 1990s, after realizing they had a similar aesthetic. Since then, they have contributed numerous landscape stories to *National Geographic,* including photo essays on Mount St. Helens, the U.S.–Mexican border, New York's High Line, and Hawaii's Na Pali coast.

Despite the many years Cook has been in the business, showing her photographs to editors still makes her nervous. She has described presenting her *National Geographic* story on Kauai's coast as "the most nerve-wracking," because Editor in Chief Chris Johns is an expert on the topic. "It was like putting your wares before the king," she says. "I thought I would get beheaded. I had to show him something he hadn't seen before." More recently, she was heartened when a room full of editors burst into applause after seeing Cook and Jenshel's photographs for an acclaimed story on night gardens, which appeared in the magazine in 2013.

For Cook, a recipient of grants from New York's Council on the Arts, it's all about hard work. "I always quote Thomas Edison: 'It's 99 percent perspiration and 1 percent inspiration,'" she says. She and Jenshel spend a great deal of time on research before beginning a shoot. "Taking pictures is not just pushing a button," she says. "Like a musician, you have to practice and be tuned and have the instinct to respond in the moment."

Preceding pages: *A work in progress, this section of Manhattan's elevated park promises to be an ideal spot to view fireworks.*

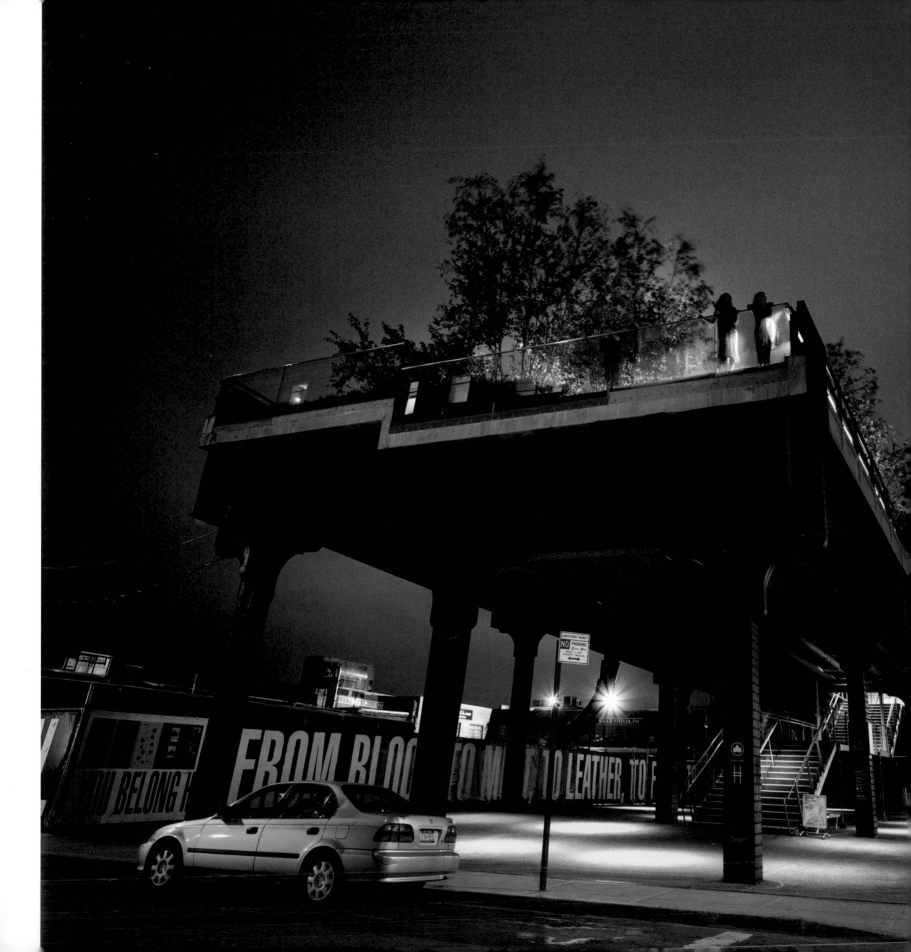

Manhattan High ~ 2010

New York City planners recently transformed a derelict 1930s elevated rail line into a popular urban oasis. Called the High Line, it is the kind of ingenious reclamation project that inspires the landscape photography of Diane Cook and her husband, Len Jenshel. Thickets of plants and flowers, art installations, and inviting sitting areas create focal points along a mile-long linear park. Situated 30 feet above city streets, the walkway yields plenty of new and surprising views of Manhattan.

At its southern terminus, the High Line passes through a hotel, then snakes northward through the west side of the city.

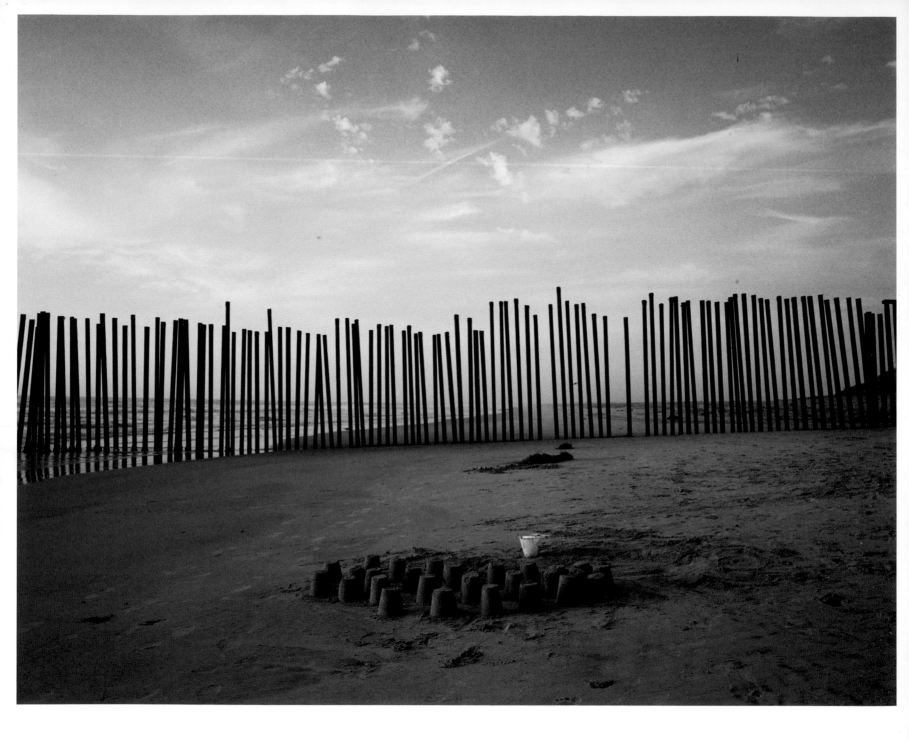

Border Walls ~ 2006

The U.S.–Mexican border is nearly 2,000 miles long, stretching from California to Texas. The most crossed international border in the world, 20,000 U.S. agents patrol it. They use high-tech ground sensors and surveillance cameras in their work, but often the most visible deterrent is a wall. In Cook's and Jenshel's skilled hands, photographs of such utilitarian fences are elevated to fine art.

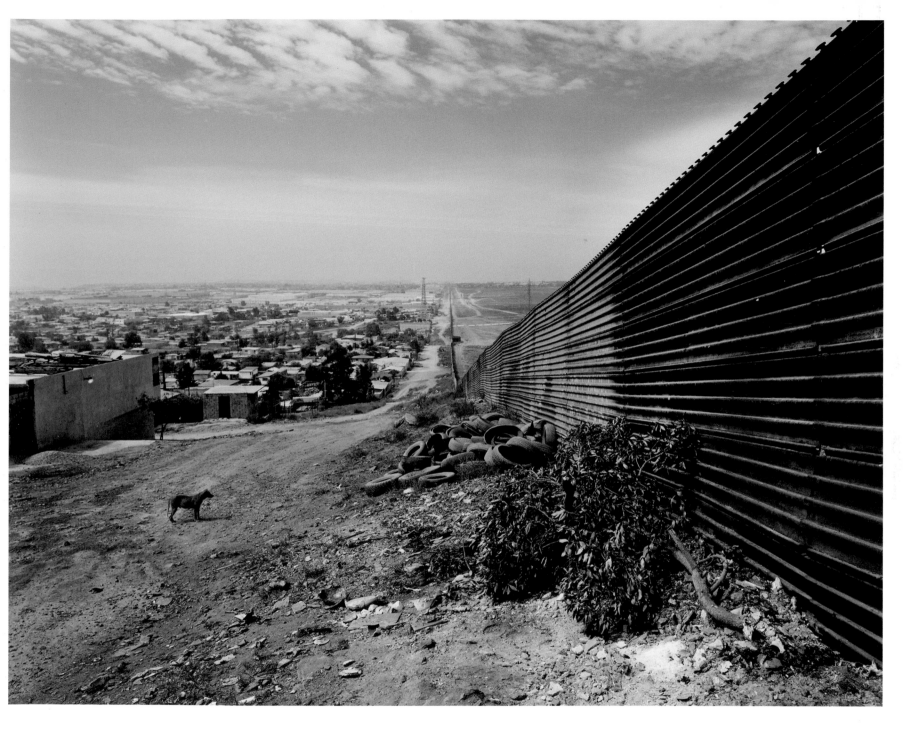

A porous fence of upended railroad tracks on a Tijuana beach (left) marks the western end of the U.S.–Mexico border.

In Tijuana, Mexico, a border wall made from surplus military steel abuts an impoverished community.

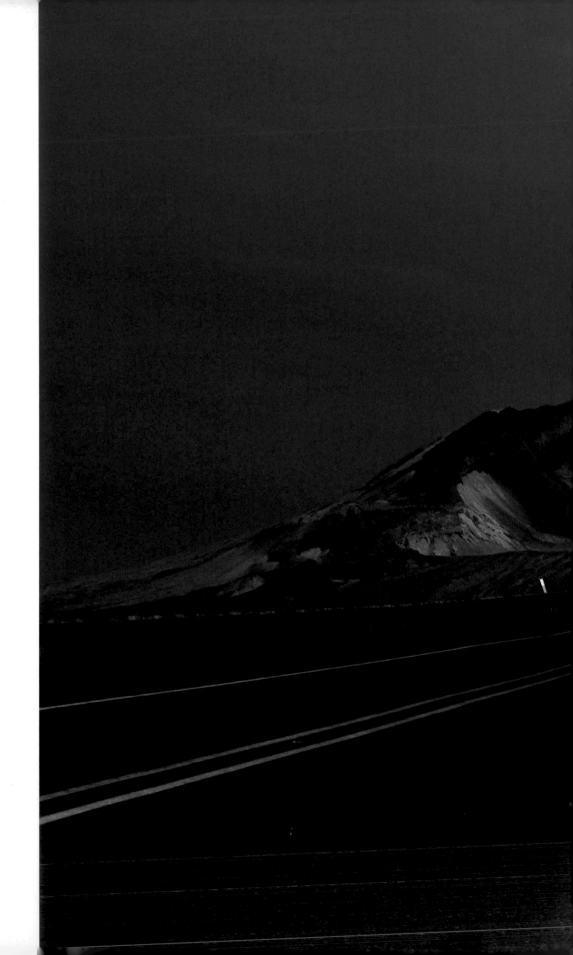

Moonrise, Mount St. Helens ~ 2009

Three decades after Mount St. Helens erupted, destroying everything for miles around, the area's ecosystem is gradually rebounding. Stands of saplings and fields of wildflowers flourish on the once desolate gray landscape. Animals, large and small, are migrating back to the area.

A full moon hangs above the highway to Mount St. Helens; the road was buried under mud and ash 30 years ago.

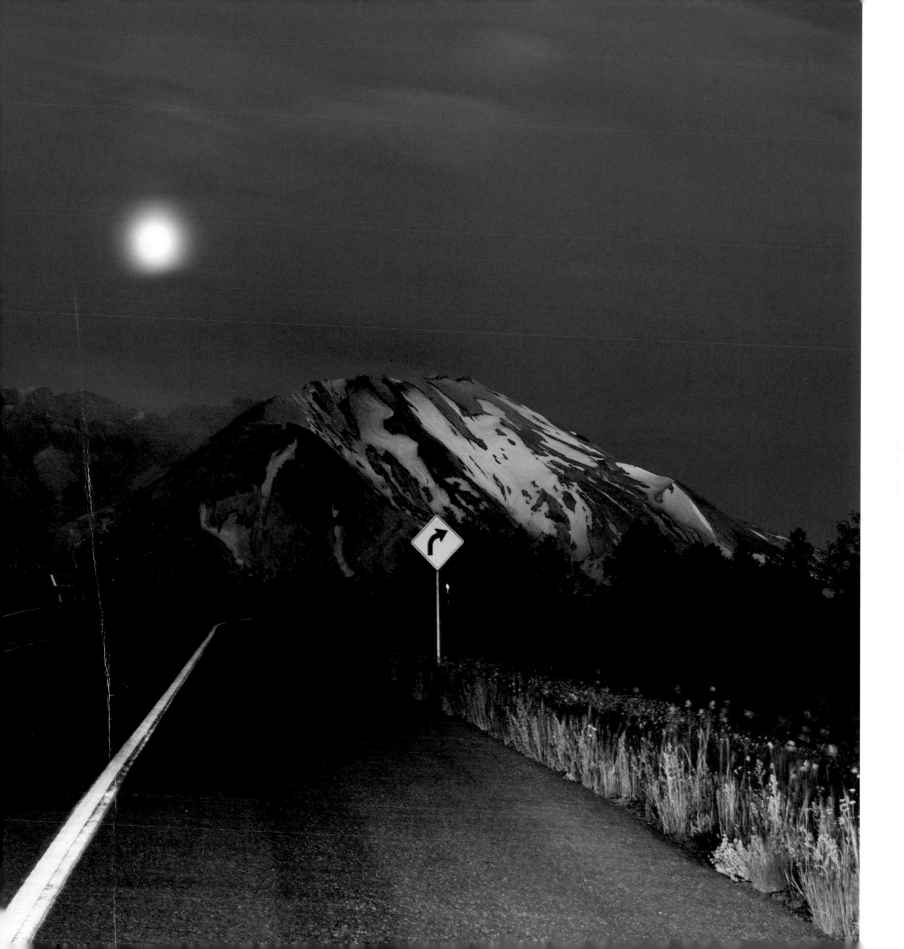

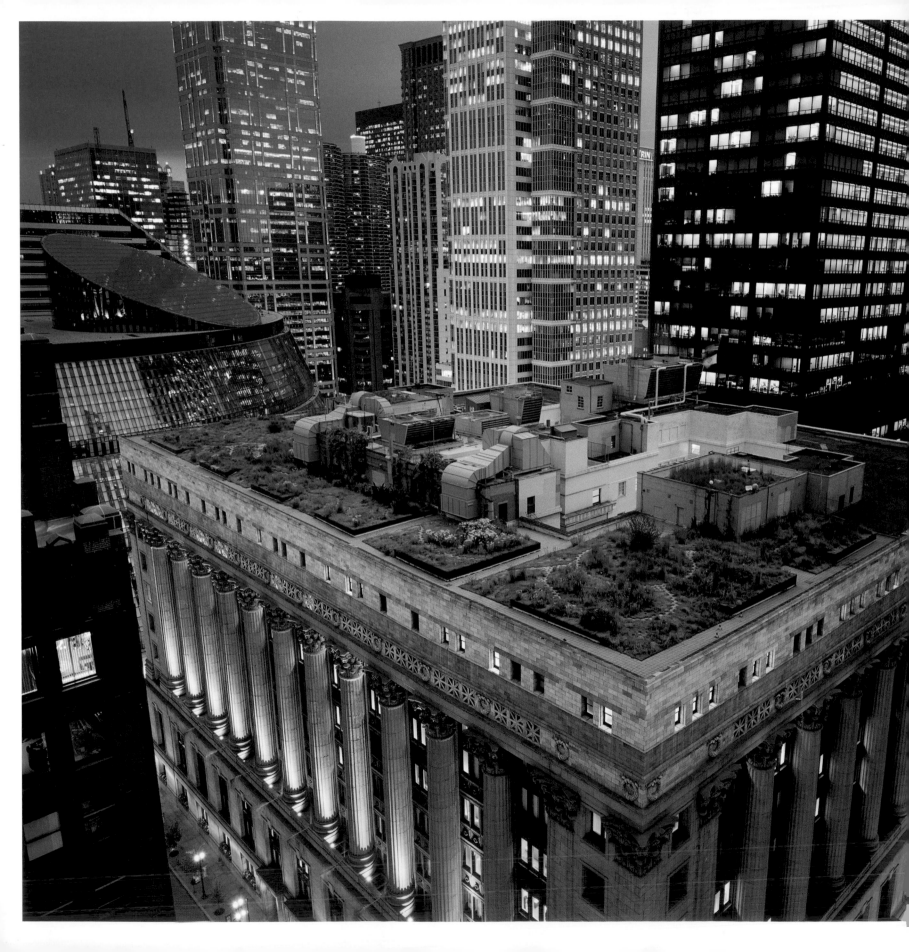

Up on the Roof ~ 2008

Cities and companies around the globe are turning the ugly tarred roofs of sky-scrapers into lush green retreats. Green roofs, or living roofs, not only beautify the concrete-and-steel jungle, but they also reduce the energy needed for heating and cooling buildings. Green roofs also minimize water runoff. Once a roof's vegetation takes hold, birds, bees, and butterflies are sure to turn up.

Thousands of grasses and plants were used to create Chicago City Hall's award-winning rooftop.

"Green roofs
are secret gardens
in the sky.
Revealing those landscapes
was magical."

*Blossoming sedums brighten the roof of a
Manhattan architectural firm (right) as its
windows reflect the Empire State Building.*

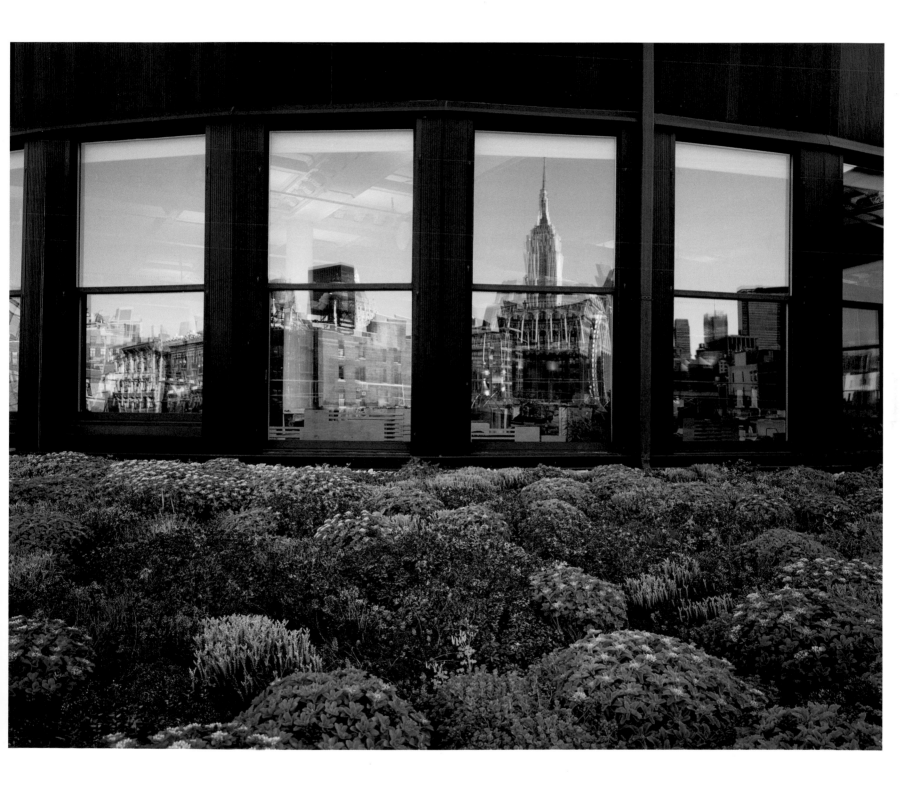

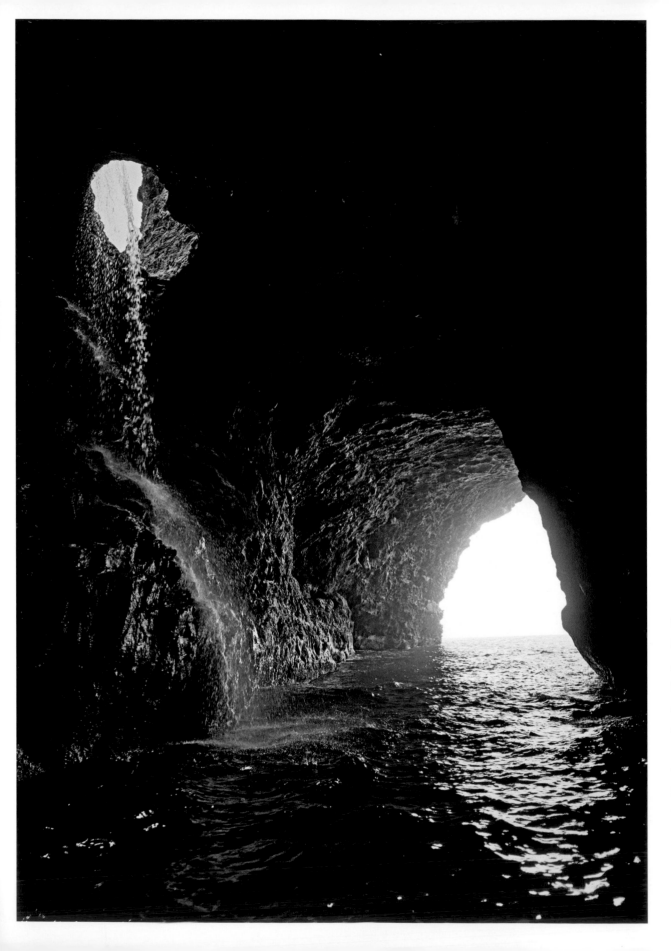

Rugged Beauty ~ 2007

Kauai's reputation as the most pristine and rugged of the Hawaiian Islands is based on the majestic cliffs, luxuriant valleys, plunging waterfalls, and otherworldly sea caves found on the Na Pali coast. This earthly paradise on the northwest side is accessible only by boat, helicopter, or an arduous 11-mile hike. Visitors will be richly rewarded, however they choose to get there, with moments of awesome wonder.

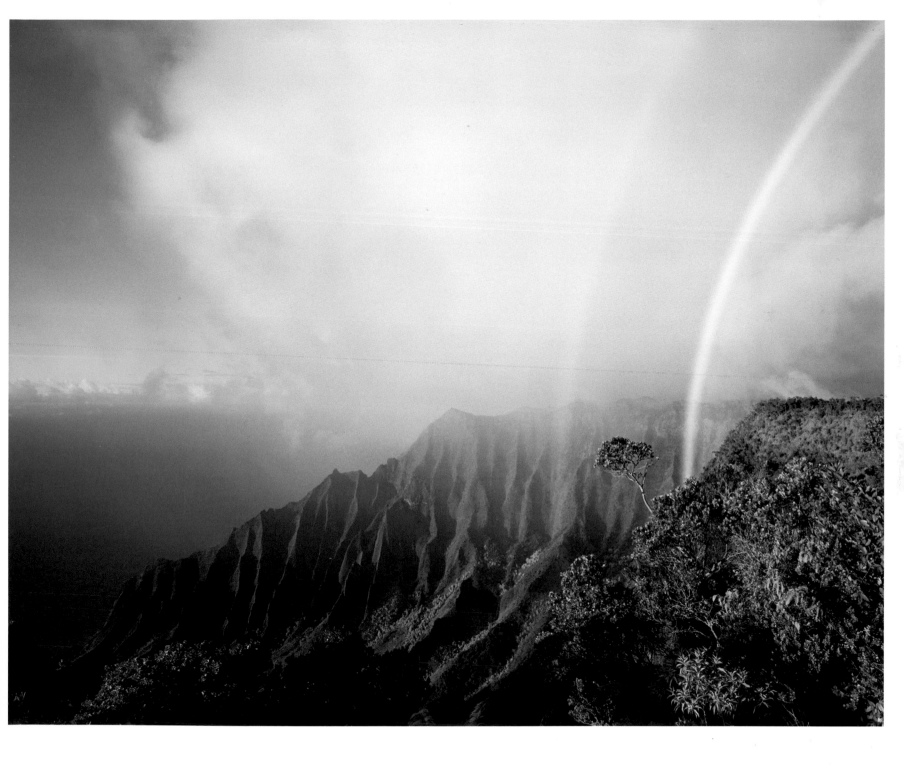

Light pierces the darkness of Waiahuakua Cave (left), creating a mystical azure pool at the base of a waterfall.

A double rainbow arcs above the jagged cliffs and dense vegetation of Kalalau, the largest valley on Na Pali.

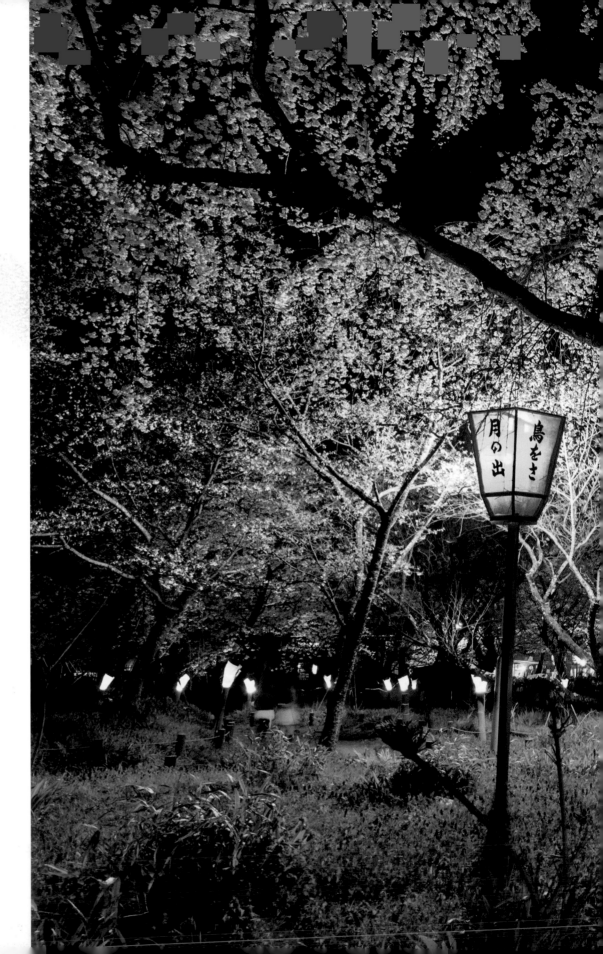

Night Gardens ~ 2012

A garden at night reveals a different world from one viewed in daylight. On a challenging assignment to photograph gardens at night, Cook and Jenshel captured a water lily slowly unfurling its petals and discovered that a flower's perfume is stronger under the stars. Ambient light as well as silvery moon-light can transform night gardens in distinct and magical ways.

Lantern light gives Kyoto's cherry blossoms an ethereal glow at night, a popular time to view them in Japan.

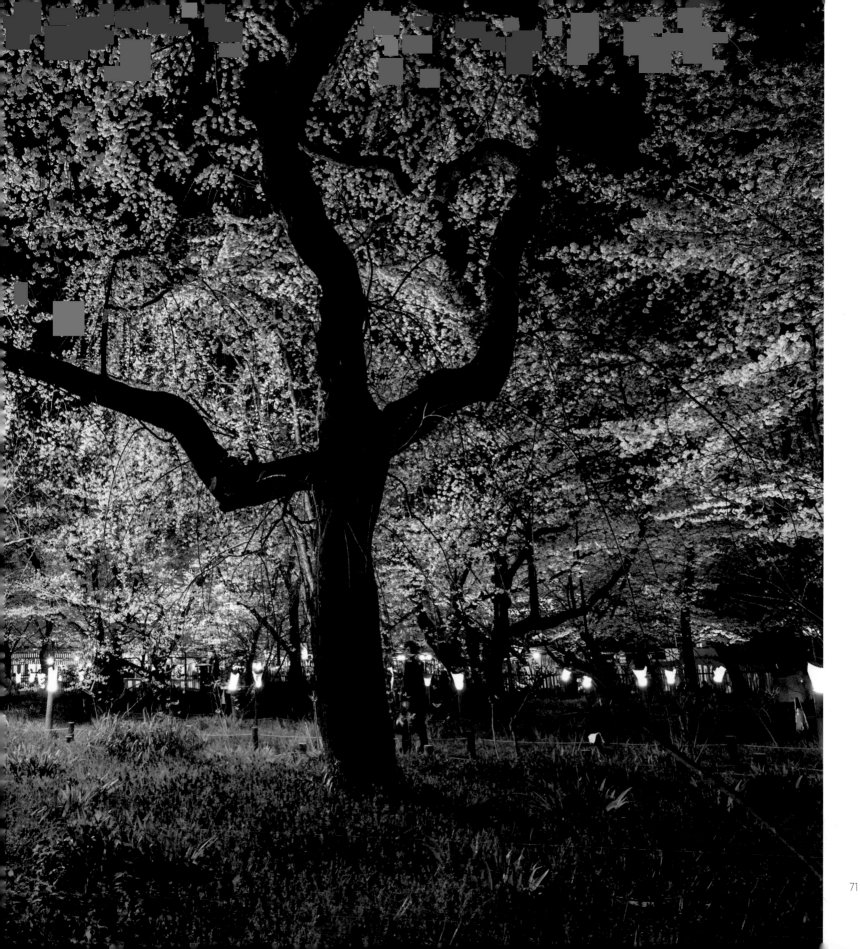

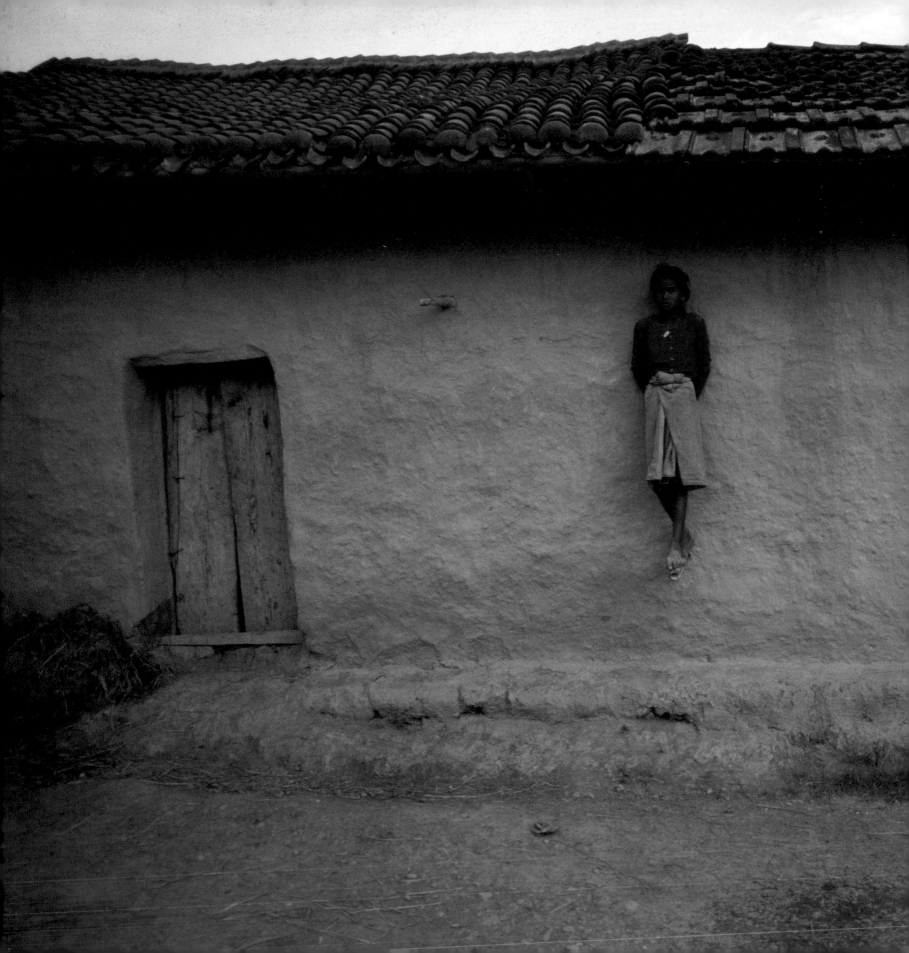

MAGGIE
STEBER

A Passion
for Life

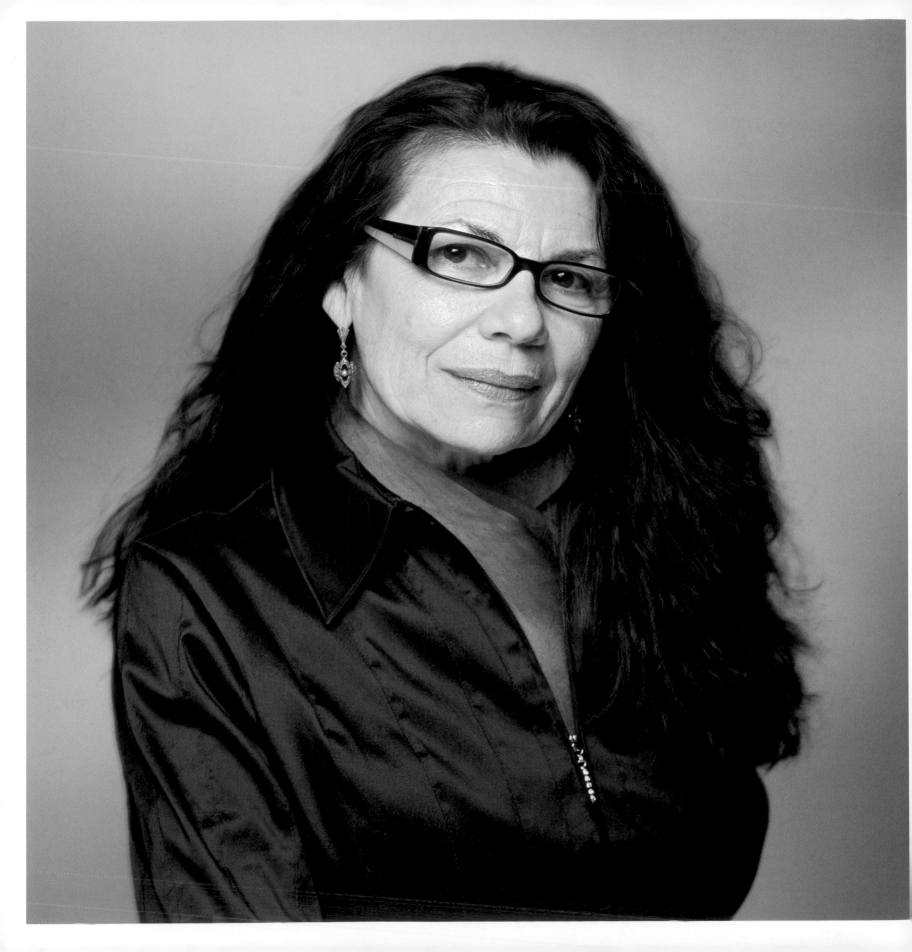

"We take a picture and make a historic document that records a moment in time. That power fascinates me."

World-renowned photojournalist Maggie Steber has covered Haiti for almost 30 years. Since her first visit in 1985, she has photographed rebellions, natural disasters, and scenes of social upheaval. She watched her own car burn to black metal; she has been on death lists. She has fled the country to save her life and experienced the devastation of the 2010 earthquake. But in her work, Steber chooses to focus on one of the least publicized attributes of Haiti: its beauty.

"Reporters never go to Haiti during the quiet times because that's not what newspeople do," Steber says. "Yet it's in those quiet times that you see what Haiti is and who Haitians are. You see the exquisite beauty of the place—and the people—who are different from the way we've defined them."

Born in Texas to a single working mother, Steber first worked at the *Galveston Daily News* in 1972. She persuaded editors to hire her for what was then considered a "man's job"—staying up all night to write and photograph a story about the fate of a local theater. A year later, Steber moved to New York to become a photo editor at the Associated Press, remaining there until she moved to Rhodesia to cover its war. "To me, the story on Rhodesia was not about the front line, where I would have gotten killed," she says. "It was about how the society was changing." She fell in love with Africa, and when she returned to New York, she longed to go back. A friend suggested that she travel to Haiti because "it was just like Africa, but only three hours away," she recalls.

In recent years Steber turned her lens on her mother, who had dementia. For this independent project, titled *Rite of Passage,* Steber made portraits of her mother, whom she said she met "all over again" in the process. "Through the photos of my mother, I am reaching out to people, showing them not to be so frightened, showing them that they can be warriors. For the first time in my life, I'm able to see my mother as not my mother."

Steber lives in Miami. She has received the Leica Medal of Excellence and awards from World Press Photo and Pictures of the Year. "I can't believe it," Steber says. "I can't believe I've had this life."

Preceding pages: *In a surreal illusion, a Nepalese girl standing on a support post of a traditional mud house seems to levitate.*

Uncertain Future ~ 1999

Despite being the gateway to Mount Everest and other majestic Himalayan peaks, Nepal ranks among the poorest nations in Asia. A ten-year civil war, which ended in 2006, disrupted tourism and economic growth, and Nepal has since struggled to regain its footing. Beleaguered by low literacy rates, especially among women, and a high prevalence of diseases like tuberculosis and blindness, the country's progress continues to lag. With a tenuous peace in place, Nepal's destiny remains unclear.

A man with one lens awaits an eye exam in Nepal, where cataracts account for 72 percent of blindness.

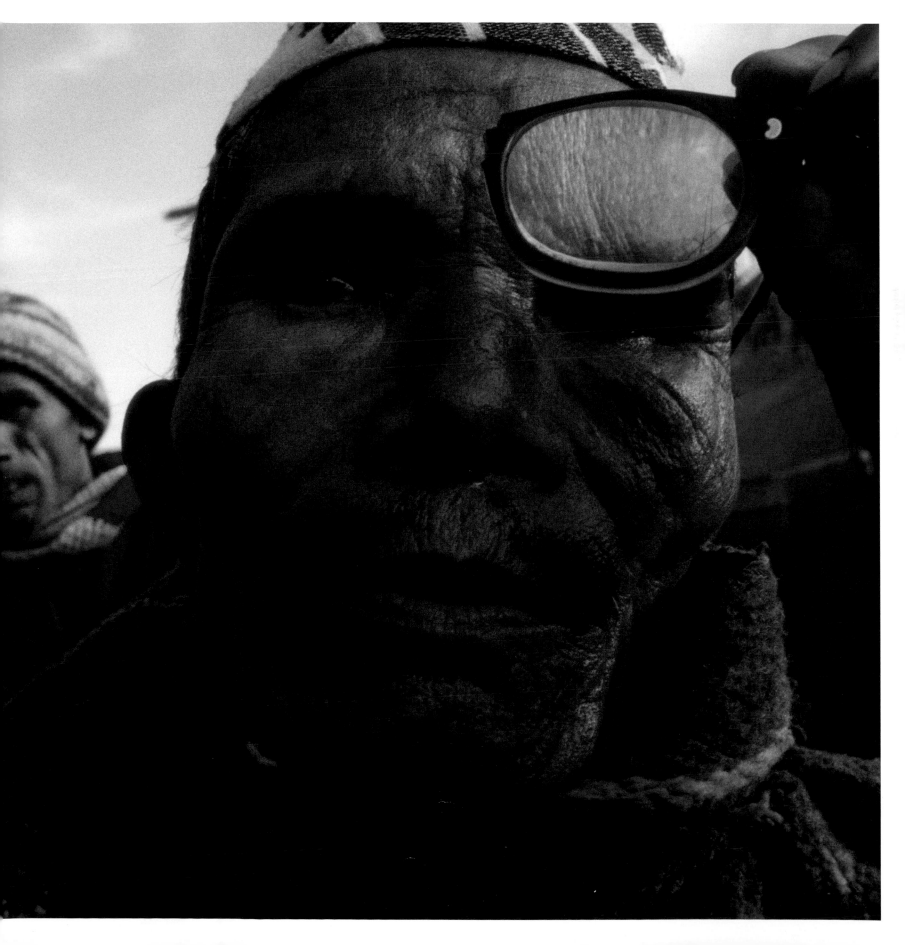

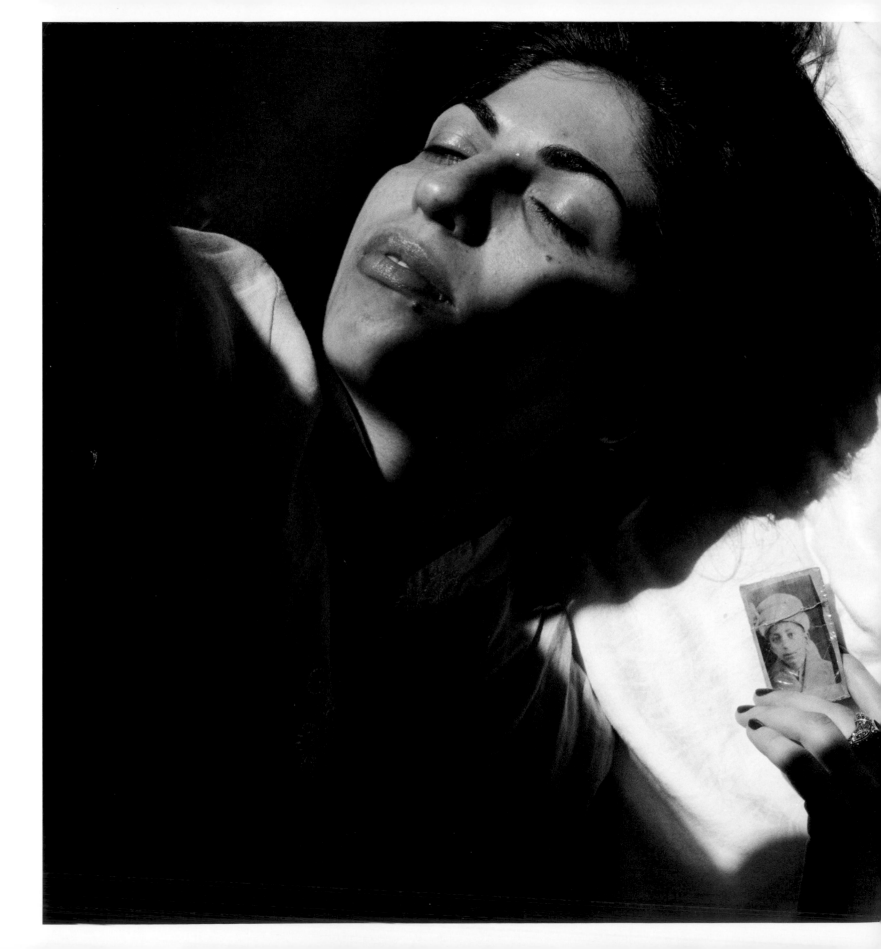

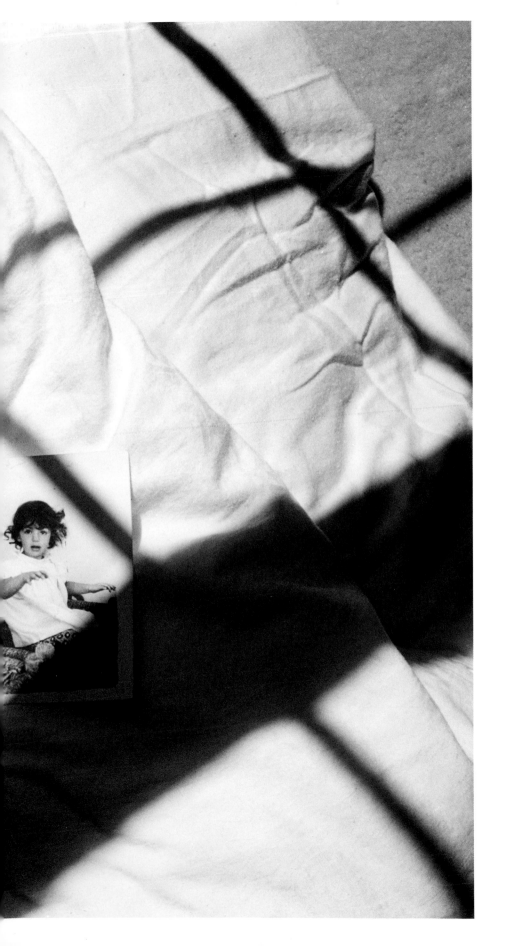

War Correspondence ~ 2005

Letters written to family and friends during wartimes are unique chronicles of traumatizing events that no textbook history can parallel. In the past, soldiers hunkered down in trenches or shipped out suddenly to a combat zone might have hastily scribbled letters to loved ones. Today, sentiments from conflict zones are likely to be conveyed via email or video and are as intensely moving as bundled ribbon-tied letters.

While teaching in war-torn Afghanistan, Masuda Mohamadi wrote detailed emails to family and friends in Fairfax, Virginia.

"For me the most profound thing
about photography
is that it is a universal language
that speaks to everybody.
It exists without borders, without barriers,
without restrictions."

*Nestled in their bed in Miami, Florida, four young
sisters (right) nap on a Sunday afternoon after
attending church.*

The Mystery of Sleep ~ 2009

We spend a third of our lives sleeping, but after decades of research, scientists are still exploring the reasons we need sleep. Theories suggest that repair and rejuvenation are critical to our well-being and that sleep deprivation may lead to death. The brain's ability to learn and retain information is also likely tied to sleep. Despite the health benefits of a good night's sleep, insomnia is at epidemic levels in the developed world.

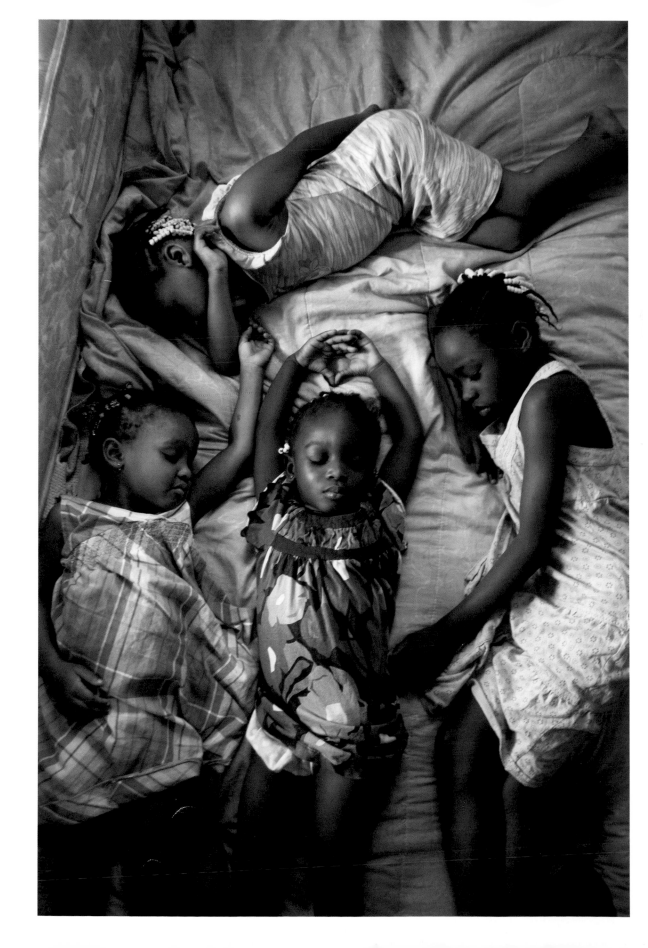

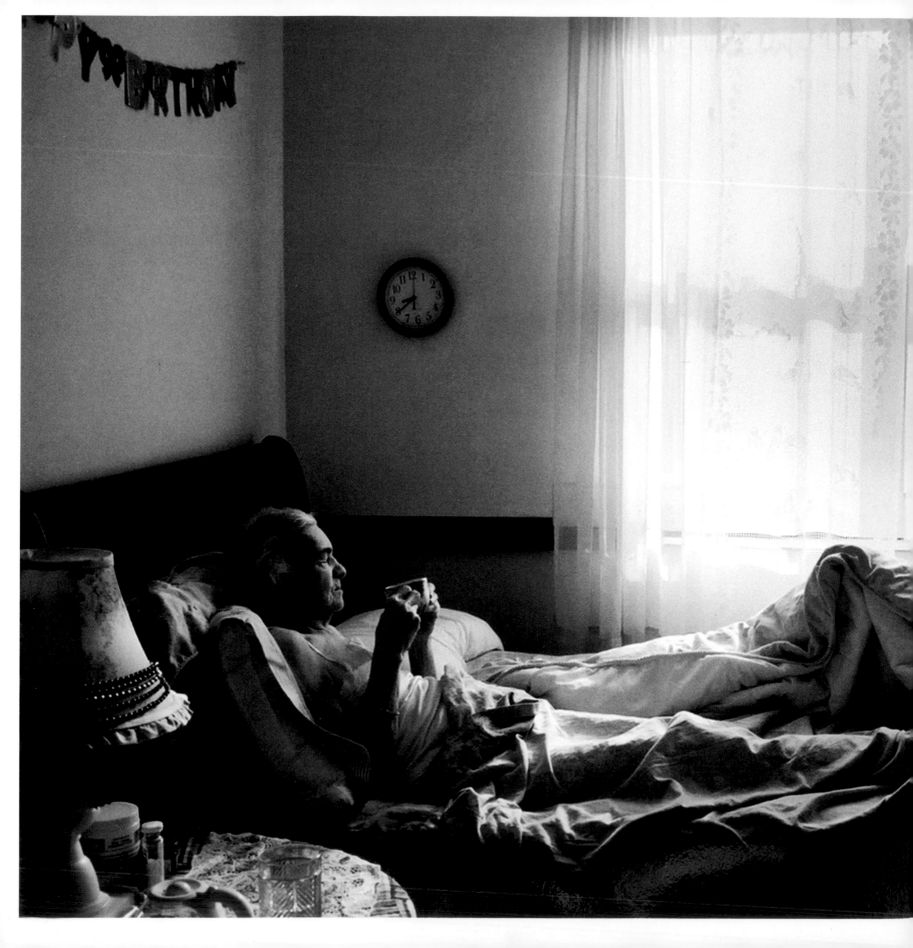

Memories ~ 2006–2007

Some five million Americans have Alzheimer's disease, and the number is predicted to rise as the population of people 65 and older increases. On the front line in the struggle to manage the disease is the family caregiver. Steber knows the heartbreaking scenario first-hand, having witnessed her mother's dementia. Her photographs of her mother and others with impaired memories reveal their dignity and grace.

The photographer's mother, Madje Steber, suffered severe memory loss during her final years at a Florida facility.

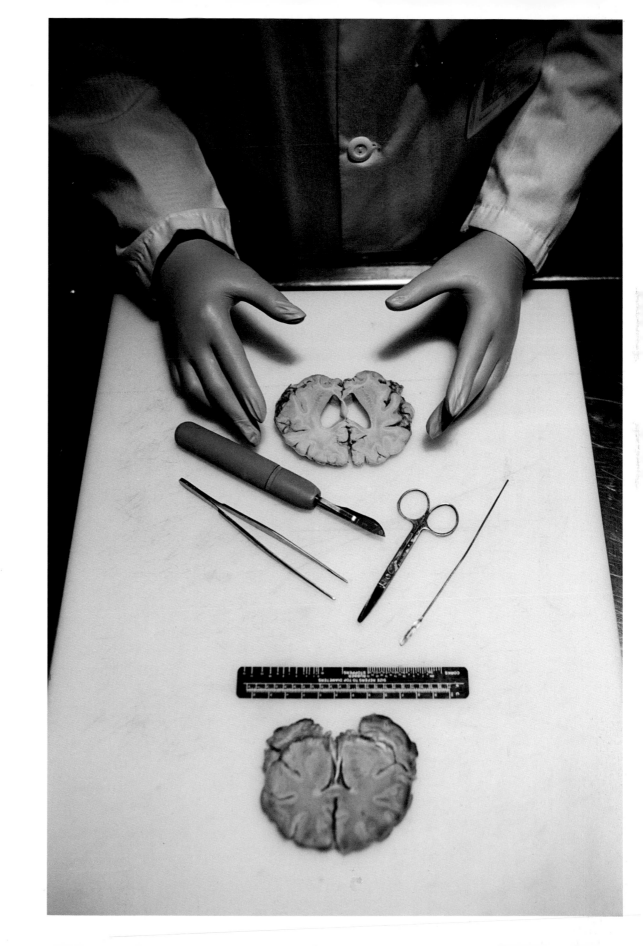

Neurologist David Snowdon (left) visits a Wisconsin convent, whose nuns have donated their brains to dementia research.

Cross sections of the brain (right) show a healthy one at the bottom and an Alzheimer-diseased sample at the top.

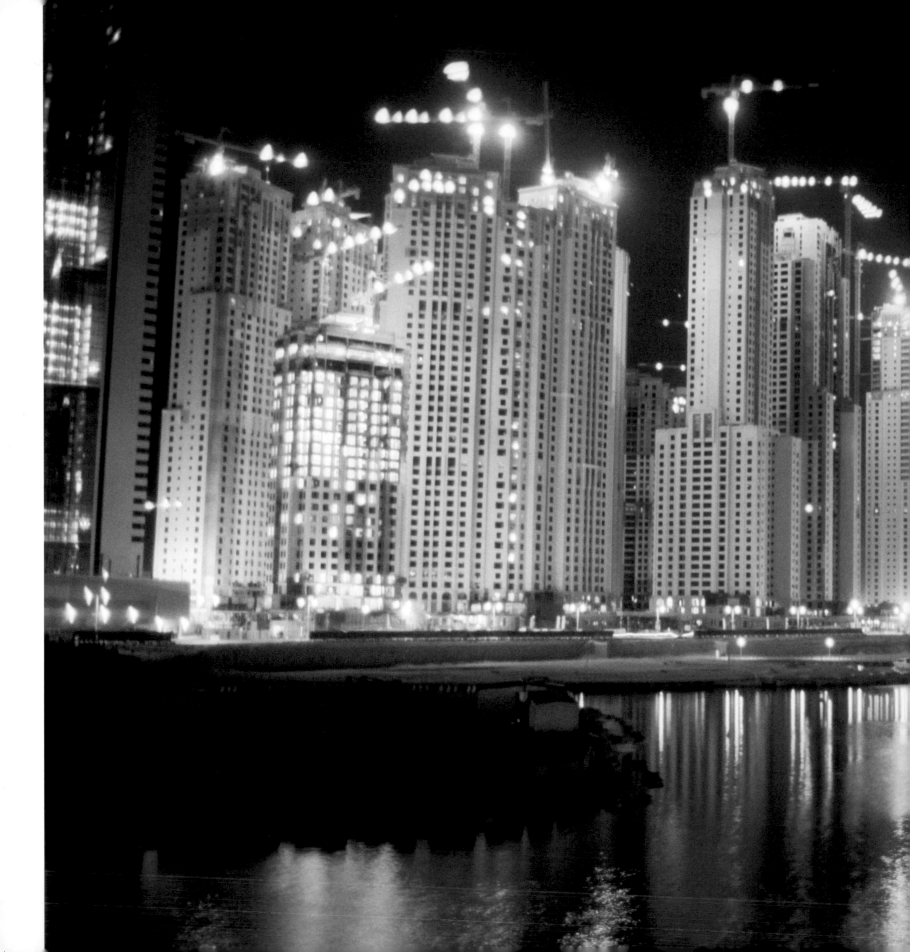

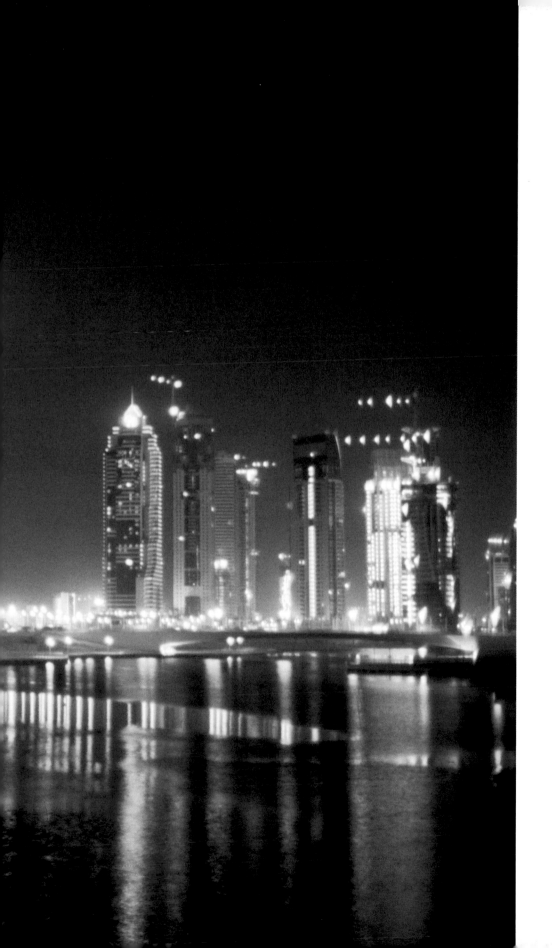

Living Large ~ 2006

Dubai is a tiny city-state in the throes of excess. It boasts the world's tallest building, the largest shopping malls, an indoor ski slope in the desert, and man-made islands. Capitalism rules in Dubai's oil-rich economy, where income taxes are nonexistent. Less than 50 years after gaining independence from Great Britain, the glittering bauble in the sand draws visitors and workers from around the globe. Detractors wonder if the bubble will burst when the oil runs out.

Sparkling in blue light, Jumeirah Beach Residence, a luxury complex, appeals to entrepreneurs flooding the city.

"I always try to find a photographic thread that can bring commonality to my pictures."

Well-paid expatriates take in a polo match at Arabian Ranches, a suburban housing development outside Dubai.

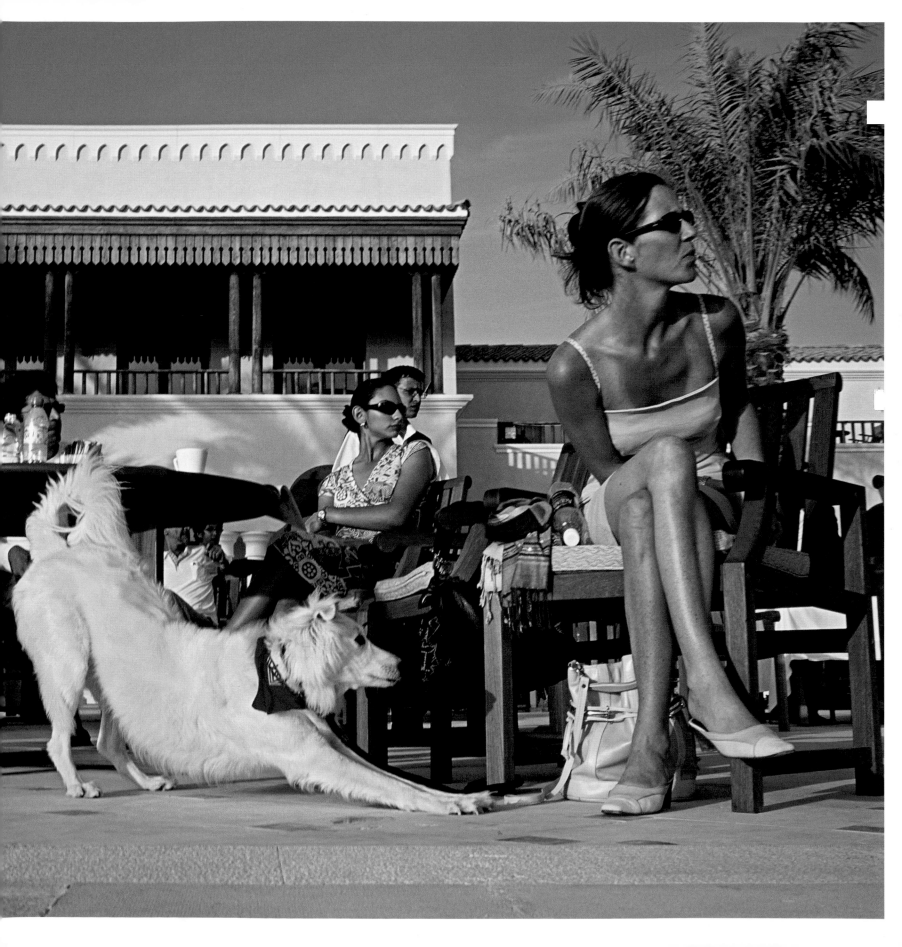

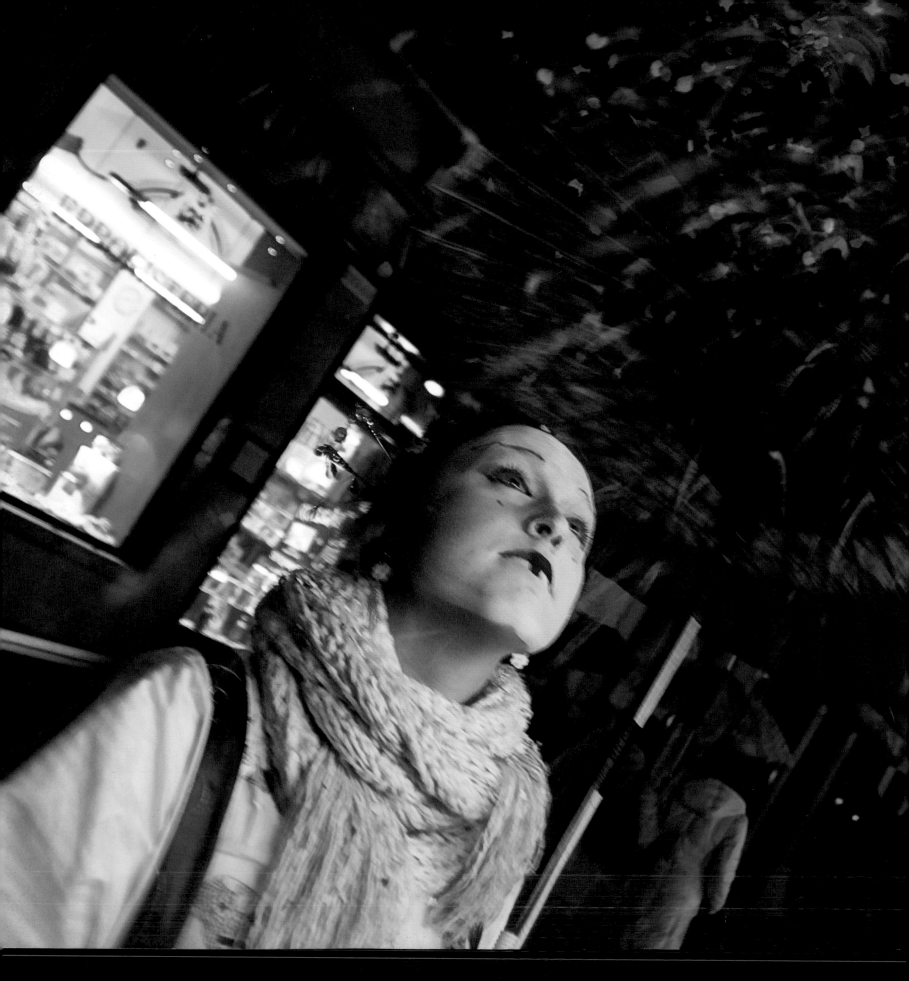

JODI COBB

Embracing Beauty

"I love seeing things I've never seen before. I love the process of making an image that speaks to people."

Jodi Cobb is one of only four women to become a *National Geographic* staff photographer. Her work has become legendary. When she first came to the magazine for a trial assignment, her only experience besides a few newspaper gigs had been photographing her hippie friends in concerts. Some, like Bruce Springsteen and Crosby, Stills, and Nash, became stars. "I had never shot color film and I had never read the magazine," says Cobb.

Her first piece was a 30-page story on Owens Valley, California. "At one point I pulled off to the side of the road and just sat there sobbing because I was so tired and lonely and insecure about my work."

Two years later, the magazine hired her full-time. She was "determined to do everything the boys could do." In 1980, she traveled to China as one of the first Westerners to set foot in the country following the 1949 revolution. "Hundreds of people would gather within a minute of my arrival anywhere and silently stare at me, because I was the first Westerner they'd ever seen," she says. "But no one would talk to me."

Despite her impressive array of news-making stories, Cobb struggled with her position as one of *Geographic*'s few female photographers. "Every fiber in my being resented that extra word identifying me—female. I felt I had an extra job to do—uphold all women—while trying to do my work."

While preparing for an assignment on Saudi Arabian women, "a lightbulb went on." Cobb recognized her advantage as a woman, for she was the only one of her colleagues who could gain access to her closely guarded subjects. The project increased her interest in human rights and influenced her subsequent work.

In the mid-1990s, Cobb traveled to Japan as the first person to photograph the closed society of geishas. In 2003, she gained wide recognition for her *National Geographic* story "21st-Century Slaves," about human trafficking. "It took me a year to do the story, and another year to get over it," she says.

Cobb won the Missouri Honor Medal for Distinguished Service in Journalism in 2012. "I love seeing things I've never seen before," she says. "I love travel. I love the process of making an image that speaks to people."

Preceding pages: A reveler pauses as a shower of confetti rains down on her during Venice's Carnevale.

Venetian Allure ~ 2008

Even as scientists scramble to save the splendid city of Venice from the encroaching sea, nothing seems to stem the tide of tourists who clog its narrow streets and cruise its scenic canals. The visitor population peaks during Carnevale, the city's annual pre-Lenten festival. The spectacle of masked and costumed merrymakers rivals the city's magnificent art and palaces. Somehow, the fragile, gilded beauty endures, luring even more besotted travelers.

A tourist's gauzy costume veils gondolas and buildings on San Marco Basin in an enchanting blue mist.

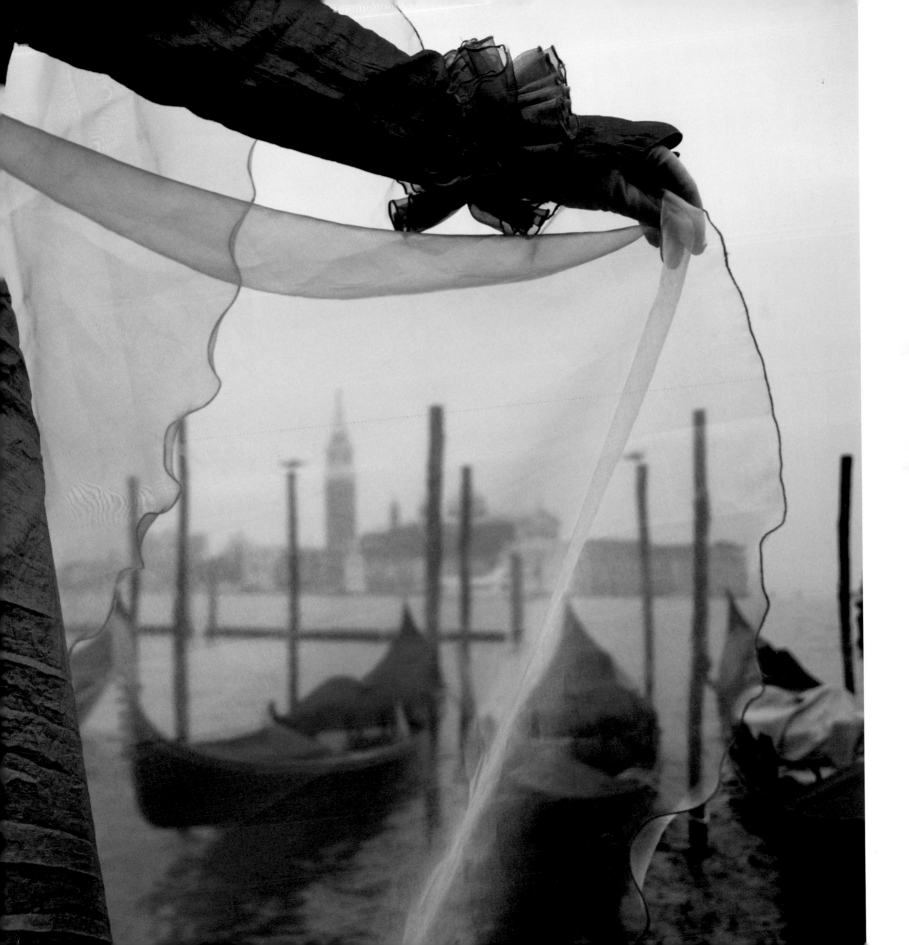

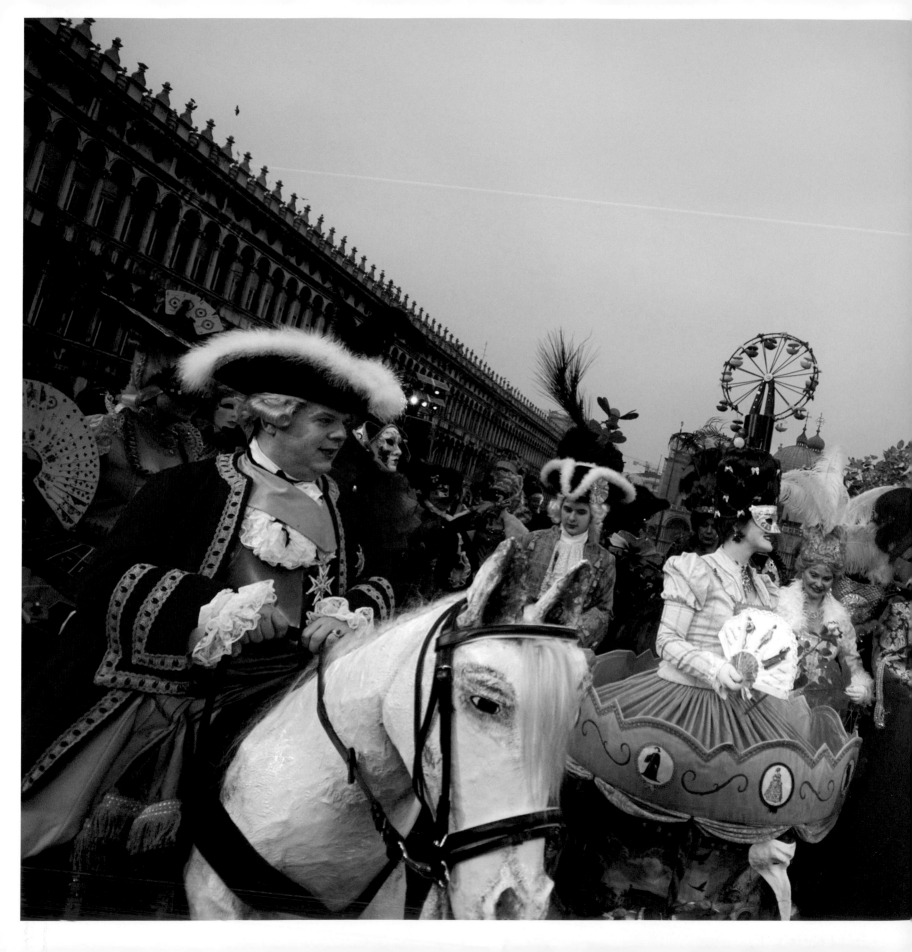

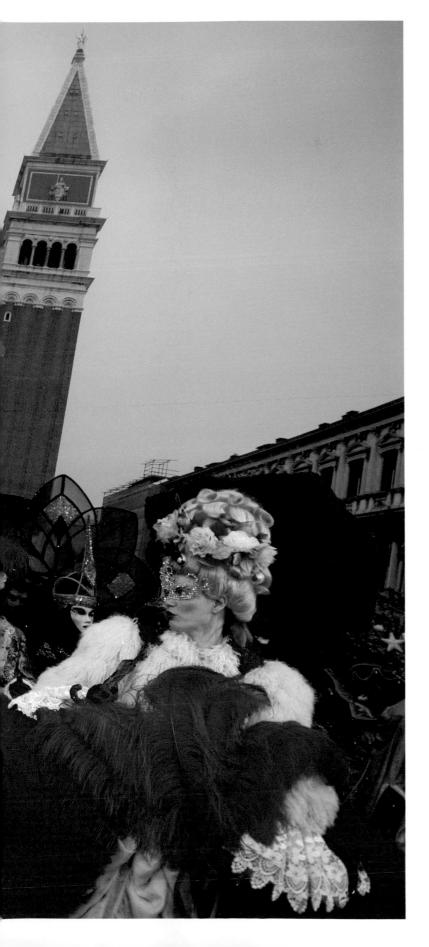

"Venice was the story
that refreshed
my soul.
It was a joy.
It was about the
power of the image,
the pleasure
of photography."

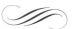

Competitors for the best costume contest throng
Piazza San Marco.

97

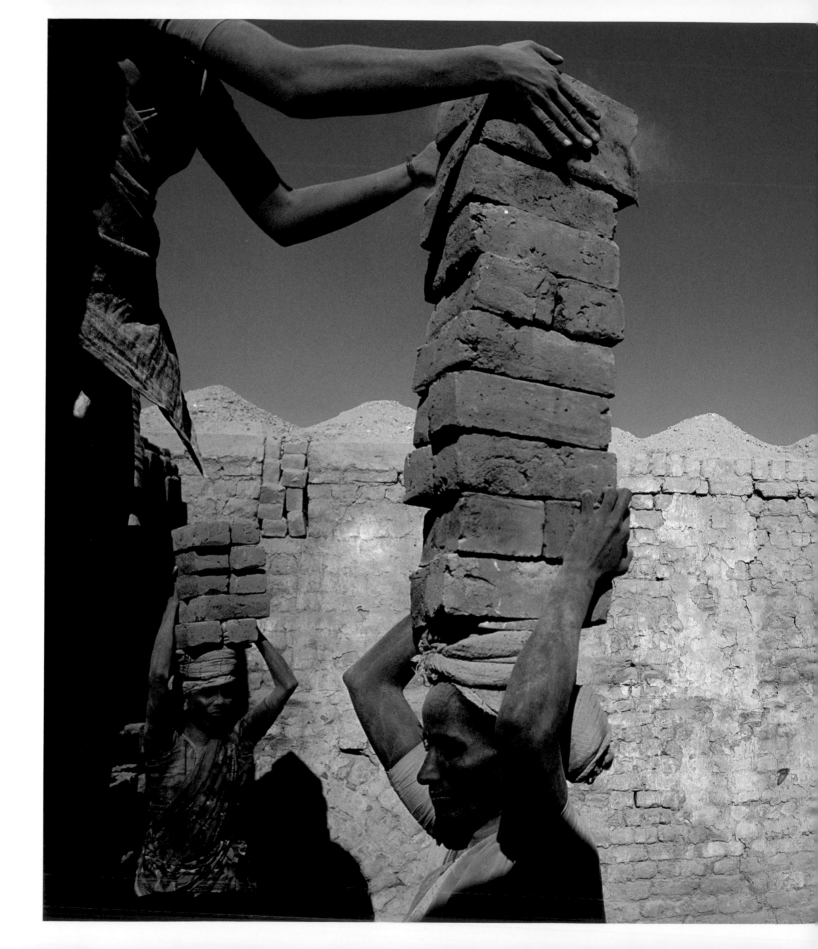

Slaves Among Us ~ 2002

The existence of slavery in the 21st century is shocking to many but a brutal reality for millions. People hoping for a better life often fall victim to human traffickers who deny them basic freedoms and exploit them in diamond mines, factories, tomato fields, brothels, and other operations. Cobb, who at times feared for her own safety, persevered to take exceptionally powerful and revealing photographs on this important issue.

A family, trapped by exorbitant loans, hauls handmade bricks in Chennai, India.

99

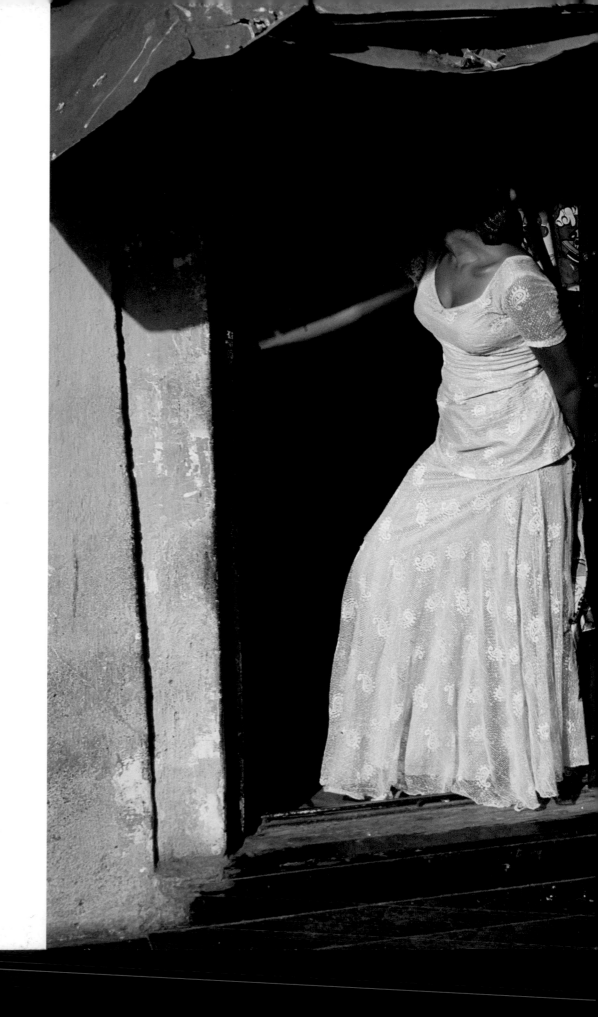

Prostitutes, who are known as cage girls and are often sex slaves, display themselves on a Mumbai street.

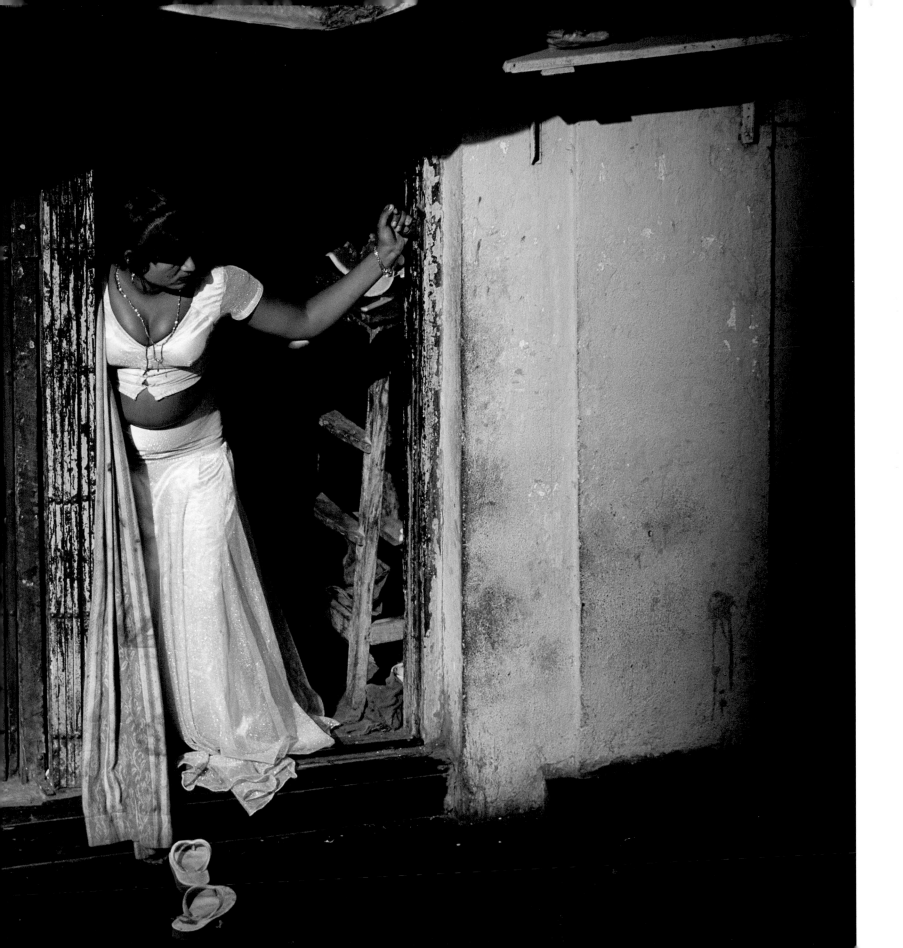

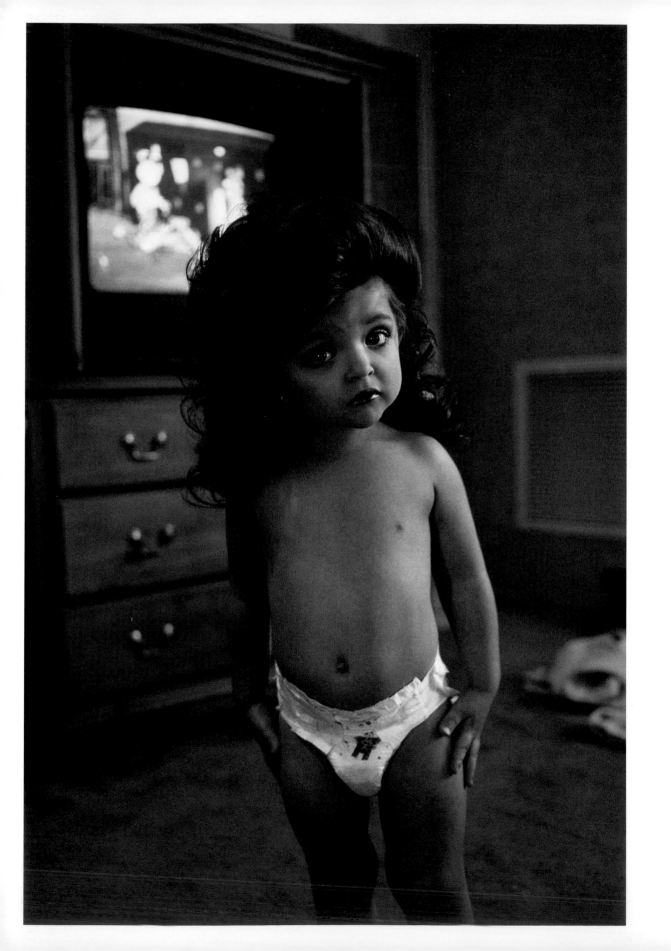

In the Eye of the Beholder ~ 1997-1998

The quest for beauty dates to the dawning of humankind, from pre-historic body adornment to today's fashion show catwalks. What defines beauty remains enigmatic, cultural, and elusive. Cobb's stylish images from around the world document the pursuit and diversity of beauty.

A Georgia beauty pageant contestant, in diaper and makeup, watches cartoons before dressing for a competition.

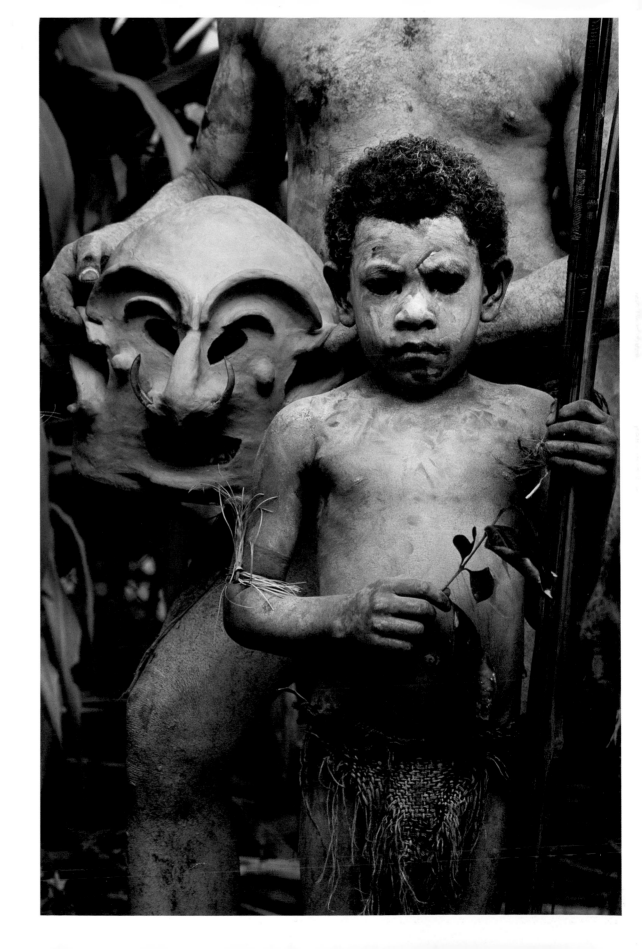

A young Asaro mudman, covered in ghostly clay used by traditional warriors, prepares for a tribal festival in Papua New Guinea.

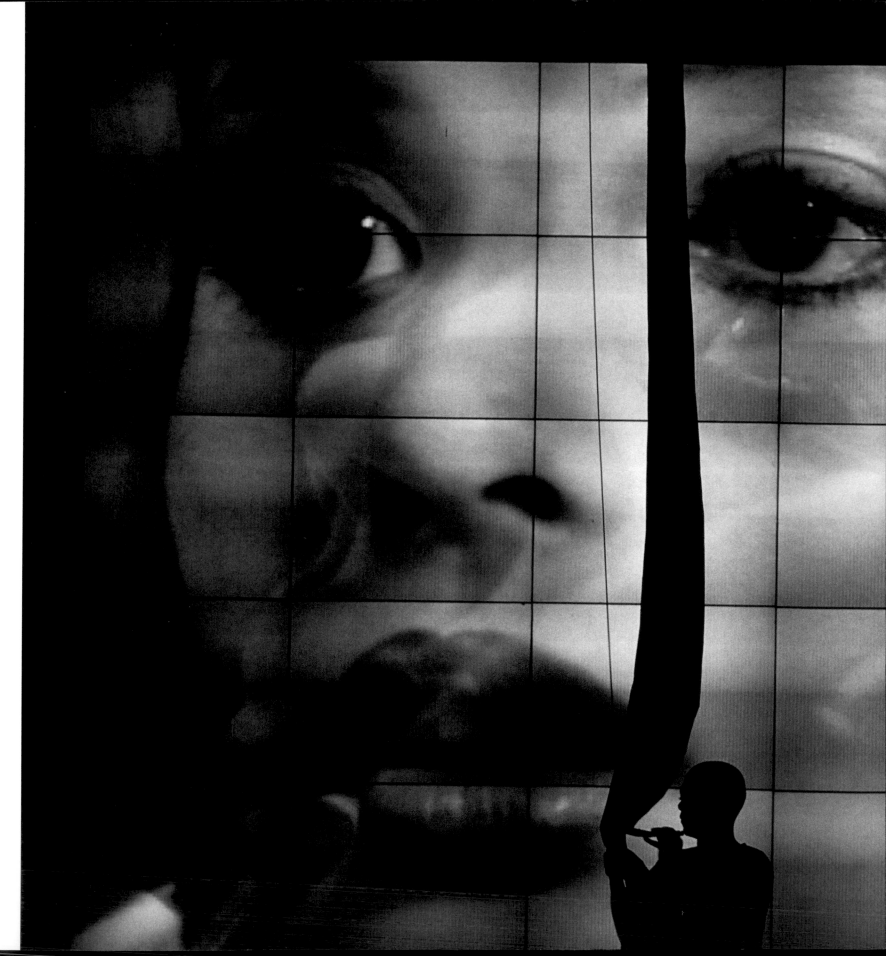

Billboard squares create a gigantic image of beauty during the rehearsal of an international modeling contest in Nice, France.

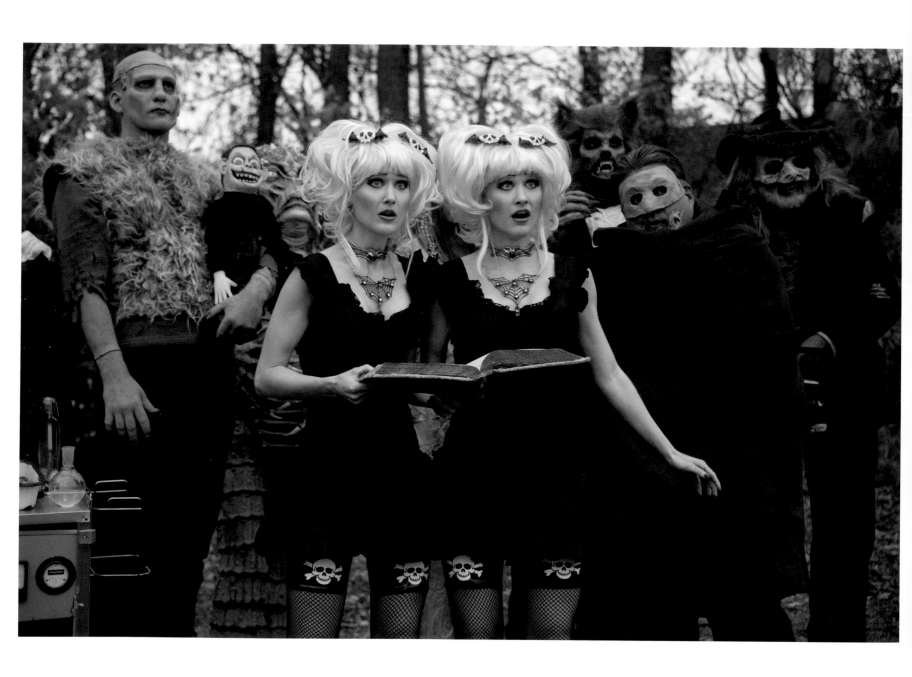

The Science of Doubles ~ 2010
Amid the talent shows and contests
at the annual Twins Day Festival, a lot
of serious science takes place. With

thousands of identical twins converging
on Twinsburg, Ohio, scientists seize the
opportunity to study individuals who
have the same DNA but are different.

"I always wanted to take photographs that lasted . . . that were powerful and could change lives and opinions and attitudes. Photography can do that."

Left: Camille Kitt (at left) and sister Kennerly, in the film Creeporia, *embrace twinhood—they play the harp, practice martial arts, and dress alike.*

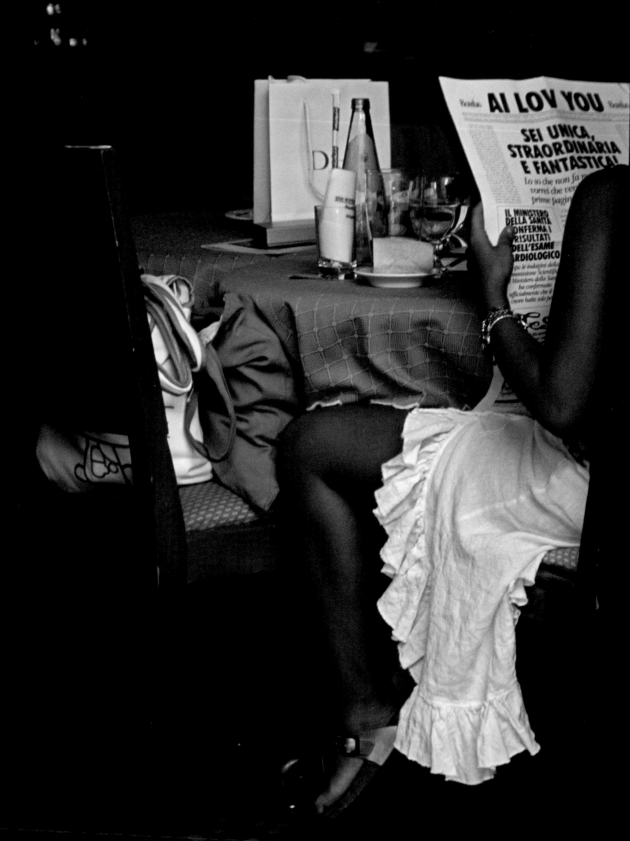

Love and Lust ~ 2003

Using MRIs, scientists confirm what most people who have ever been in love have experienced: Fiery passion fades as couples develop lasting bonds. The chemicals in the brain that ignite heady romance differ entirely from those that nurture long-term relationships. There is wisdom in comprehending the transition.

A woman in Florence, Italy, savors the message on a large greeting card.

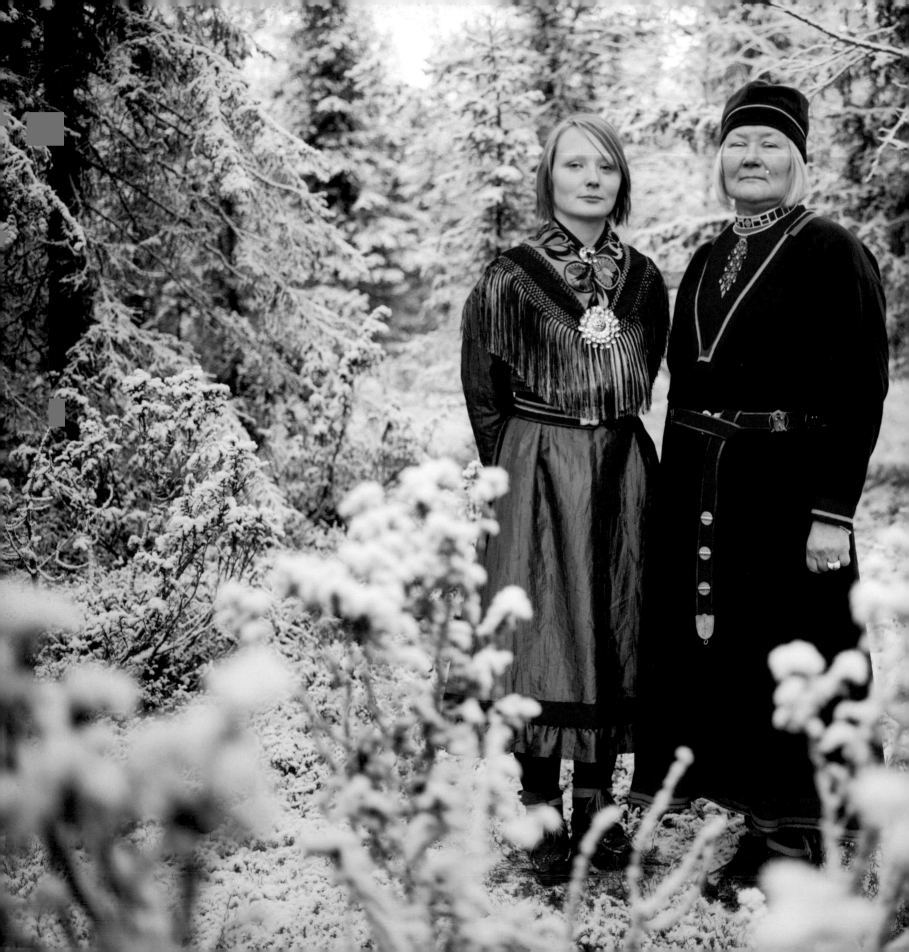

ERIKA LARSEN

Finding the Human Moment

"It's extremely relevant to my work that I am a woman. I celebrate it."

Erika Larsen began her career by documenting intimate moments within her own family. Soon, she began to explore the lives of families dealing with cancer or suicide. "I realized early on that people were very comfortable having me in their homes," she says. "It didn't seem possible to make images any other way."

Born in Washington, D.C., Larsen was first introduced to photography by her father, a designer for the Hubble Space Telescope. He would often bring home Kodak images of planets and their moons. "I remember the quality, and thinking I am holding something so close that is actually so far away. I thought photography must be magic," she says.

As a student, Larsen focused on filmmaking and animation in both college and graduate school at the Rochester Institute of Technology between 1994 and 1999. But she found photography more enticing. "I liked how I could work independently as a photographer, whereas in film I had to work with a whole crew."

Larsen is best known for her documentation of the Arctic Circle's Sami people, a story that appeared in a 2011 issue of *National Geographic*. Between 2008 and 2011, she immersed herself in their culture, working as a *beaga,* or housekeeper, before shooting a single image. She cooked, cleaned, sewed, worked with reindeer, and learned the Sami language at a local university. "I realized that in order for me to do what I needed to do, I was going to have to be somebody's helper," she says. "What I really wanted to do was let them teach me. I didn't want to come with prejudgments or ideas of how it should be."

In 2008, Larsen was awarded a Fulbright fellowship for the project. "I didn't go there to make images about the supposedly backward ways of this culture. I believed the best thing I could do was go in, learn the language, learn what makes these people unique," she says. "I also learned about myself by watching other people go through their own human journey. We're all human and dealing with the same issues." Larsen's work has been included in the Smithsonian's National Portrait Gallery, the Swedish Museum of Ethnography, and the Ájtte Sami Museum.

Preceding pages: Sami women in Sweden wear traditional fringed and appliqued costumes specific to their region.

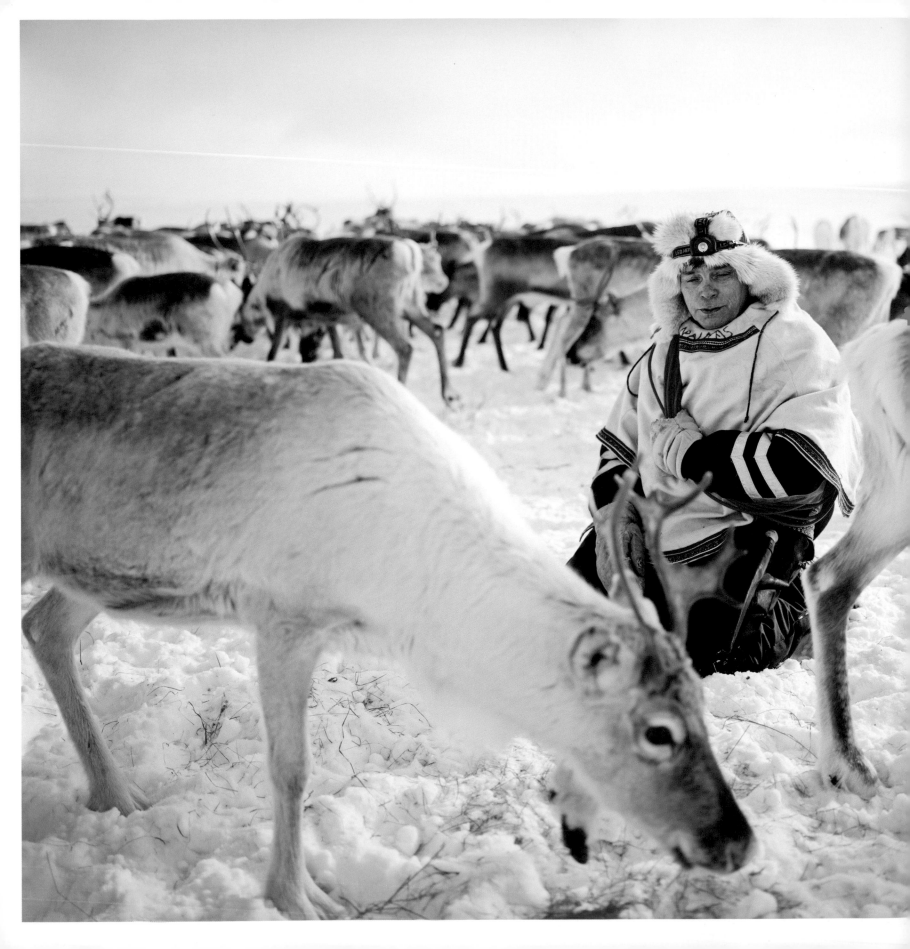

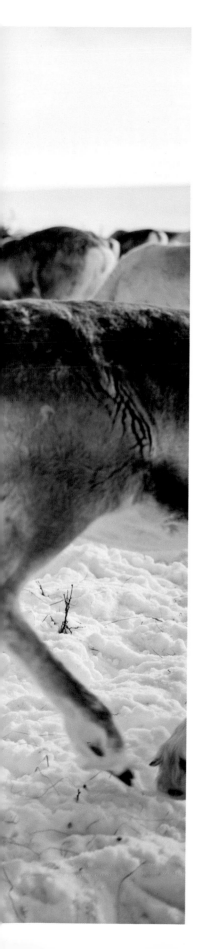

Reindeer Walkers ~ 2008–2011

Among the Sami, an indigenous people who live in the far reaches of Sweden, Norway, Finland, and Russia, is a coterie of reindeer herders. About 10 percent of the Sami follow the herd, preserving a traditional livelihood even as they modernize at a rapid pace. Herders use ATVs, snowmobiles, and even helicopters to round up their reindeer. Teenagers text while marking calves. Erika Larsen's three years with the Sami yielded indelible images of their distinctive way of life.

Practicing a time-honored custom called yoiking, a Sami herder in Norway chants softly while tending his reindeer.

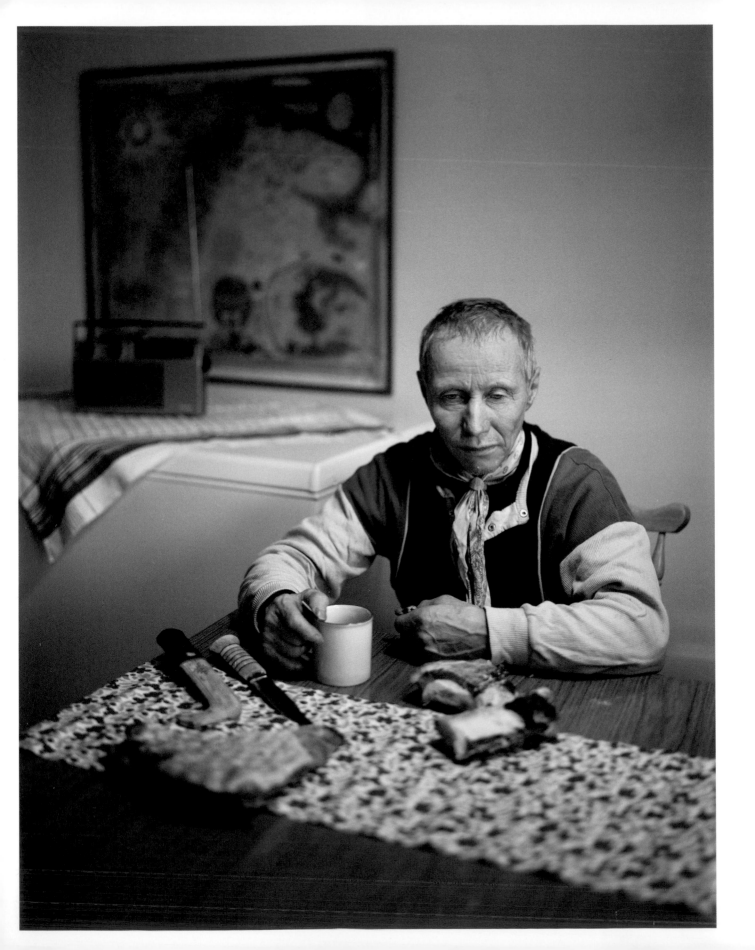

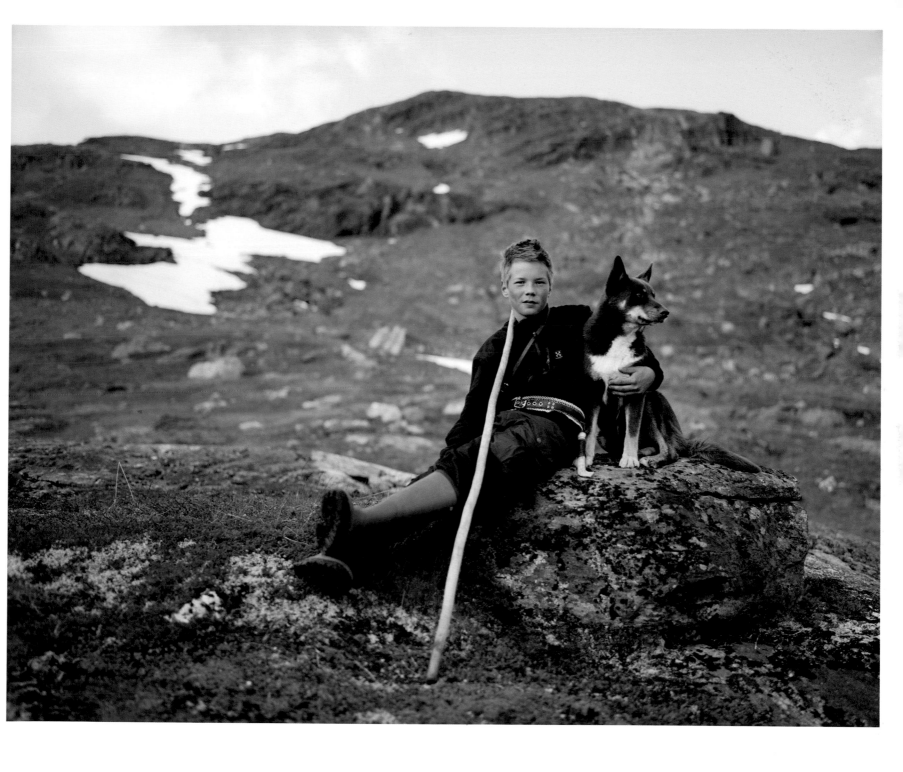

Coffee completes a Sami's meal of homemade bread and dried reindeer meat (left), a staple in the diet of herders.

During the summer, a 12-year-old herder and his dog patrol the pastures bordering Norway and Sweden.

117

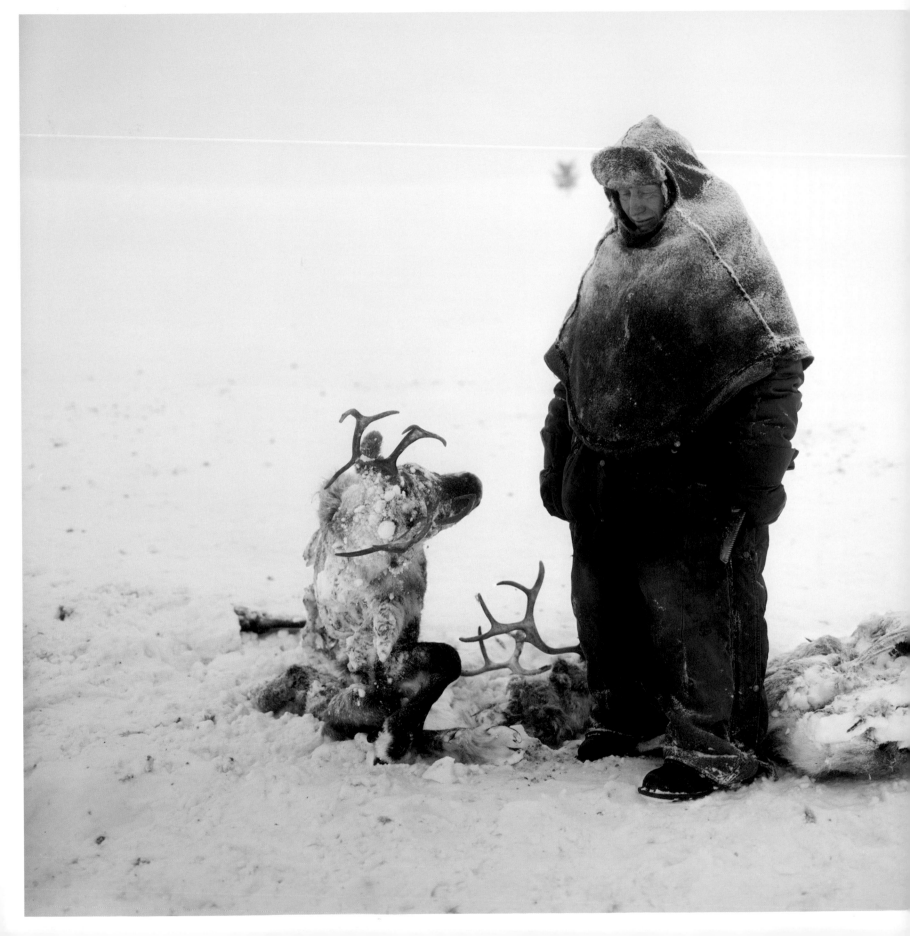

A Sami in Sweden mourns the loss of two reindeer that starved after locking horns in a fight for dominance.

"Mostly what I'm doing in life
is following my instincts
and learning as I go along."

A herder in Sweden, this 14-year-old girl (right)
plans to attend college and "explore the world"
yet keep reindeer a "part of my life."

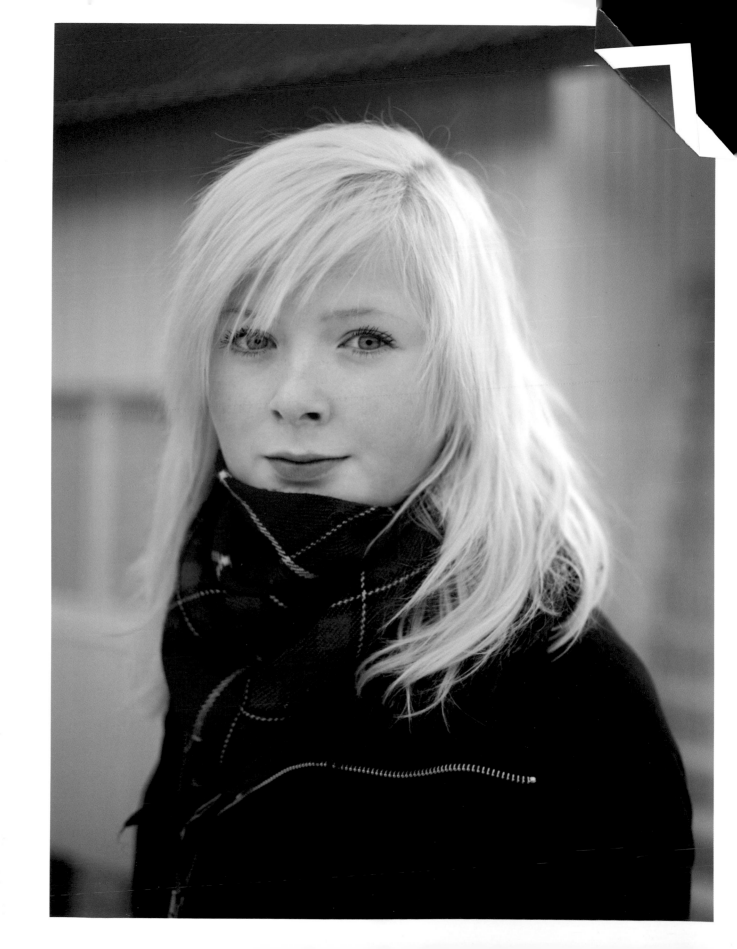

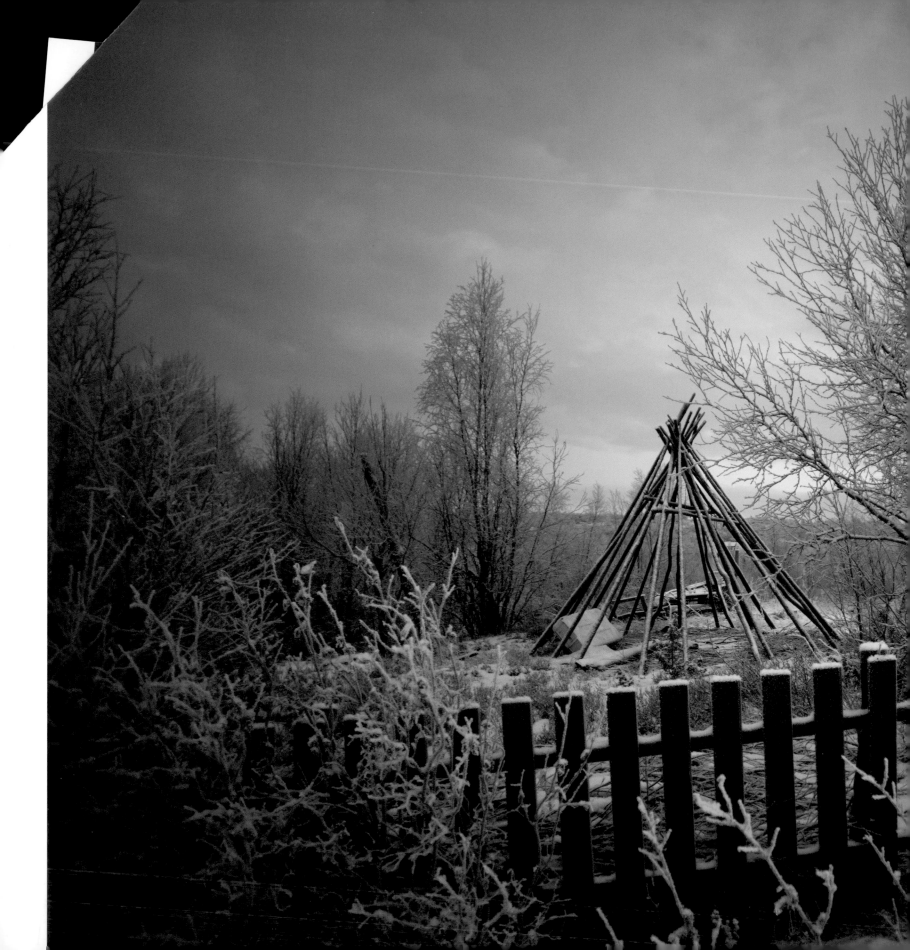

Tepee-style structures are common in Sami villages, where they are often used to smoke reindeer meat.

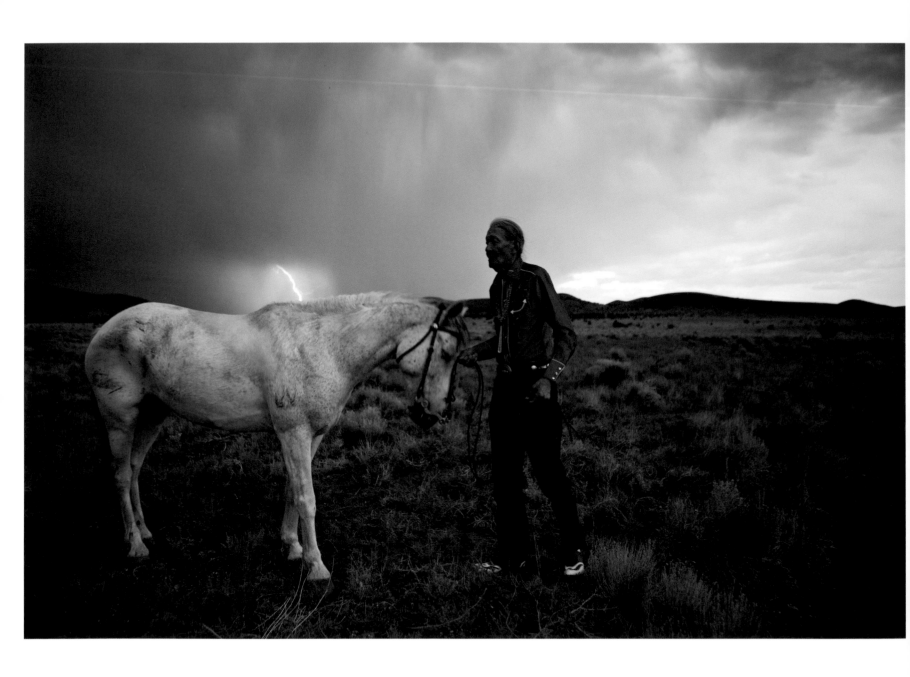

Sky Dogs ~ 2011

According to historians, Native Americans in the Southwest were so awed by the size of horses that they initially referred to them as sky dogs, believing them to be giant creatures from the heavens. The lives of Plains Indians would soon be transformed by the animals' gifts of power, speed, freedom, and utility.

"The whole world
is still an open book for me.
I'm fascinated by people and cultures,
and how each culture relates
to their rituals, to their family,
to their land."

This traditional Navajo medicine practitioner (left)
is often gifted horses in return for his services.

A horse's ceremonial livery complements the decorative regalia of a Wanapum girl in central Washington.

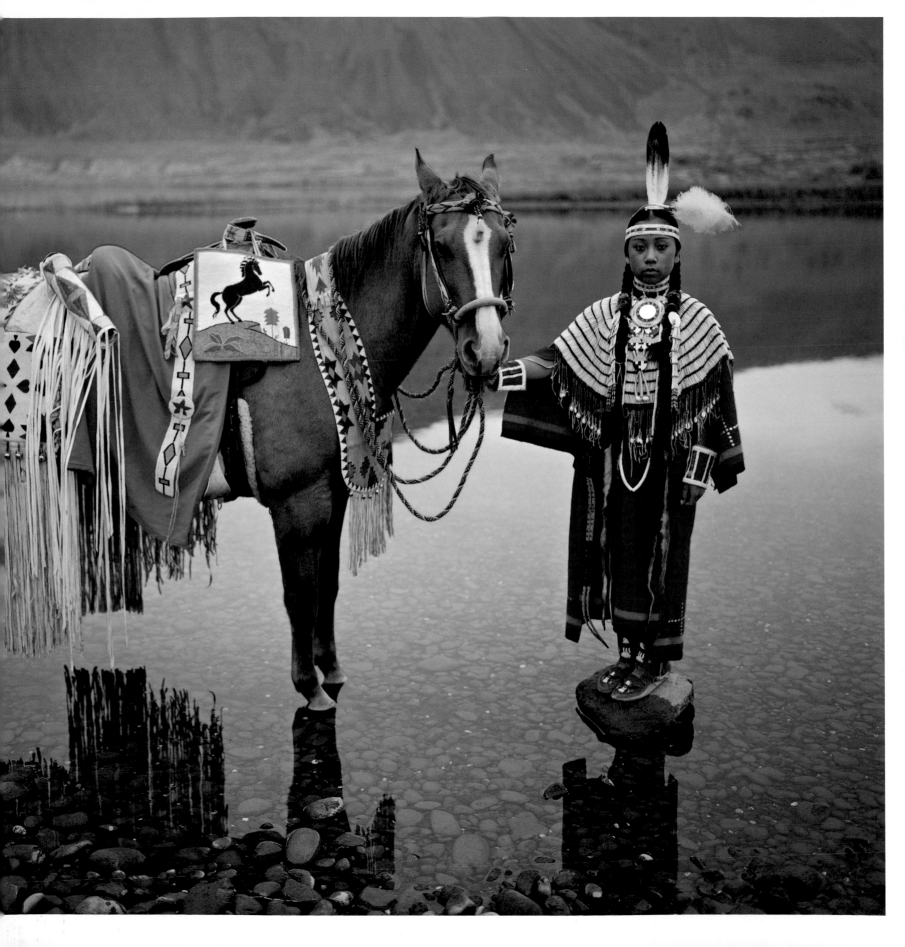

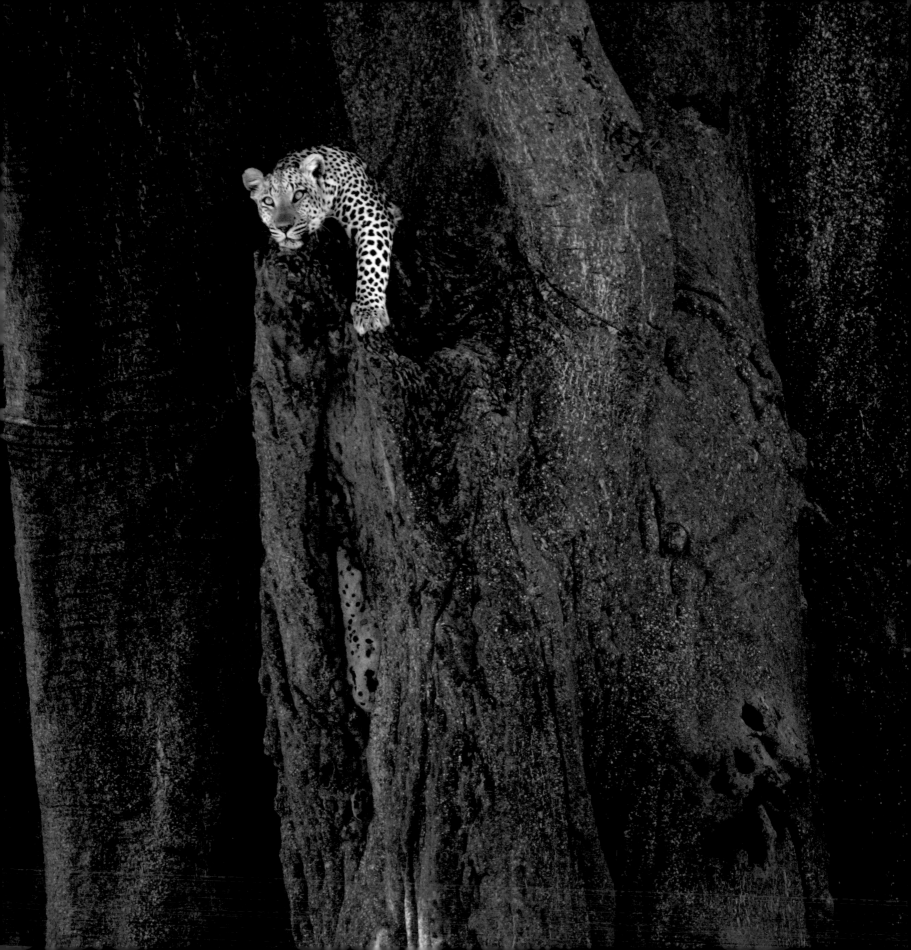

BEVERLY JOUBERT

Capturing the Wild

"In the field, we're not just voyeurs in a moment of time. We're actually living that moment and are part of nature."

For photographer Beverly Joubert, conservation is at the heart of every image. For 30 years, she lived in Botswana with her husband, Dereck Joubert, photographing declining populations of lions, leopards, elephants, and other species in order to focus world attention on their plight. "My role is to use my photographs as a tool to stir emotions," she says, "so that individuals take responsibility for endangered wildlife." The couple's work has resulted in 22 films, one dozen books, several articles for *National Geographic,* five Emmy Awards, and Botswana's Presidential Order of Merit.

"It's an emergency situation," says Joubert. "Africa has lost 90 to 95 percent of all of its leopards. The lion populations have also declined dramatically. Our goal is to create an awareness that stops the decline of species and helps rebuild wilderness areas."

Joubert does not aim for "sensational shots" of teeth and claws, which are often produced when the animal feels challenged by a photographer. Instead, many of her images portray the relaxed side of these predators, which requires her to win their trust. "If an animal notices us trying to fix their behavior, they'll change expressions and we'll feel like we've failed," Joubert says. "True invisibility is about patience. We are never challenging or harming the animals, so we feel nothing will harm us."

Joubert began her career as a filmmaker, but found she enjoyed shooting the films' poster photos even more. Working in tandem with her husband, she shoots the stills while he shoots the video footage. The couple communicates using sign language so as not to disturb the animals. Joubert spends little time with other people. "I'm happiest and most at peace when living out in the field," she says. It's there that nature and wildlife are free from human intrusions. "I wish we could be more like elephants," she says. "They have such compassion. There's so much caring amongst the herd."

Preceding pages: *A leopard in the Okavango Delta takes refuge in the hollow of a giant baobab tree.*

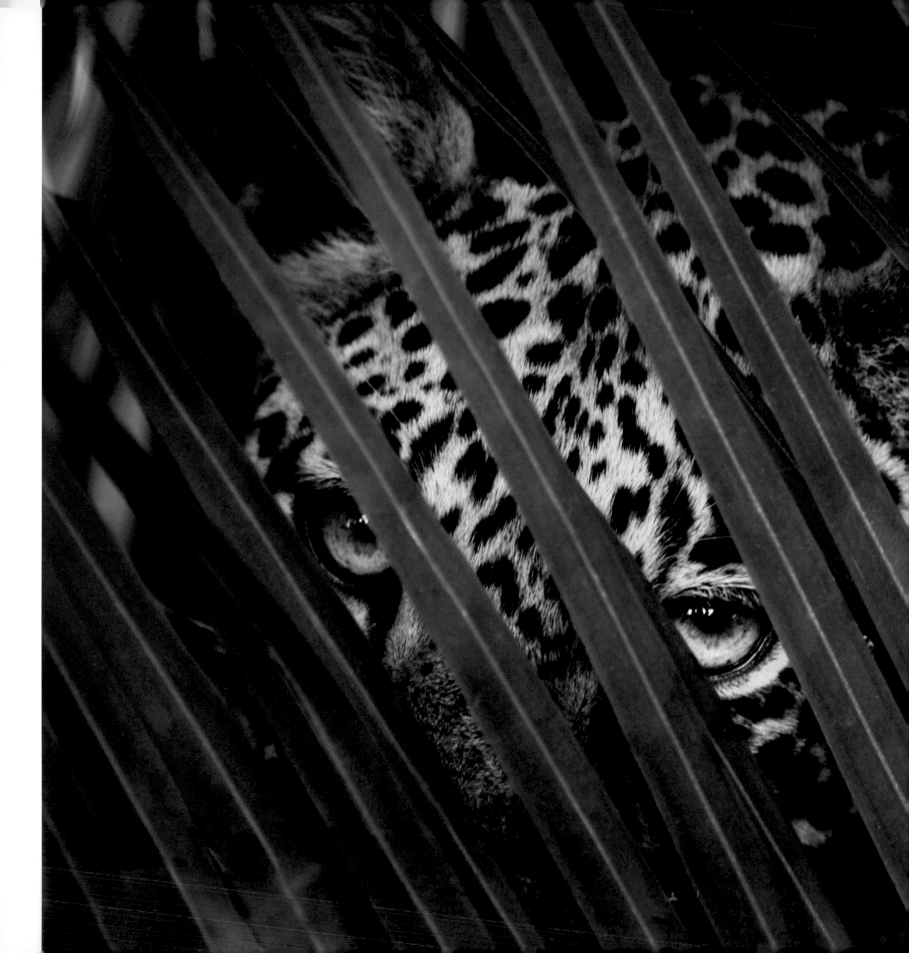

Life Among Leopards ~ 2004-2005

A tireless advocate for the conservation of big cats, Beverly Joubert photographs with the mission of revealing animals in all their uniqueness so that others see them as she does. Her images of leopards in Botswana's Okavango Delta utterly succeed in illustrating the special bond between mothers and their cubs. Joubert and her husband, Dereck, delight in observing animals in the wild when they are just days old and then following them for many years.

A leopard's spotted coat provides camouflage in the dense forest.

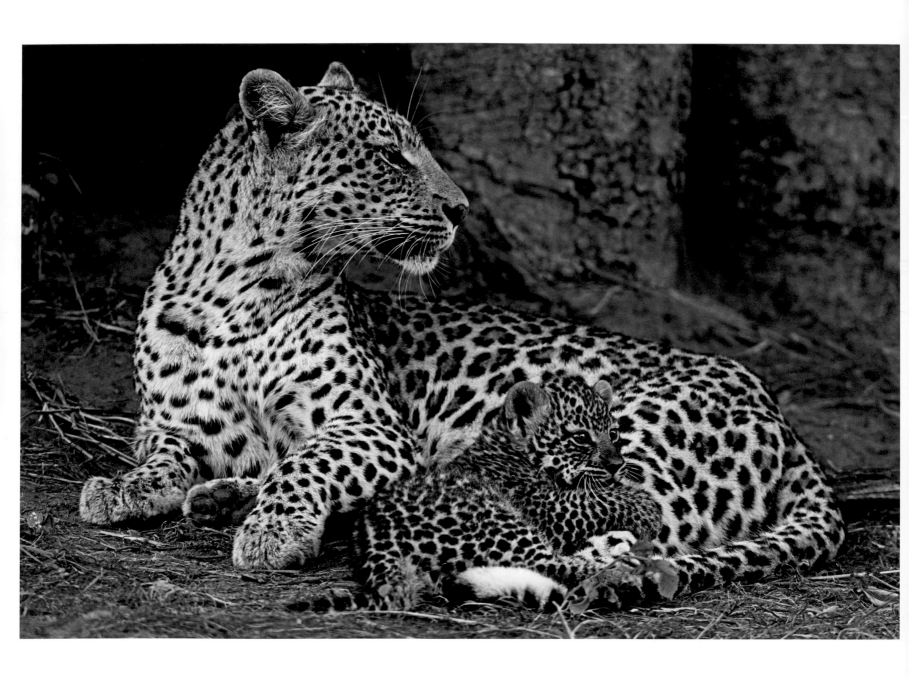

After nursing, a two-week-old cub cuddles with his watchful mother.

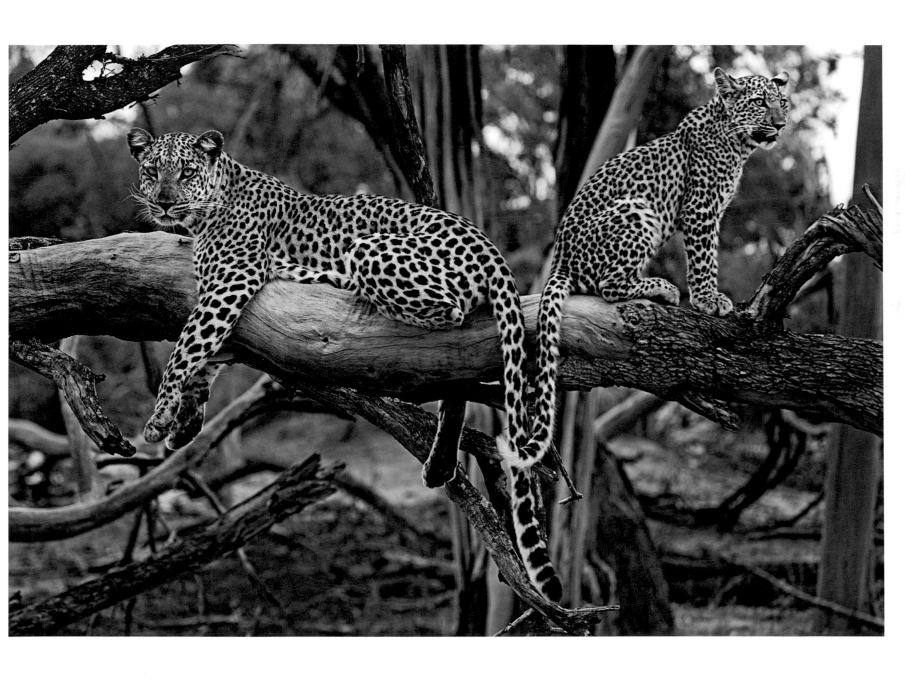

At six months, a cub stays close, reassured by the touch of her mother's tail.

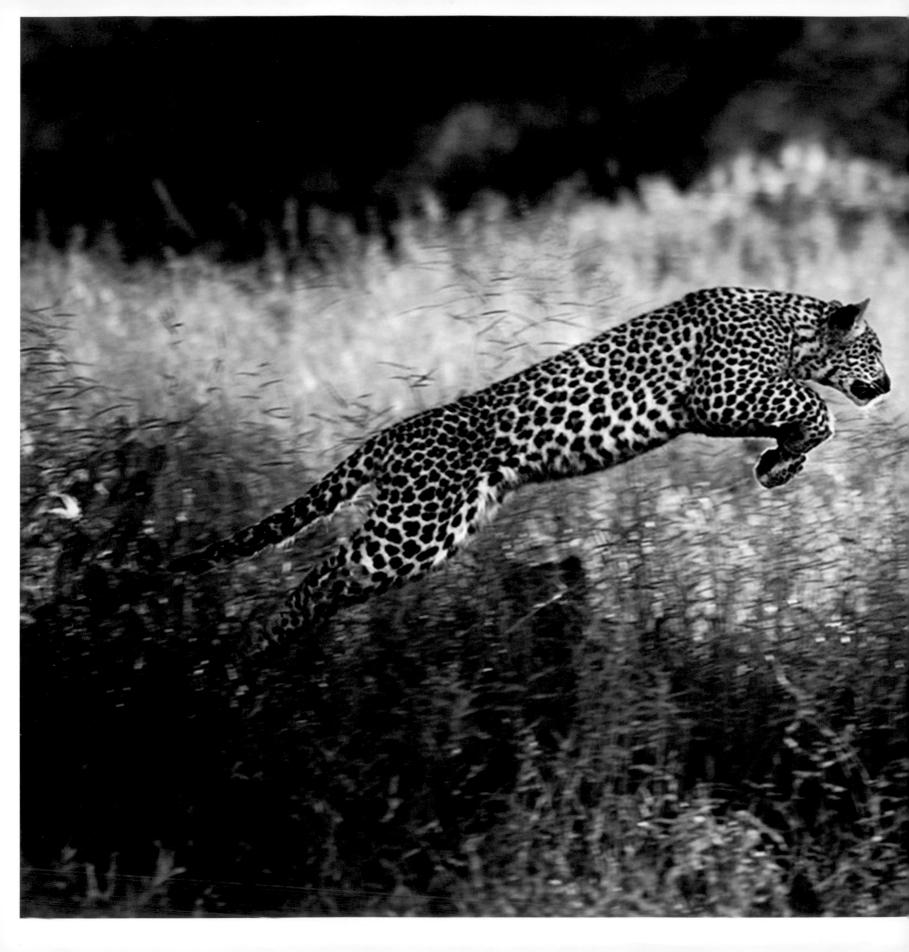

"In a still photograph, you have to be able to tell the whole story and hope that the emotion and information is portrayed in that one image."

In a hunting game with her mother, a young leopard leaps through tall grass.

137

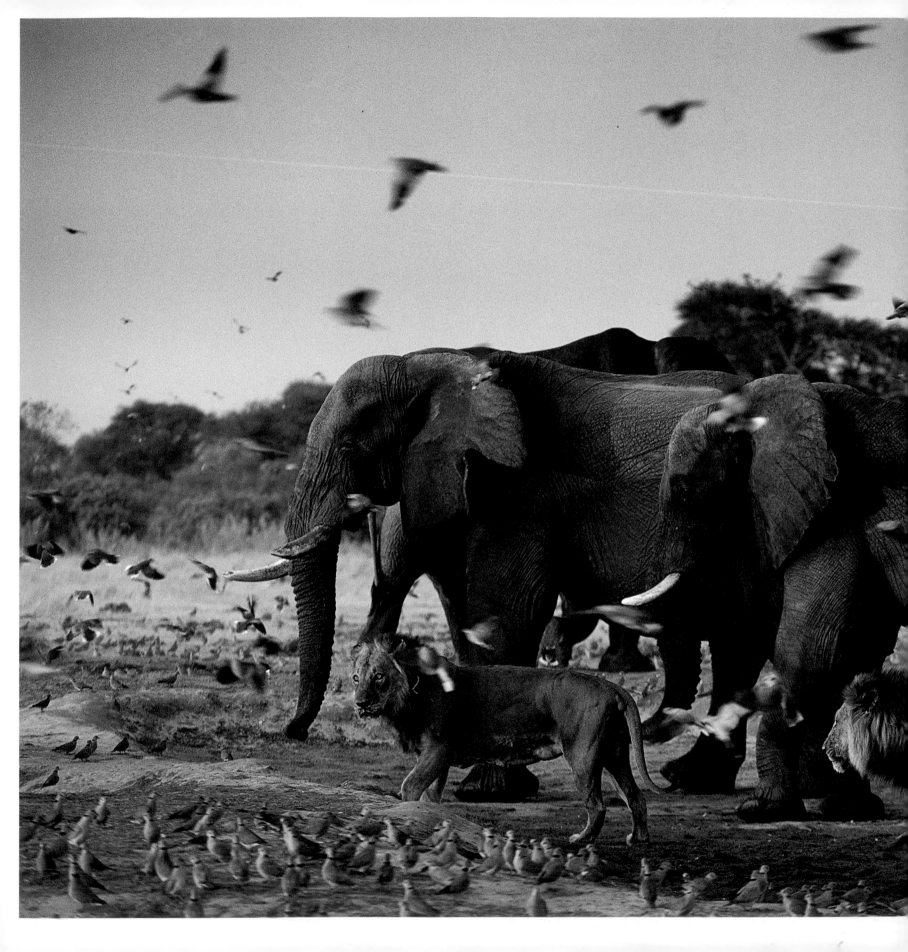

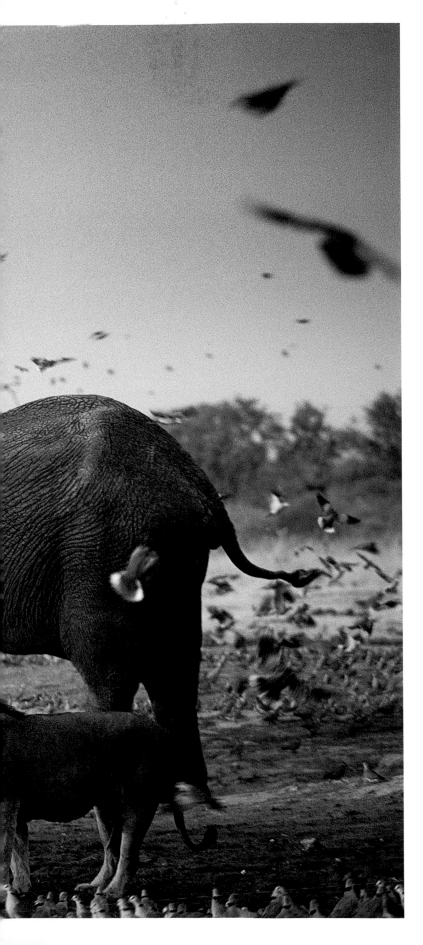

Water Wars ~ 1993

During the dry season in Chobe National Park in northern Botswana, a shrinking water hole brings natural enemies in close proximity. Fighting can erupt as animals bully each other and jockey for slurps from a four-inch-deep puddle of water. Elephants, the biggest animal on land, dominate the hole. They can consume 50 gallons of water a day. Lions at the park began boldly attacking the elephants, not just for water access but also in an unusual act of predation.

In early morning, lions, elephants, and birds linger at an evaporating pond.

"Each day out in the field
is completely different —
a uniquely new story."

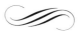

A day-old buffalo calf (right) expires in the grip
of a defiant lioness, one from a pride that feasts
voraciously during calving season.

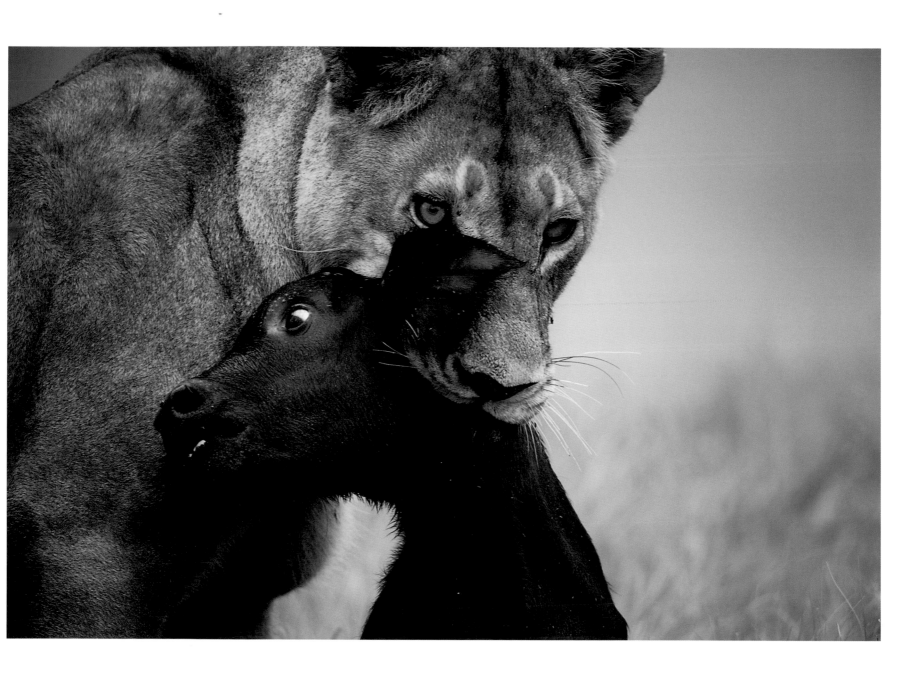

Easy Prey ~ 2005

Over the last few years, a herd of Cape buffalo in Botswana's Okavango Delta has become the fast food of choice for lionesses in one of the area's prides.

Fearless in their hunting, the lionesses charge directly into the herd to bring down an animal. Buffalo counter with their hooves, sharp horns, and sheer numbers to drive them off. .

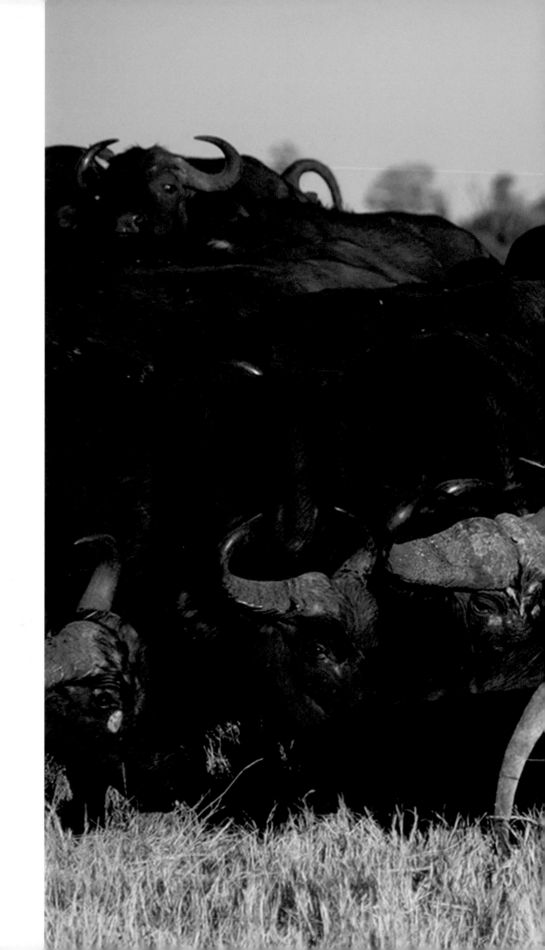

Besieged by a phalanx of scythelike horns,
a lioness relinquishes her prey.

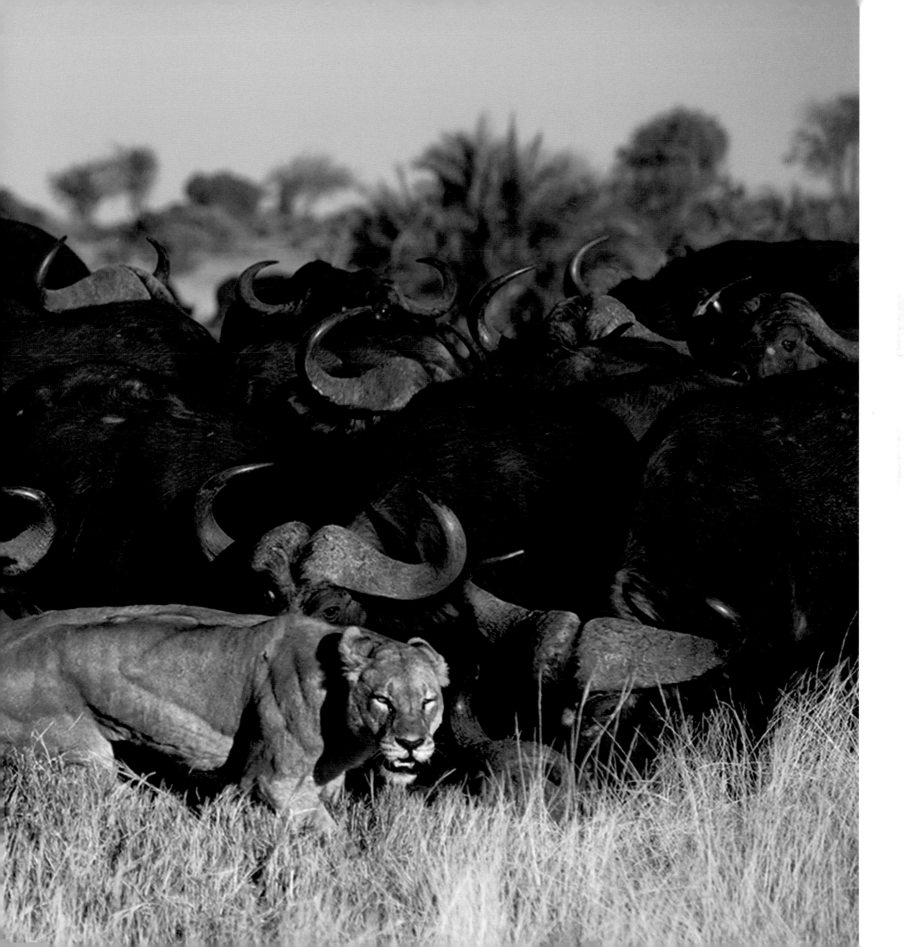

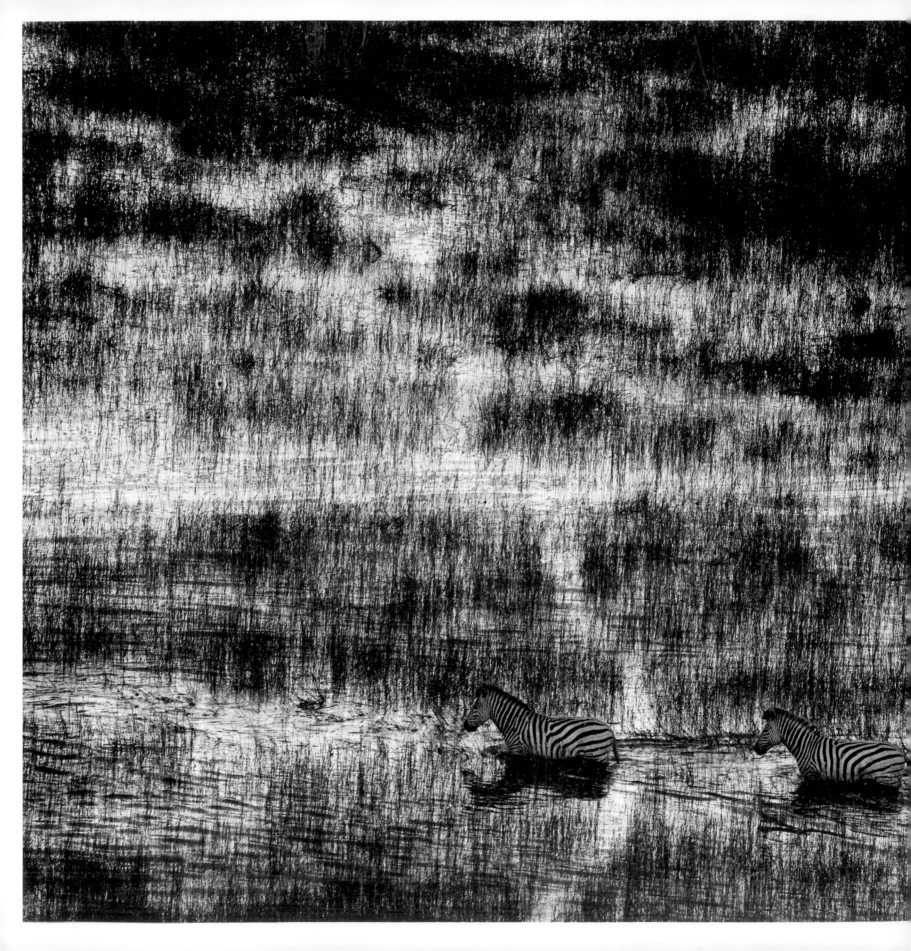

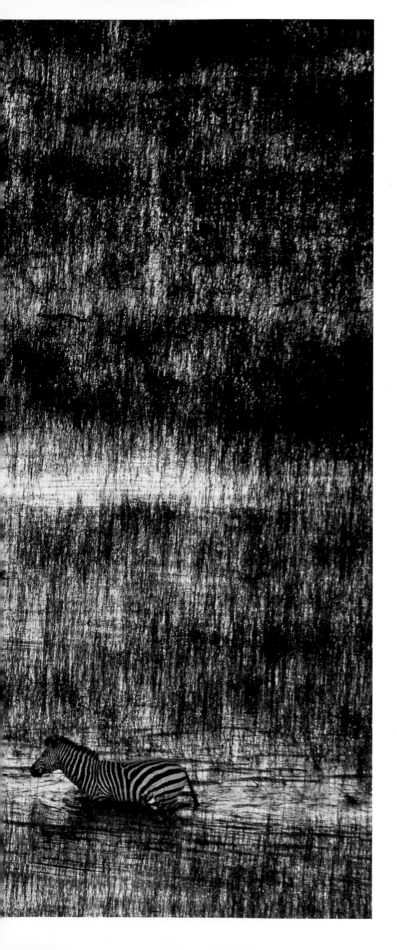

Flooded Desert ~ 2009

Botswana's Okavango Delta is an extraordinary oasis in Africa's vast and arid Kalahari Desert. Created by heavy seasonal rains that flood the Okavango River, which has no outlet to the sea, the delta's replenished marshes and ponds support abundant, spectacular wildlife. Though challenging to some savannah animals, the annual high water is a bountiful, life-sustaining gift of nature.

Migrating to higher ground, zebras traverse floodwaters in Okavango.

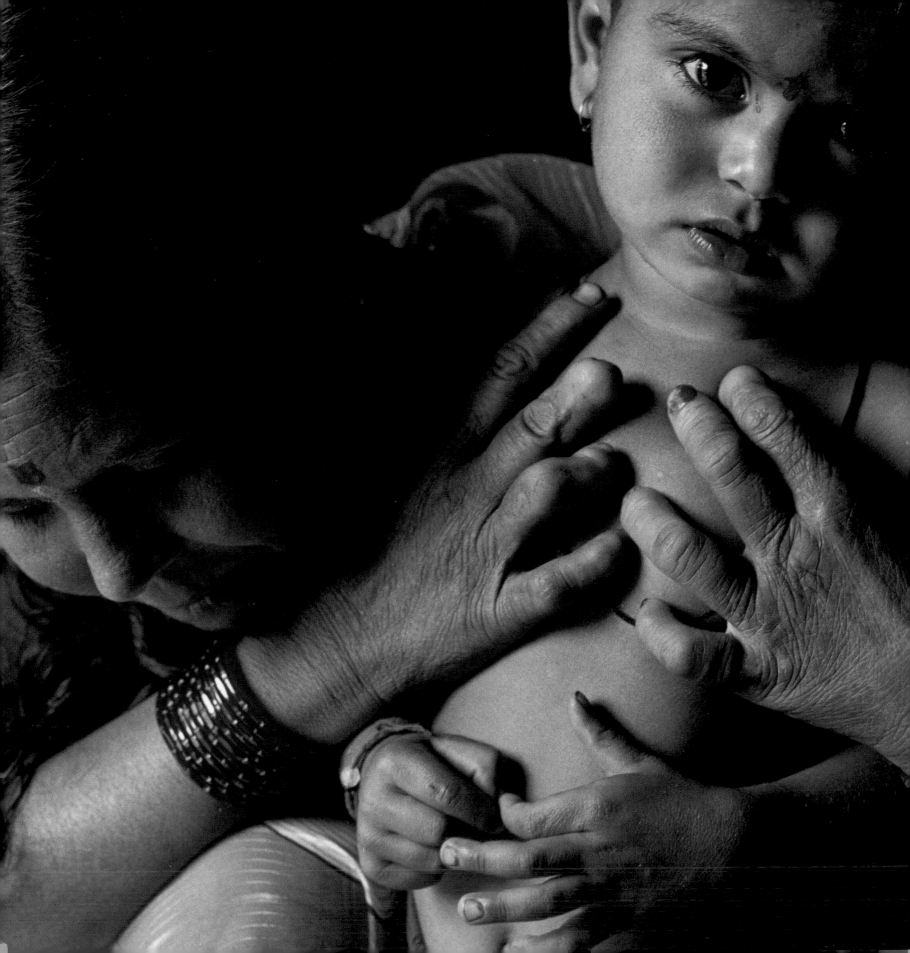

LYNN JOHNSON

Inspiring Change

"I always want photographs to move people to action. That is the reason I do what I do."

"I don't think you understand: I *have* to do this," says Lynn Johnson of photography. And for more than 30 years, she has. Whether documenting the Dong people in China, farmers in Zambia, or victims of avian flu, Johnson always finds the perfect moment to click the shutter. "Photography is about listening and about the richness of the stories," she says. "My job is to share those stories with integrity and power."

Johnson got her start in the mid-1970s, when women were a minority in the field. Before graduating from the Rochester Institute of Technology in 1975, she assisted the first presidential photographer, Lyndon Johnson's Yoichi R. Okamoto, when he came to Rochester on assignment. When she arrived for her first day of work, Okamoto looked shocked. "A girl! I'm not working with a girl. She'll never be able to carry my equipment," he said. "Of course, from that moment, I was out to prove him wrong," says Johnson, who remained friends with Okamoto until his death.

After college, Johnson worked as a photographer for the *Pittsburgh Press* for seven years. She left to join a documentary project commissioned by heiress Adelaide de Menil that chronicled the lives of Long Island baymen. The experience spurred Johnson to pursue a career in documentary photography. Soon, her images were appearing in *Life, Newsweek, Sports Illustrated*—and, in 1989—*National Geographic*.

Many in the field say Johnson—a Knight fellow and recipient of the Robert F. Kennedy Journalism Award for outstanding coverage of the disadvantaged—has carved a path for younger generations of women photographers, although she herself still sees a gender divide. "It's an issue at every level: with what you decide to shoot and how you're received. Then you have to decide, are you going to make it an issue?"

Johnson, who lives outside of Pittsburgh, says she has no choice but to be a photojournalist. "I'm an addict," she says, unable to resist being in the presence of powerful human emotion. "It's an awakening of cells, nerve fibers, an unfolding of my body from crossed legs sunk in a chair to leaning forward. An alertness fills me up from the core outward. I'm on the edge of my chair fighting the urge to stand."

Preceding pages: *In 2008 a village health worker, cured of leprosy that in the past led to shunning, now treats children in India.*

Conservation and Culture ~ 2004

On the edge of Zambia's South Luangwa National Park, a wildlife sanctuary and major tourist attraction, local villagers live in extreme poverty. Two-thirds of the country's population survives on less than a dollar a day. To discourage poaching, conservationists offer local residents jobs and educate them about protecting animals. But for some villagers, bush meat is sustenance and a cultural tradition.

A lively gathering spot for customers, this beauty shop is a rare example of a woman owning a business in Zambia.

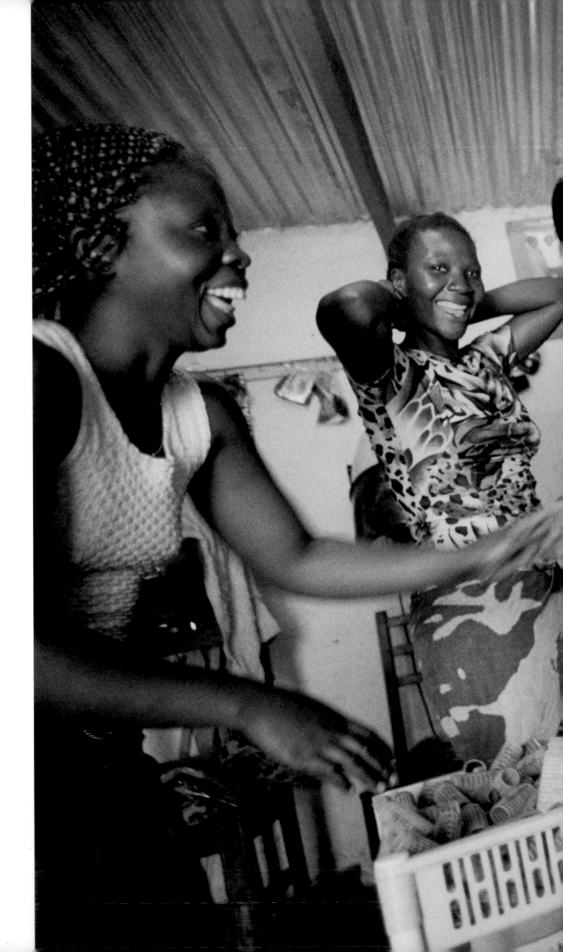

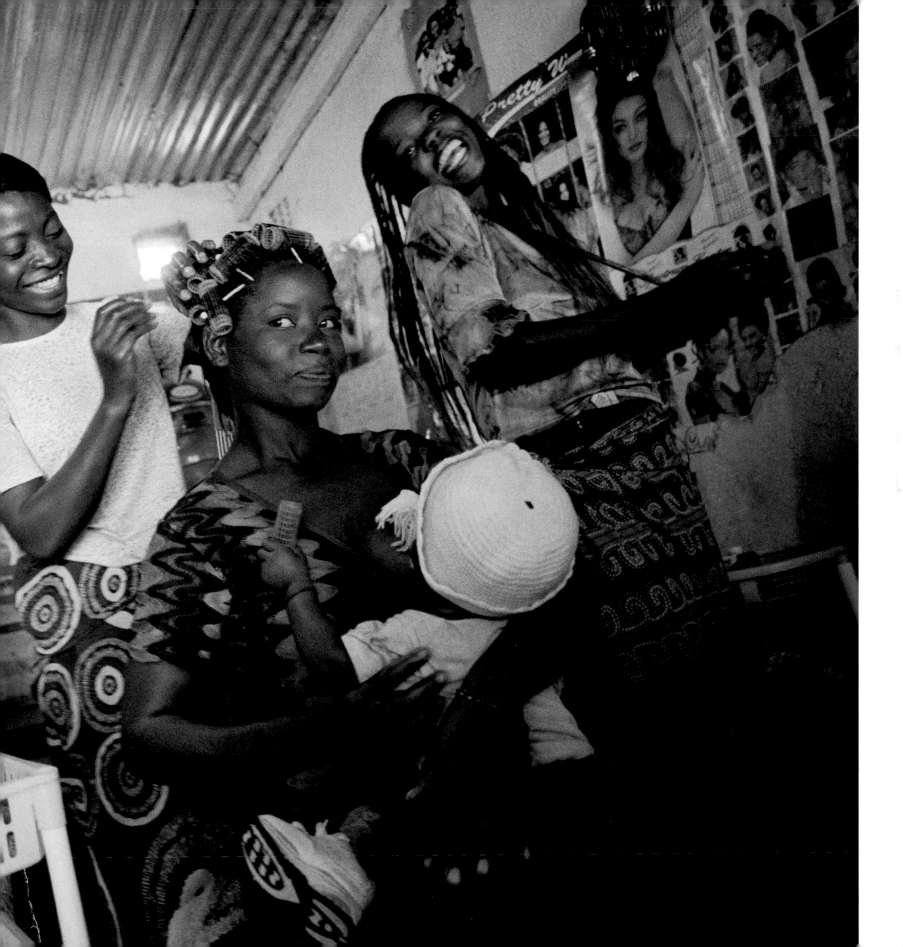

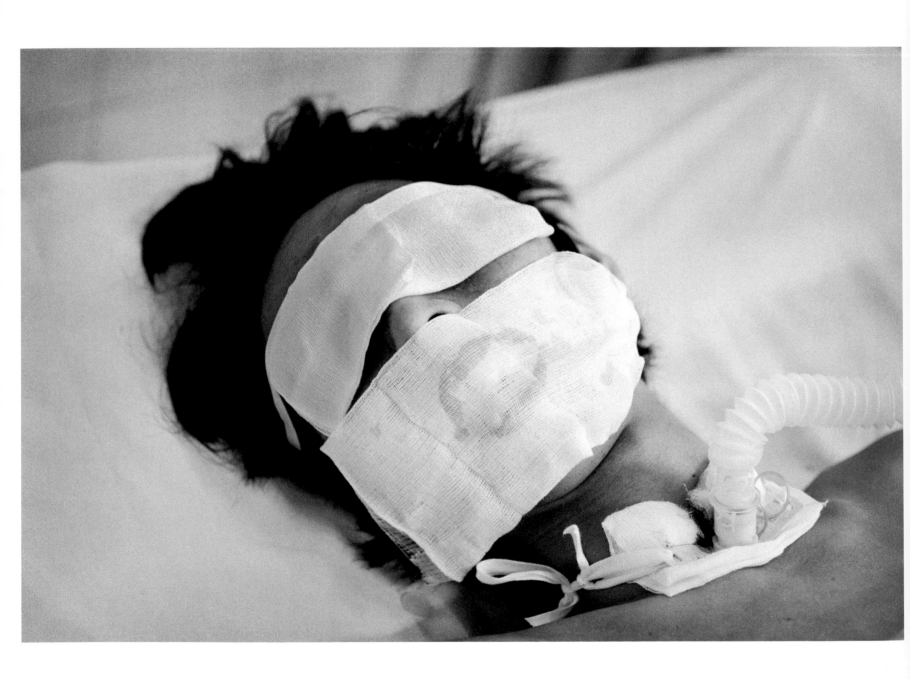

Flu Watch ~ 2004

When the first case of bird flu in humans was documented in 1997, experts began to fear that a pandemic was inevitable. Scientists suspect the deadly Spanish flu that killed millions of people in 1918 originated in birds and jumped to humans.

"The challenge is
to try to find an image
or moment that will
help the reader understand
loss, pain — that thing we can
never fully engage with."

Comatose and on a ventilator, a bird flu patient in
Hanoi (left) who was not expected to live made a
remarkable recovery.

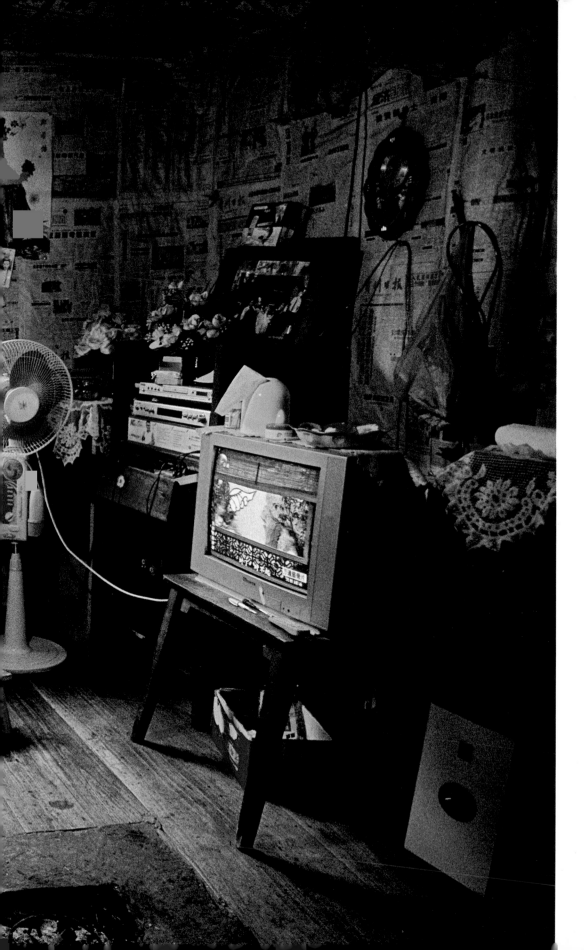

Song of Life ~ 2007

Visitors to the villages of the Dong people, an ethnic group living in a remote region of southern China, can expect to be serenaded upon arrival. The Dong sing almost every day about everything—love, work, the history of their people. The tradition, like many others, endures even as half of the population lives elsewhere to be closer to work. Parents leave their children in the village with grandparents who teach them Dong ways.

Visiting her home village, Dong television star Wu Qinglan shows her grandmother a video of her recent performance.

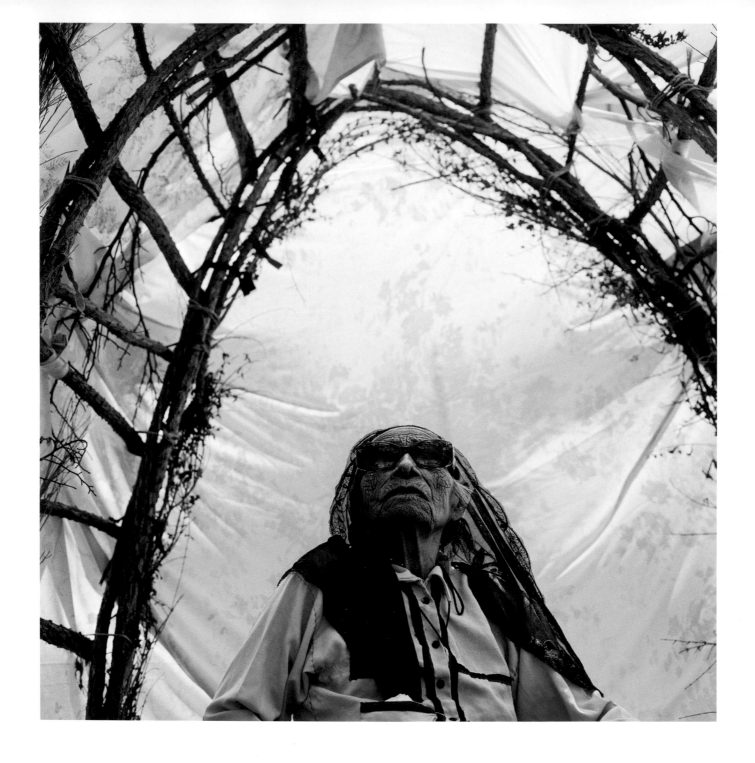

Endangered Voices ~ 2011

In an increasingly globalized era, people learn to communicate in a common language, usually English, or perhaps Chinese or Spanish, the world's other dominant languages. The phenomenon puts thousands of indigenous languages at risk and even drives some into extinction. Concerned that half of the world's 7,000 languages will vanish within a century, linguists race to study, catalog, and possibly save obscure tongues before they are silenced forever.

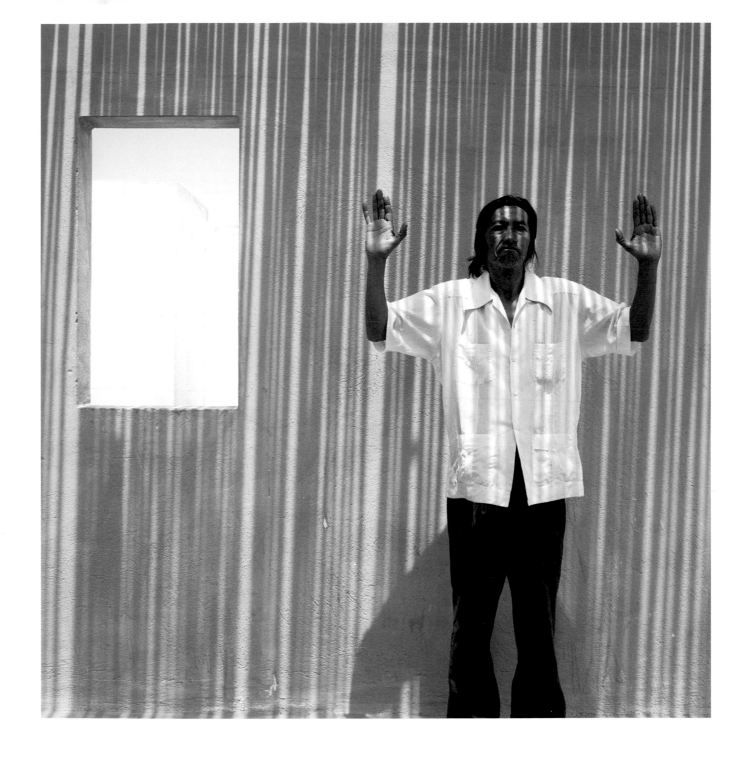

In a traditional shelter for elders too infirm to travel with the tribe, a woman in Mexico (left) prepares to sing in the Seri language.

A man raises his hands to demonstrate a Seri gesture of greeting that means "I come in peace."

A Deadly Legacy ~ 2009

Land mines kill and maim thousands of people every year in some 80 countries around the world. Seventy-five percent of the victims are civilians, often children. Cambodia, one of the most densely mined countries in the world, is reducing casualties and winning praise for its systematic mine removal, which includes educating people about the dangers of buried explosives, and providing medical care and job training for victims.

A 14-year-old boy, injured by a land mine, waits hours for treatment on his infected legs at a hospital in Thailand.

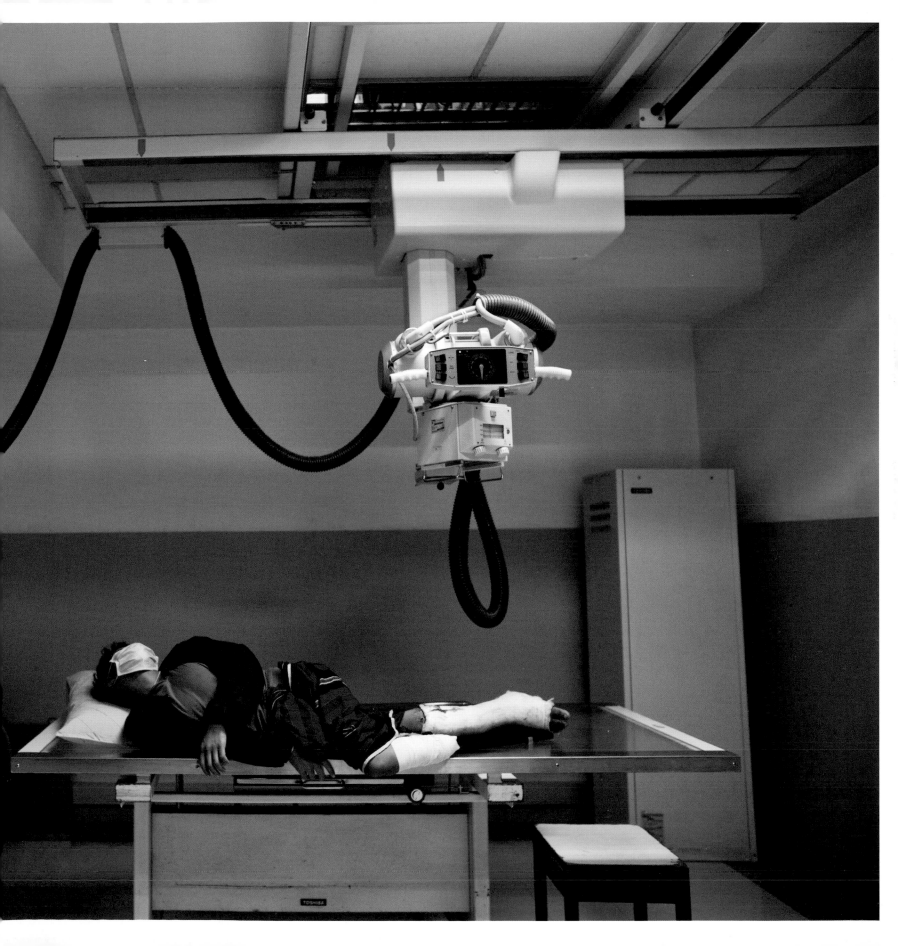

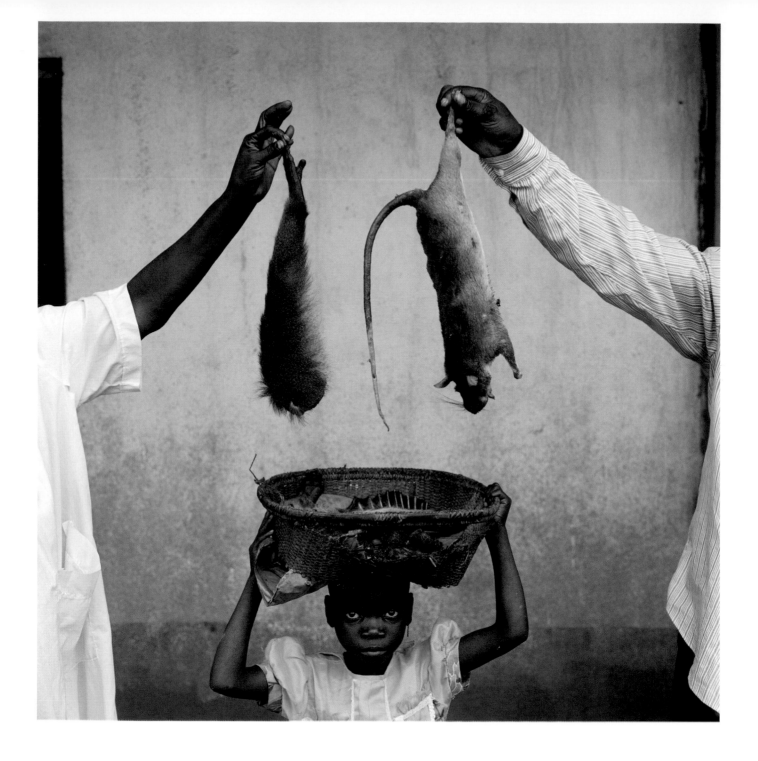

Lethal Contact ~ 2006

Rabies, bubonic plague, Lyme disease, and about 60 percent of human infectious diseases occur through a process called zoonosis, meaning they happen when a pathogen crosses to humans from another species. Scientists anticipate an emergence of new zoonotic diseases as close contact between humans and animals increases. In 1970, the monkeypox virus was first identified in humans in the Democratic Republic of the Congo. Its transmission to humans is linked to monkeys, Gambian rats, and squirrels.

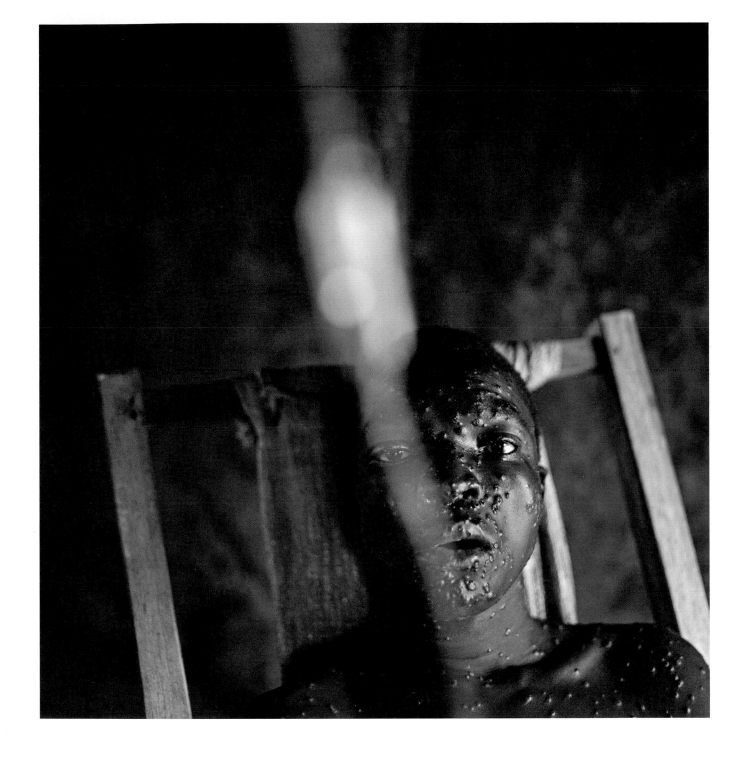

Despite the health risks, bush meat like the Gambian rat and severed monkey arm from the girl's basket (left) are common fare.

An IV saline drip sustains monkeypox sufferer Norbert Lohalo-Nkoy, but he later died from complications of the disease.

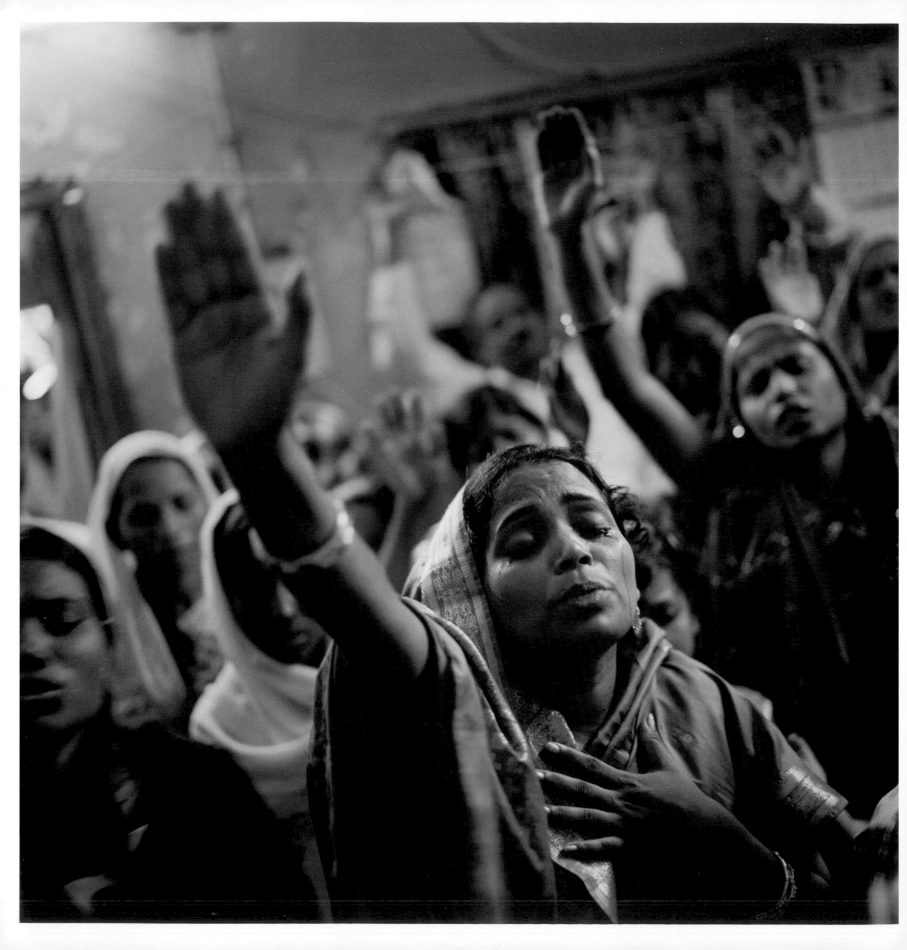

Keeping Faith ~ 2011

A Christian sect in southern India traces its origins to the apostle Thomas. According to St. Thomas Christians, he arrived in the state of Kerala in the first century, raised the first Christian cross in India, and performed miracles. In an overwhelmingly Hindu country, minority Christians sometimes face persecution at the hands of extremists. A 2008 attack left an estimated 60 Christians dead and thousands homeless.

Forced out of their church building, Christians in Odisha, India (left), gather clandestinely in their pastor's home for services.

Secret Battle ~ 2008

Some women in the U.S. military say it's hard to know who the real enemy is. Recent investigations reveal that more than 20 percent of female veterans have been sexually assaulted or raped while serving. Fearful that they will be harassed or their careers ruined, women often keep silent. When reported, the conviction rate for such crimes is less than 6 percent. Post-traumatic stress disorder (PTSD) is frequently worse among rape victims than among combat survivors.

A woman who was raped while serving in Iraq rarely leaves her Austin, Texas, apartment except for PTSD counseling.

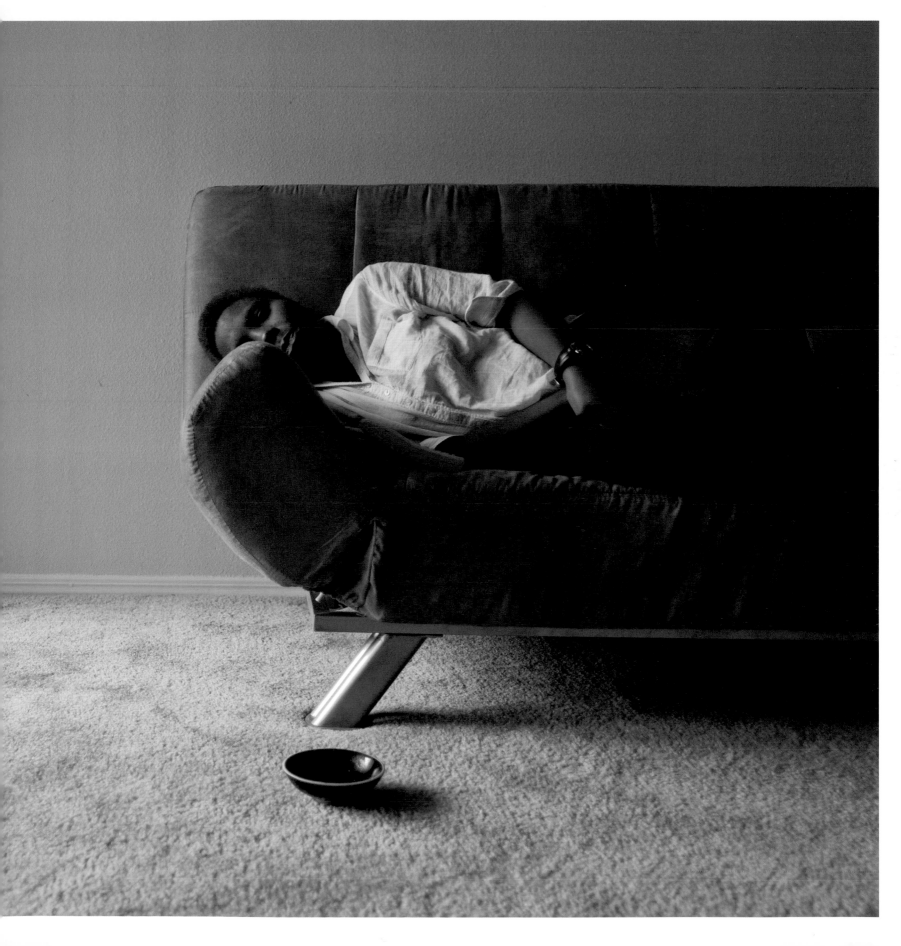

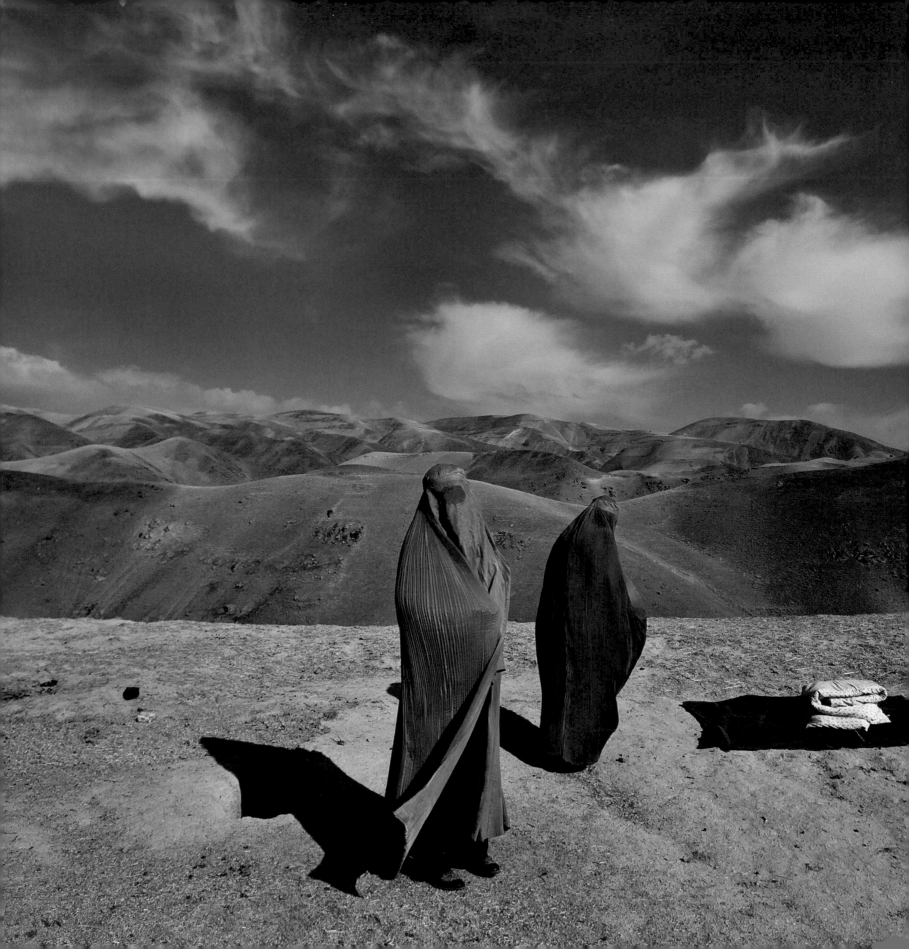

LYNSEY ADDARIO

On the Front Lines

"I think it's really important to cover people who don't have a voice."

With more than ten years of experience as a war photographer in the Middle East and Africa, Lynsey Addario spends a lot of time on the front line—whether reporting for the *New York Times* or *National Geographic*. But her stories often involve afflicted civilians—particularly women. "Everyone covers war for different reasons," Addario says. "Some are in it for the adrenaline rush, some for the exciting lifestyle, and others because they care. For me, it's about telling the story of human suffering and getting those images to policy makers. I hope to effect change."

Addario, a MacArthur Fellow, can go to great lengths for her cause. She has been kidnapped twice: first in 2004 and then again in 2011, when she was one of four *New York Times* journalists taken hostage in Libya by Qaddafi's troops. "We thought we were going to die," she says.

Born in Connecticut to a family of hairdressers, Addario struck out in a new direction, studying international relations and Italian language in college. She became interested in photography when she went to Buenos Aires to learn Spanish. She begged the local newspaper for a job, which she got after photographing Madonna in concert. She soon became interested in the camera as a tool for storytelling.

Over the next several years, Addario lived in the Middle East and Africa, covering the Iraq war, Darfur, the Lebanese and Israeli war, and the political upheaval in Libya. She is most proud of her work documenting Afghan women, which she began in 2001 as a *New York Times* correspondent. "That wasn't combat," she says of the Taliban regime. "That was just scary." Part of the project became the subject of a 2010 *National Geographic* feature called "Veiled Rebellion."

In 2011, Addario discovered she was pregnant and moved to London with her husband, journalist Paul de Bendern. But she continued to travel to war zones for work. After her son's birth in 2012, she committed to at least one year away from the front lines. "But I am my work and my work is me," she says.

Preceding pages: *A stranded village woman and her pregnant daughter desperately try to find a ride to a clinic.*

Strong Women ~ 2009-2010

Addario's Afghanistan photographs reveal the indomitability of women struggling for their humanity in a hostile environment. The women face relentless challenges—war, marital abuse, limited education, suicide, and poverty. But a nascent independence is evolving as some women dare to defy cultural mores. They attend school, apply for driver's licenses, train for the Olympics, go to political rallies, and engage in other acts of courage.

Setting their sights on the Olympics, young women boxers train in Kabul.

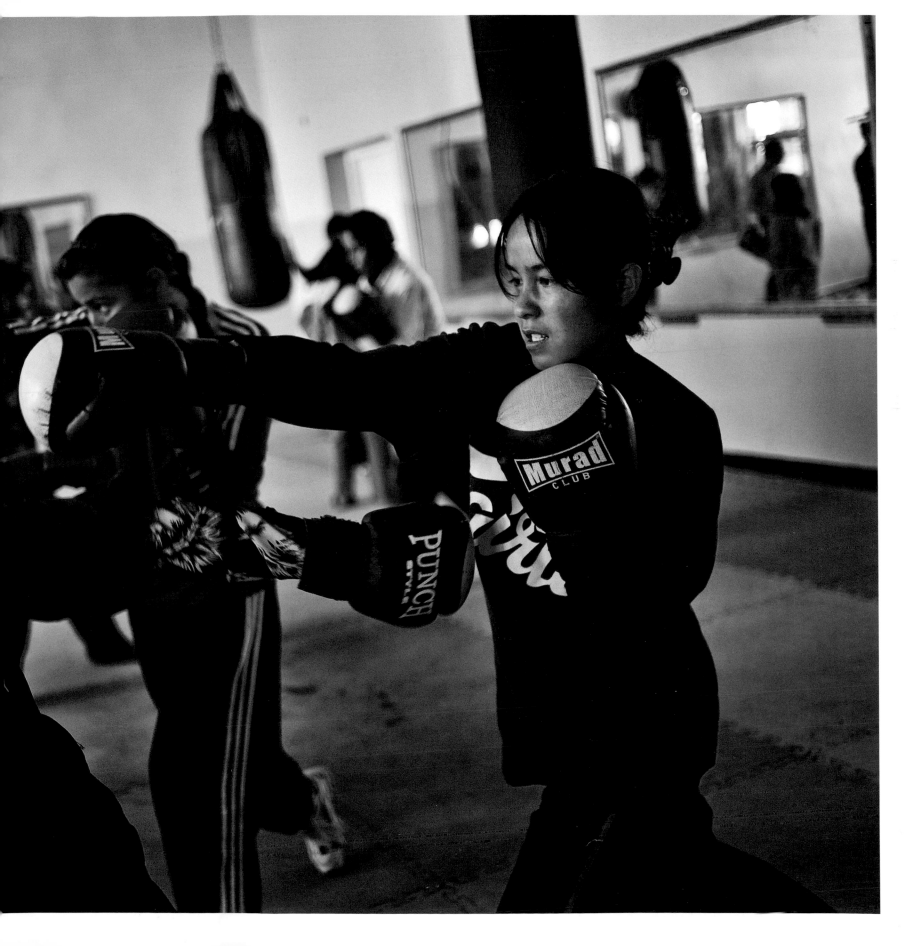

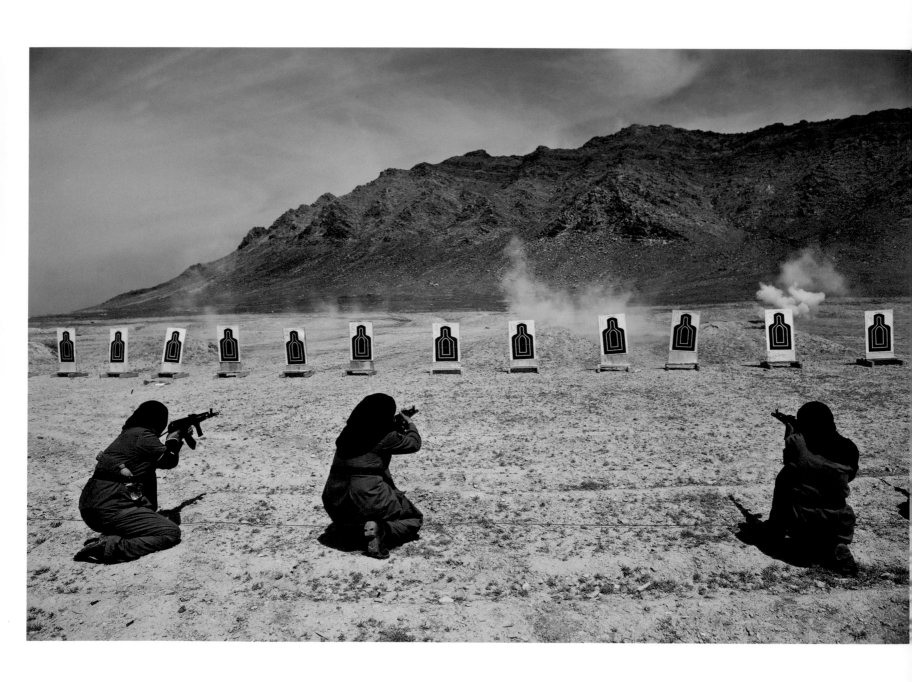

Women—mostly widows—train for police force jobs at a firing range near Kabul.

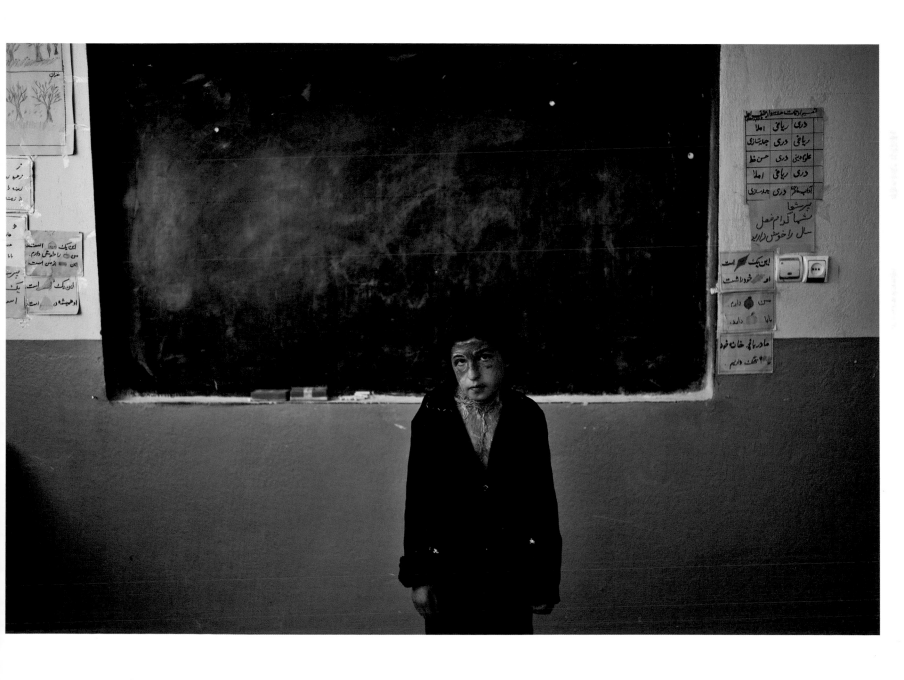

An 11-year-old girl, badly scarred from a self-inflicted fire, attends school in Herat.

173

Baghdad Calm ~ 2010-2011

As the war in Iraq wound down in 2010, a period of calm began to descend on Baghdad. Signs of normalcy emerged. Soccer cheers replaced sniper fire, shops and theaters bustled with patrons, and people paused to take in misty mornings. Though living in religiously segregated enclaves and vulnerable to sporadic violence, residents seemed determined to reclaim their lives.

A couple joins the marriage boom that the city enjoyed when violence subsided.

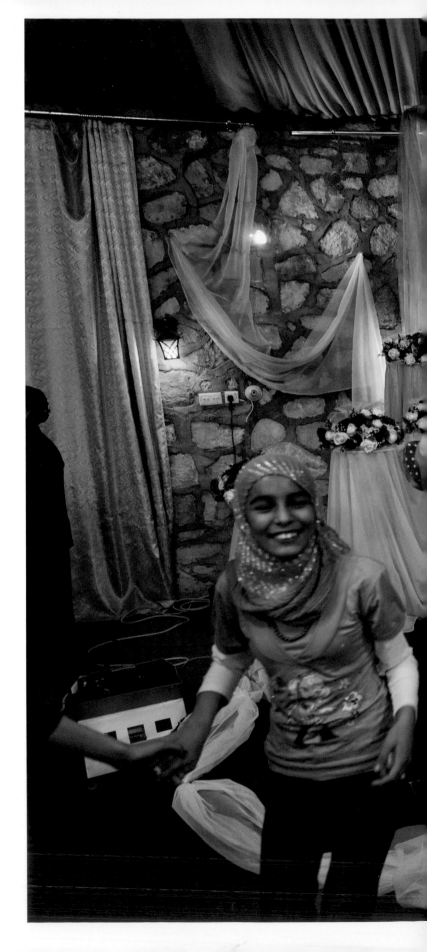

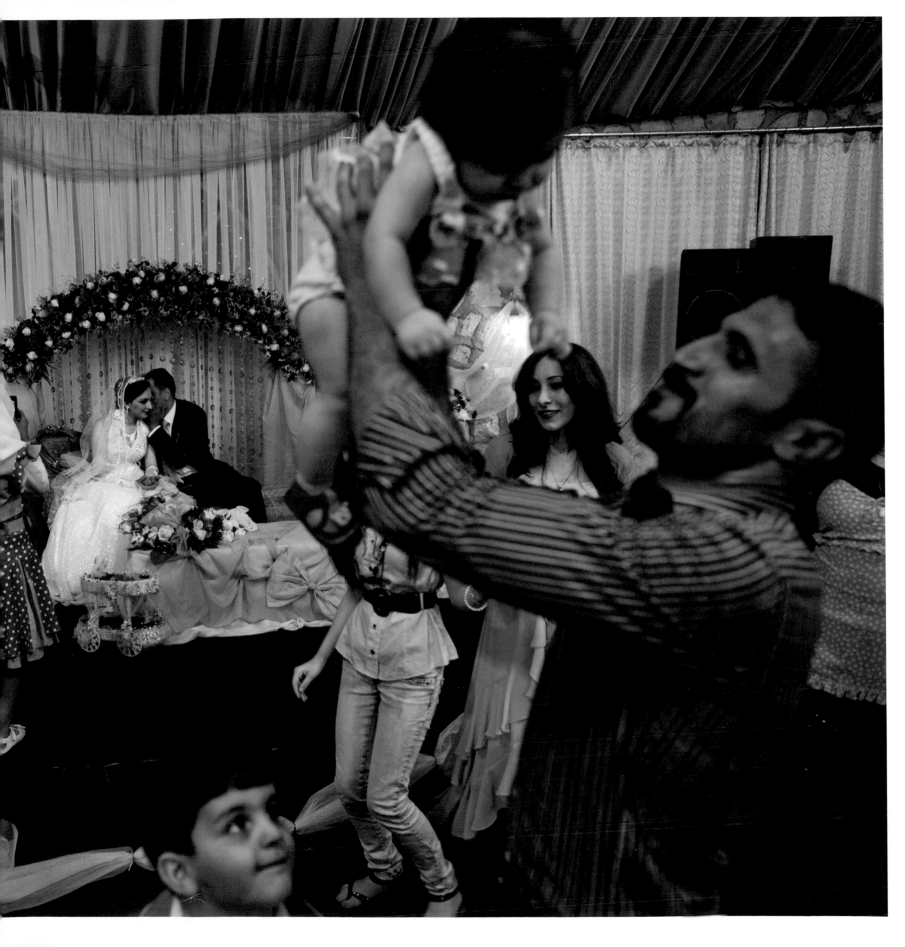

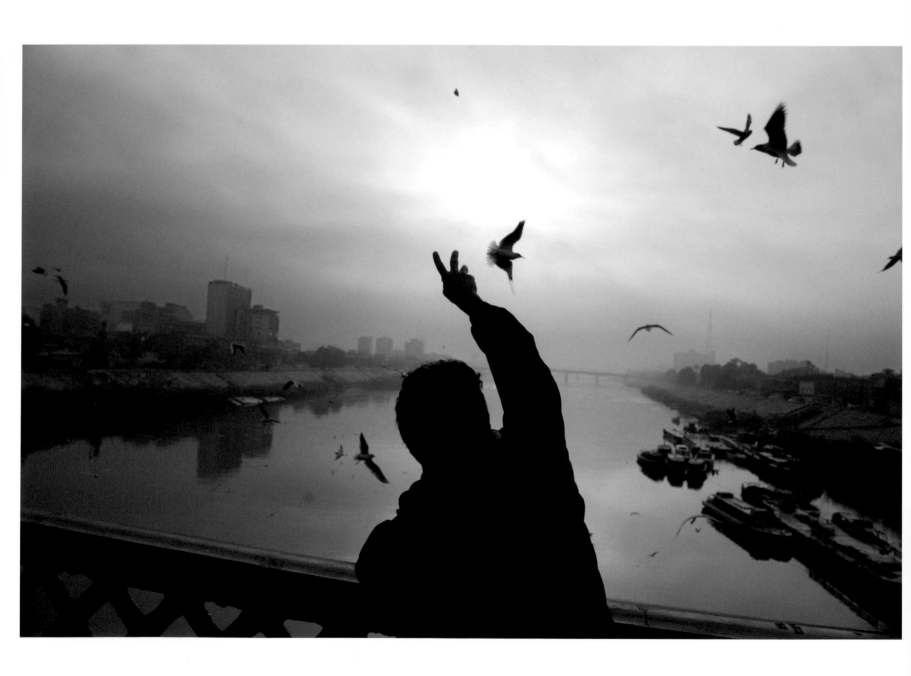

*A man on a bridge spanning the Tigris River
feeds gulls as dawn breaks over the city.*

"I try to bring
a new perspective to stories.
I try to bring something unique
to the coverage.
If I don't feel I can do that,
I have a very hard time
working in that place."

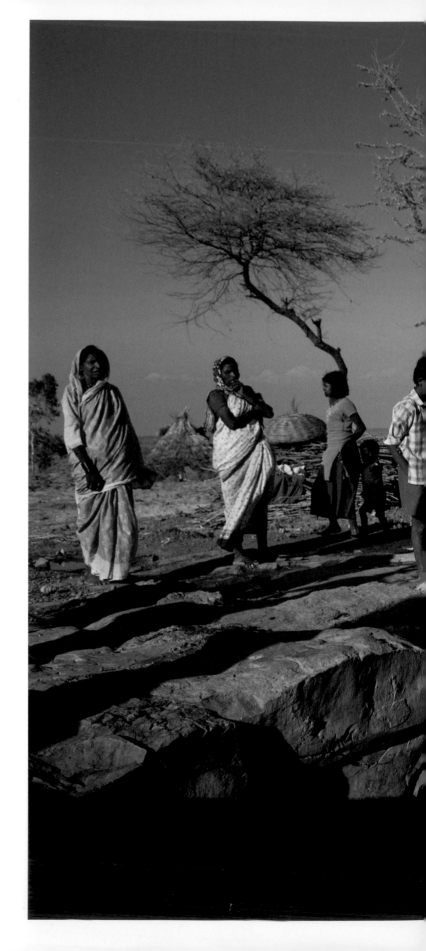

Water for India ~ 2008

With climate change wreaking havoc on weather patterns, the South Asian monsoon has become more and more unpredictable. The result has been cat-astrophic for farmers who depend on the annual rains for crops. A nonprofit group tried to remedy the problem in central India by helping locals design a watershed program to make more efficient use of rainfall.

Villagers watch a government tanker refill a near-dry well, their source for drinking and bathing water.

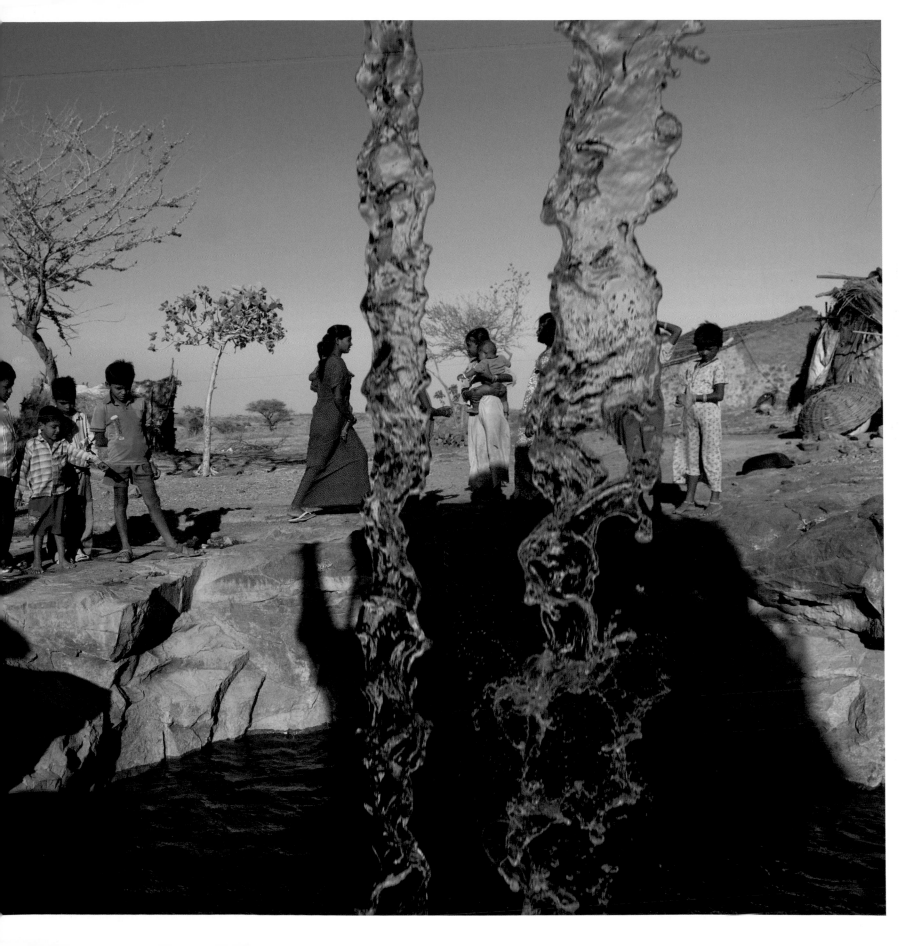

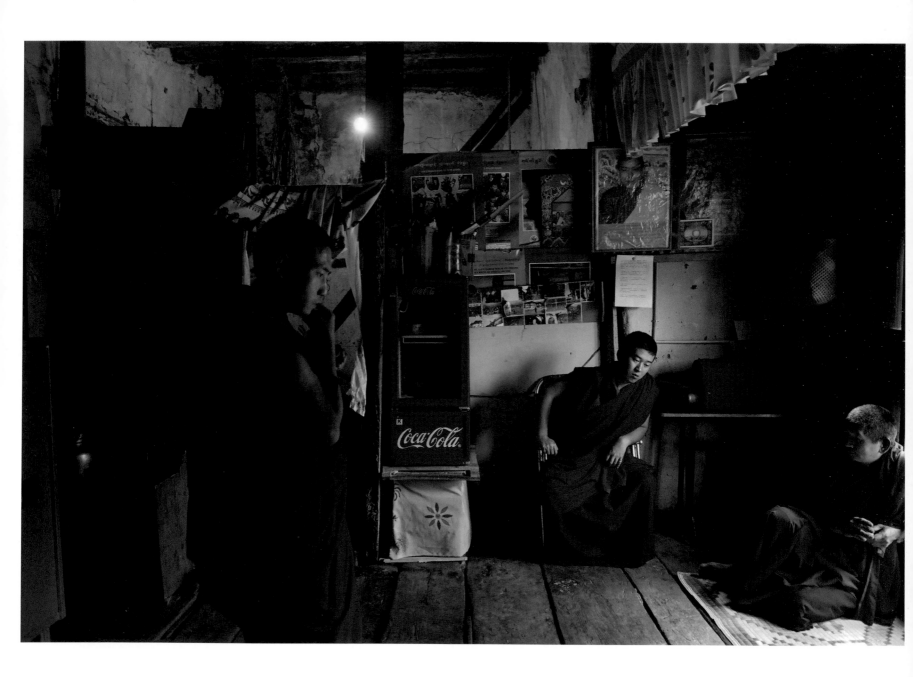

The Soul of Bhutan ~ 2007

Nestled in the Himalaya, the people of isolated Bhutan worried about how to modernize without losing their culture or destroying natural resources. Enlightened leaders now measure prosperity in terms of gross national happiness (GNH).

"I have a whole process
before I photograph.
I usually spend hours talking
before I even take out
my cameras."

Monks (left) relax in the living quarters of a
government-subsidized monastery.

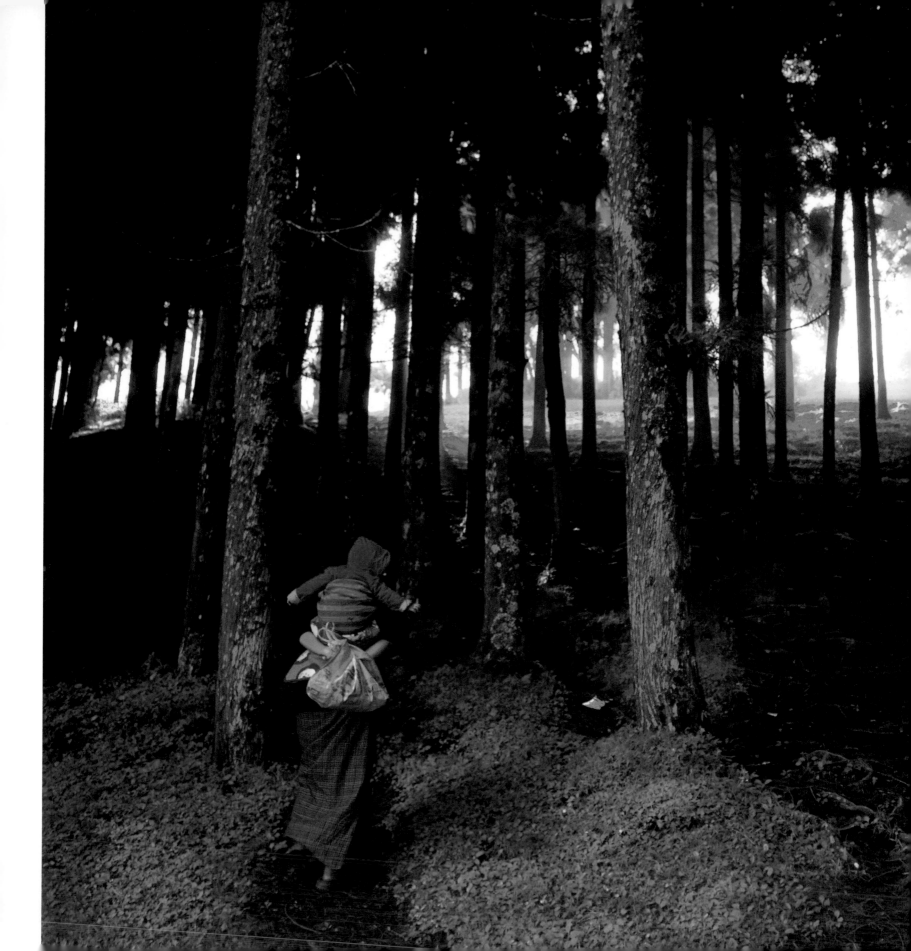

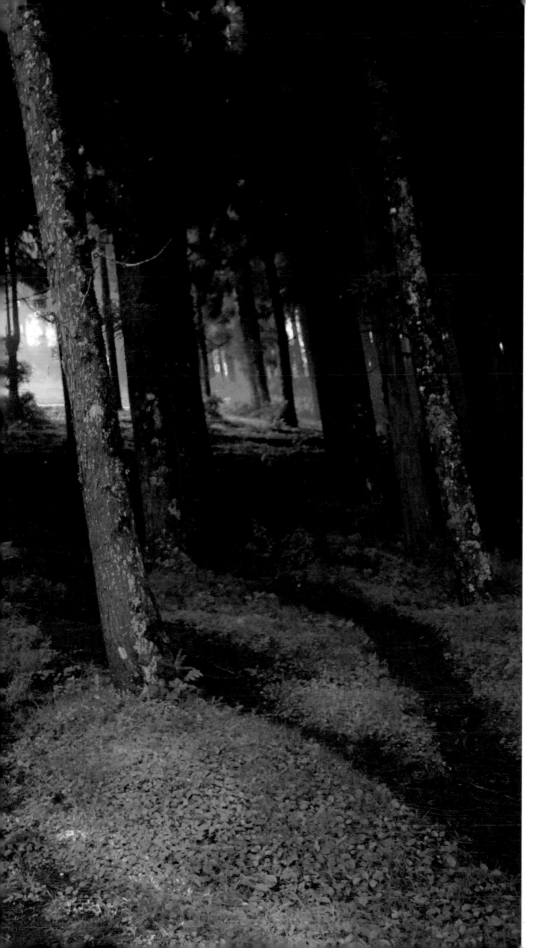

A woman carrying her baby walks in a protected forest, a pristine area where backpacking is discouraged.

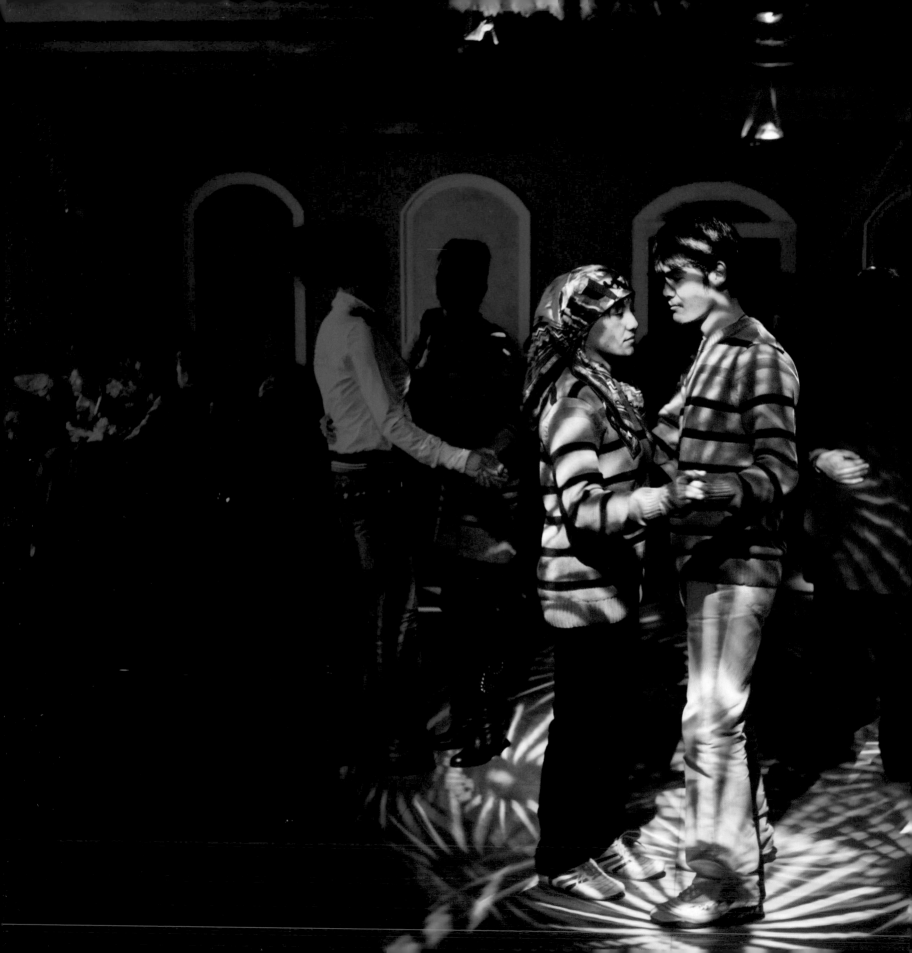

CAROLYN DRAKE

Defying Labels

"What my pictures can do is inspire people. I'd like to bring a different perspective on the world."

Over the course of a distinguished career that includes Guggenheim and Fulbright awards, Carolyn Drake has come to see herself as "part artist, part journalist." In 2001, as a 30-year-old film studies graduate of Brown, Drake quit her office job at a multimedia company and enrolled in part-time photojournalism classes at the International Center of Photography in New York City. "I couldn't spend the rest of my life behind a desk," she says.

The more she shot still images, the more she appreciated the relative simplicity of her work as compared to documentary film. Soon, she had fallen in love with photography and went to graduate school in visual communication at Ohio University, where she won several College Photographer of the Year awards. Drake joined *National Geographic* as a photo intern in 2006, and quickly won over editors with her photo essay on the Chabad-Lubavitch sect of Jews in Brooklyn, New York. "The most interesting time on a project is when you're on the border between being an outsider and an insider—able to separate from it, but also identify with it," she says. In the years that followed, Drake moved to Istanbul and traveled to Central Asia, where she spent six years photographing two diverse projects. For the first, she documented the physical and social changes surrounding two rivers, which according to Islamic tradition symbolize Paradise.

For the second project, she traveled to China's remote far west, where she photographed the Uygur people. Part of her work was published in *National Geographic* and won Duke University's 2008 Dorothea Lange-Paul Taylor Documentary Prize. "I do photography because it is a way to learn through experience," she says. "I learn most when it's something physical and emotional."

Drake currently lives in Water Valley, Mississippi, where she is at work on her first photography book, *Two Rivers*. She lives with her partner of nine years, Andres Gonzalez, who is also a photographer. "We don't have kids," she says, "we have photographs instead."

Preceding pages: *In Hotan, a Uygur town with a rising Han Chinese population, Uygurs socialize at their own nightclubs.*

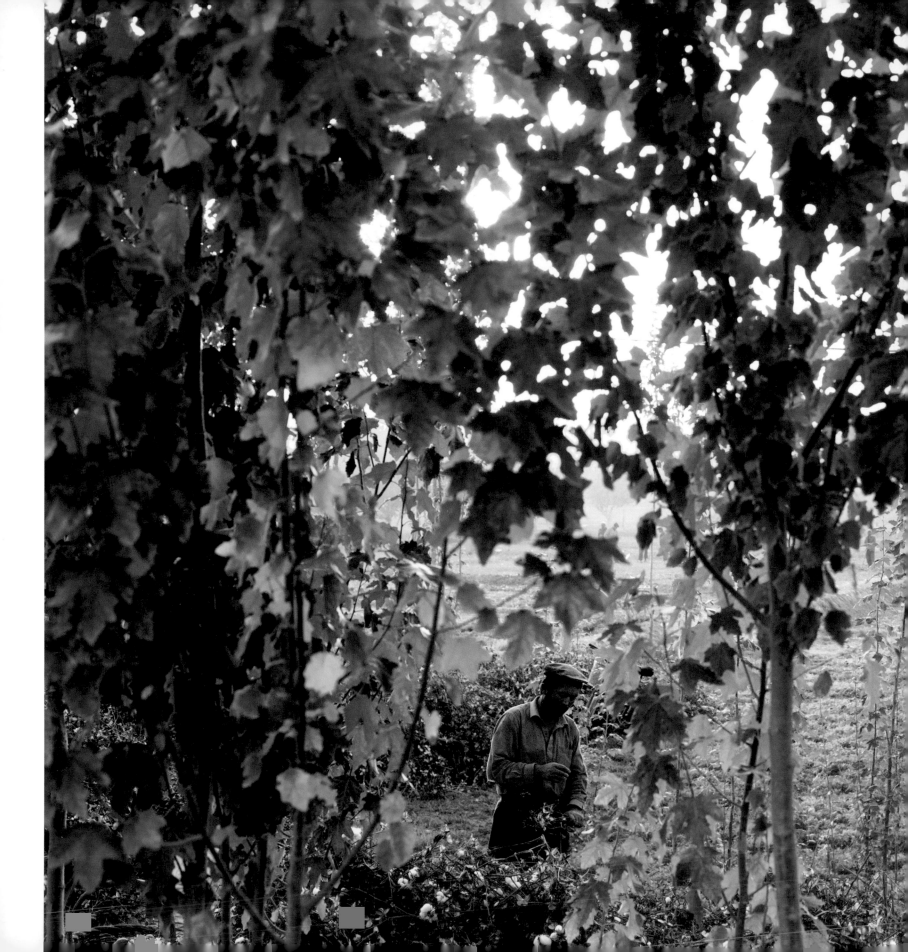

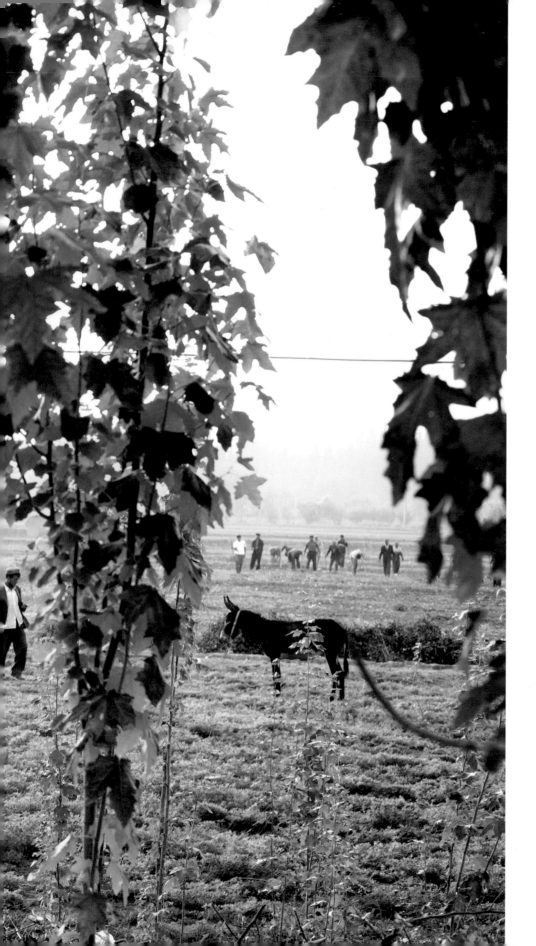

Ethnic Transition ~ 2008-2009

At one time, Uygurs—an ethnic Muslim minority in China—were clearly the dominant ethnic group in the province of Xinjiang. Over the last 20 years, however, millions of Han Chinese have migrated to the area to develop rich deposits of coal, oil, and minerals, swelling the Han population to almost equal that of the Uygurs. Some Uygurs hope to flourish in the boom, but others fear that inequality and religious prejudice are undermining their aspirations and culture.

Uygurs harvest cotton in Xinjiang, a region that has made China the world's largest producer of the water intensive crop.

189

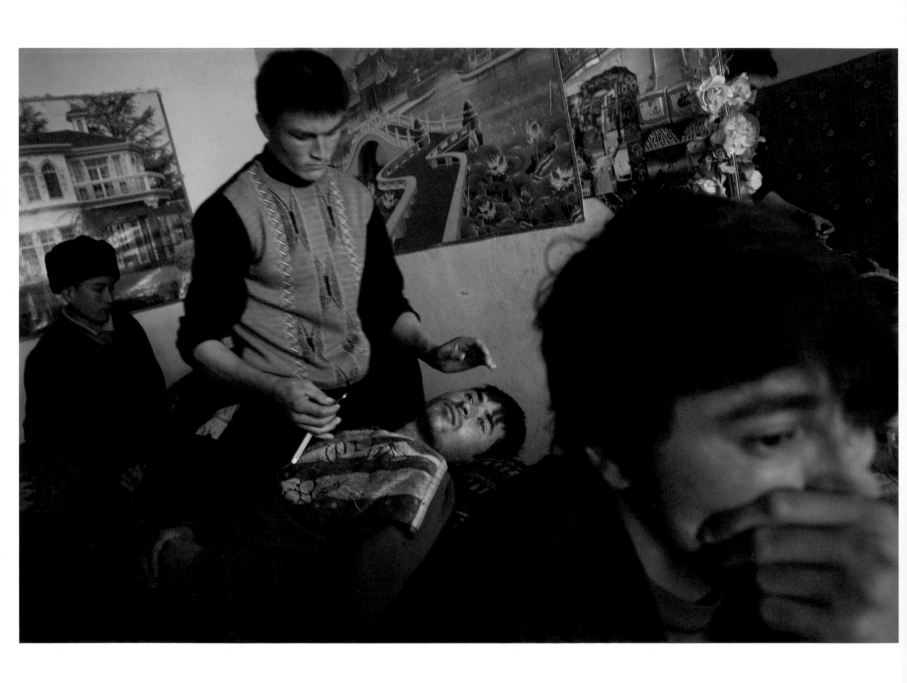

Along the edge of the Taklimakan desert, Uygur men gather in a village barbershop for shaves, haircuts, and local news.

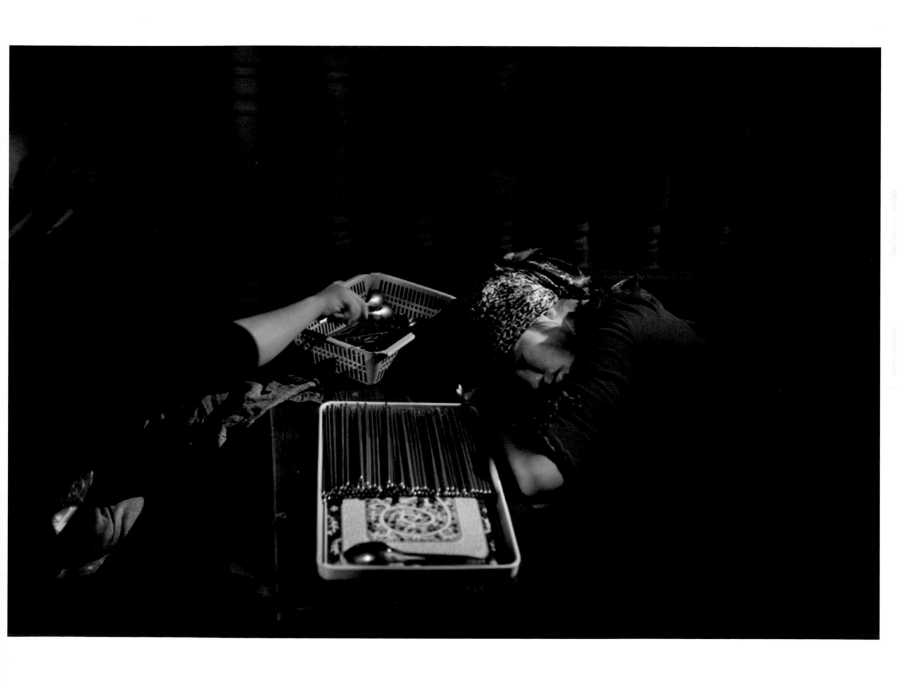

A Uygur waitress sorts chopsticks and cutlery in a city restaurant in Xinjiang as her exhausted co-worker naps.

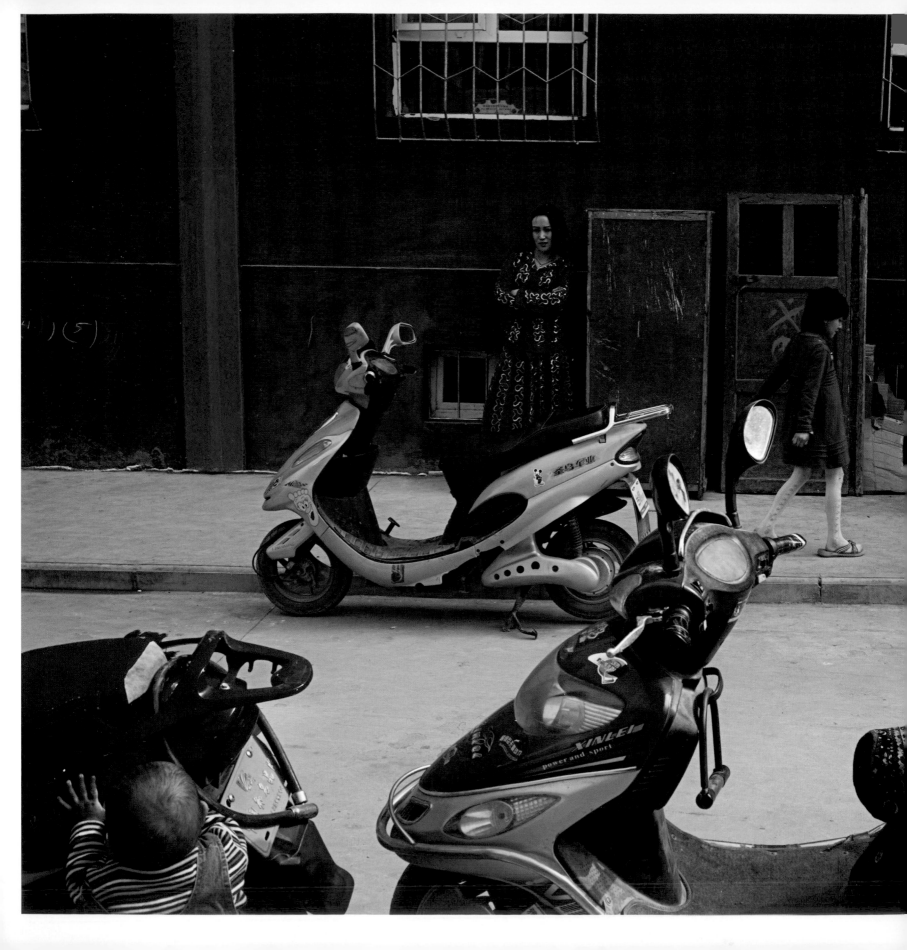

After razing Uygurs' traditional mud-brick neighborhoods, officials erected modern flats and offices near the historic Kashgar district.

"Making a
good photograph
is about editing.
It's about seeing
something that draws
you in but doesn't give
everything away."

Prayer flags fly over an ancient imam's gravesite,
a popular Muslim shrine in the vast desert
bordering Hotan.

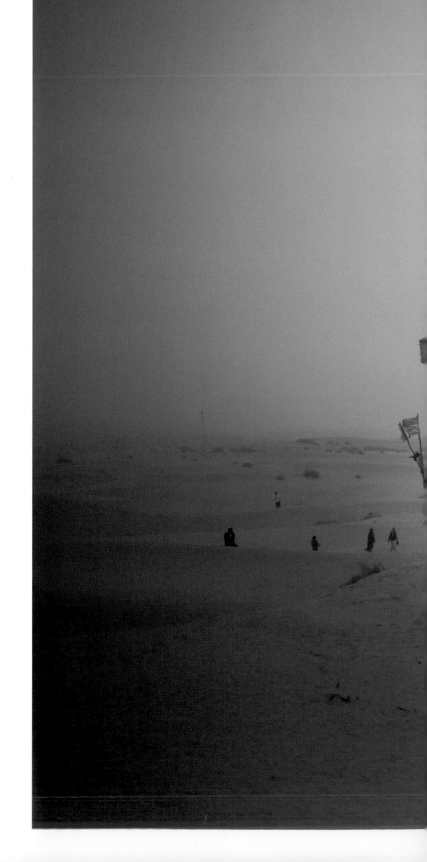

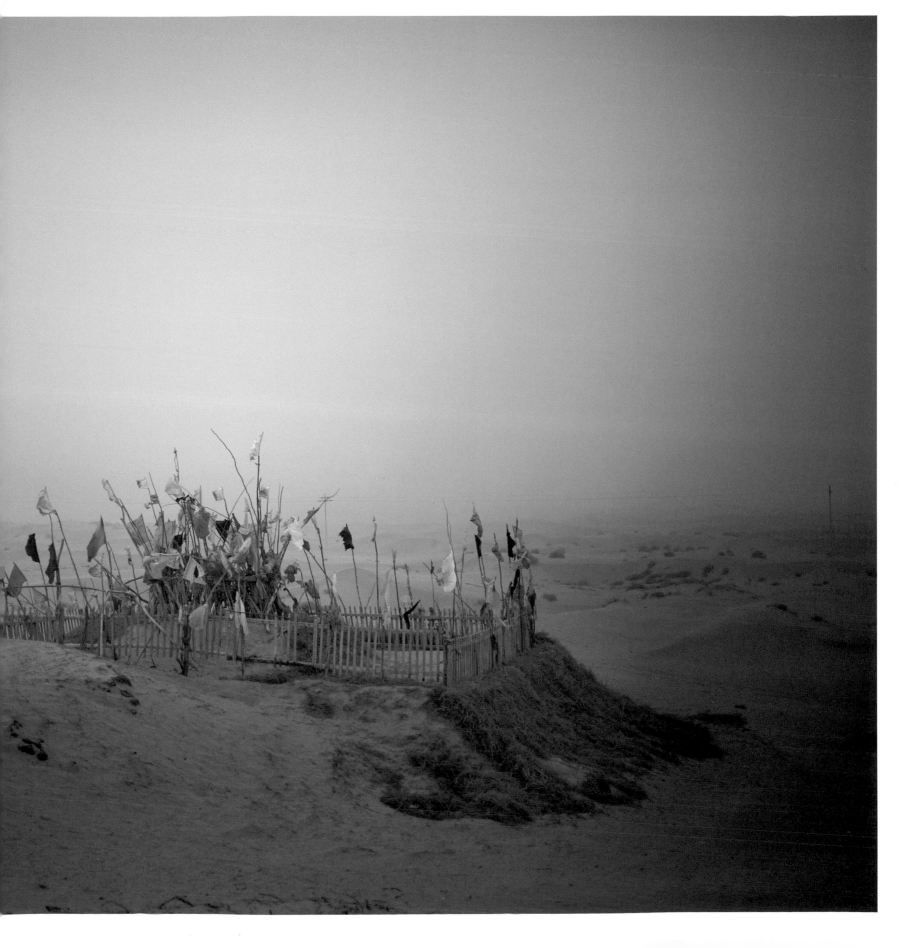

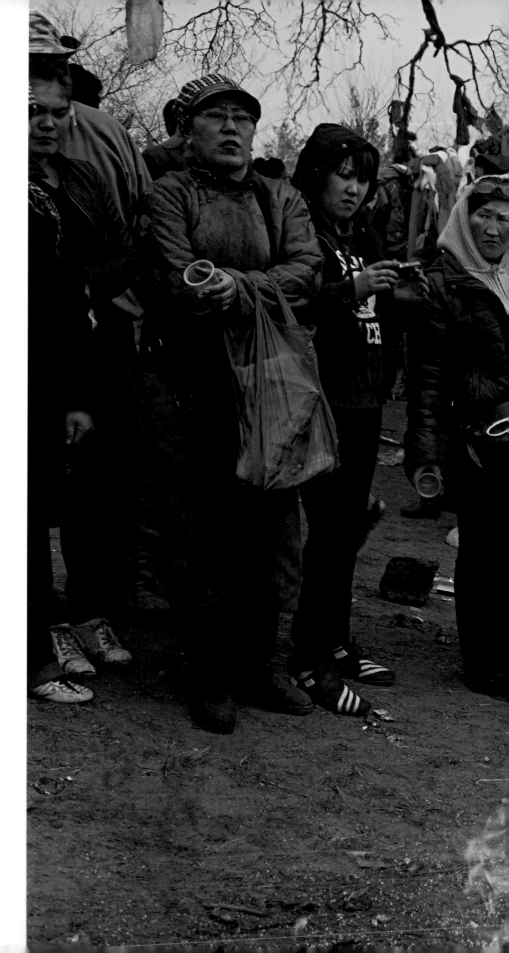

Shamans' Revival ~ 2010-2011

For decades, the Soviet Union banned all religion including shamanism, the belief that humans in a state of trance can act as intermediaries between the visible and spirit worlds. With the end of Communism in 1991, shamanism experienced a revival in parts of Siberia, Mongolia, and Central Asia, where it continues to thrive today. Shamanism's sometimes dramatic rituals draw crowds hungry for cultural and spiritual fulfillment, and those who work as shamans range from goat herders to lawyers.

A pilgrim in Mongolia kneels before a fire during the annual ritual of the Mother Tree, the shamanists' symbol of eternity.

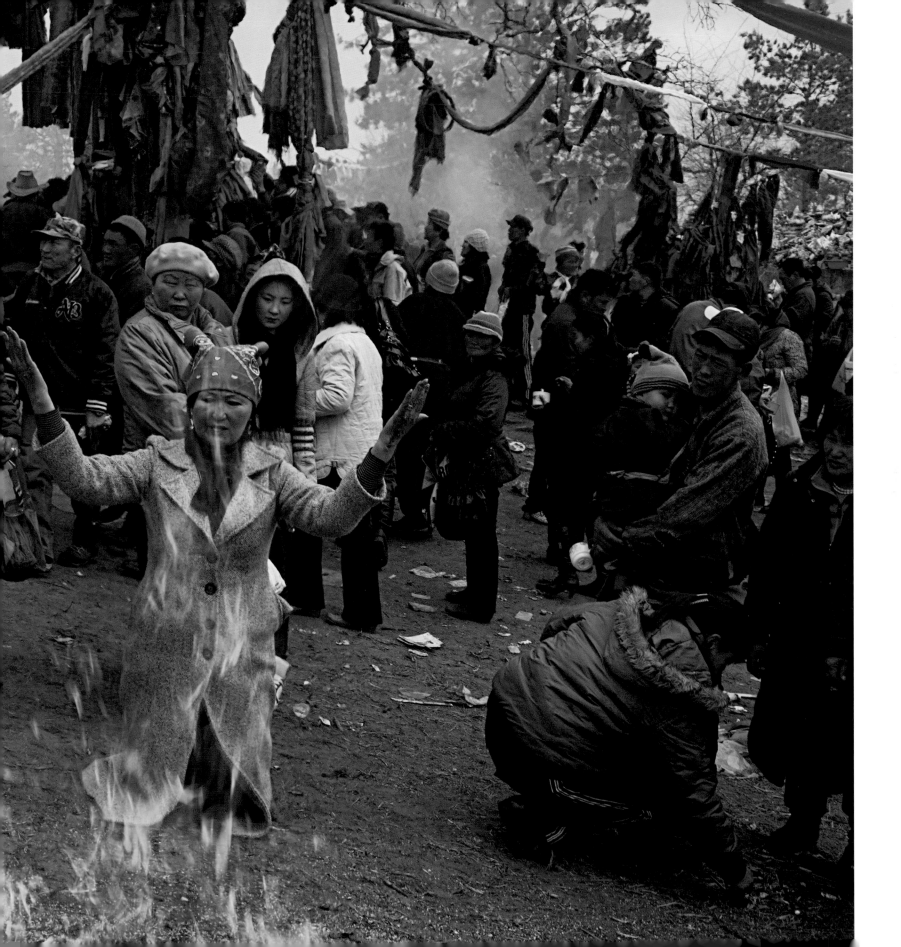

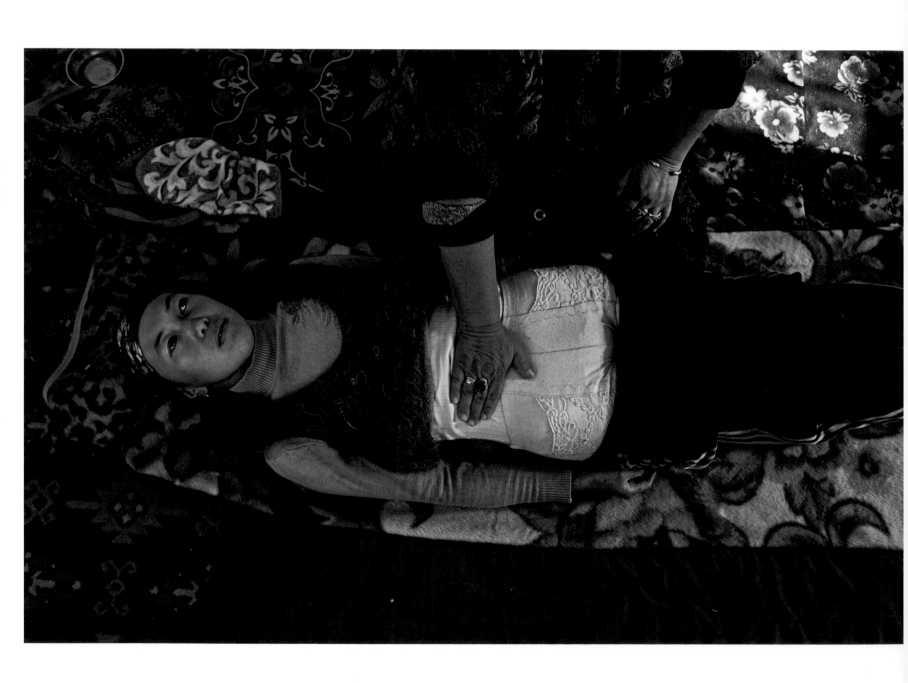

Renowned for her healing powers, a Kyrgyz shaman massages a village woman.

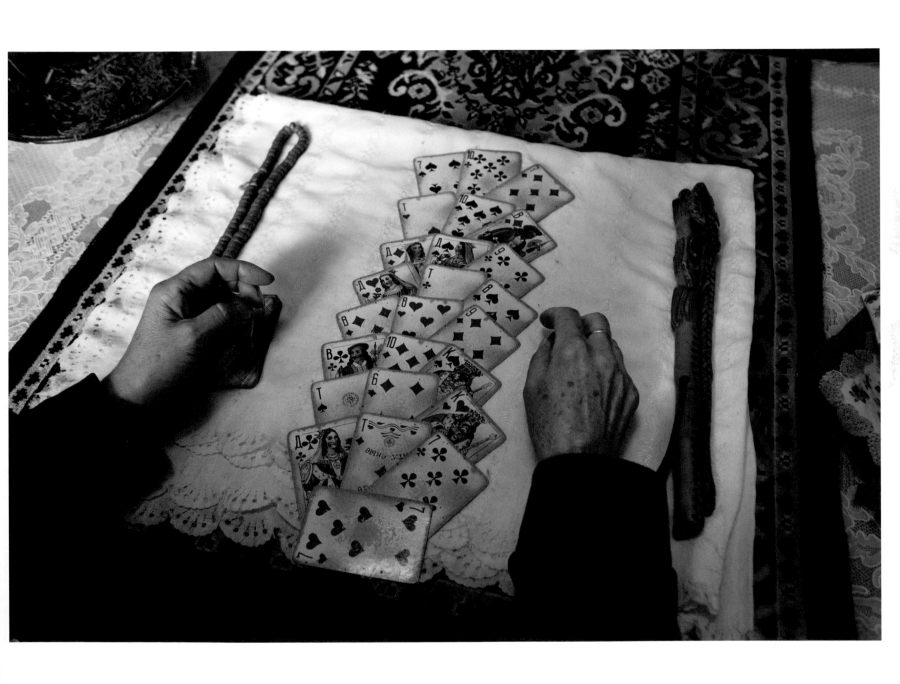

To guide their decision-making, the Kyrgyz often seek out shamans to read their fortune with cards.

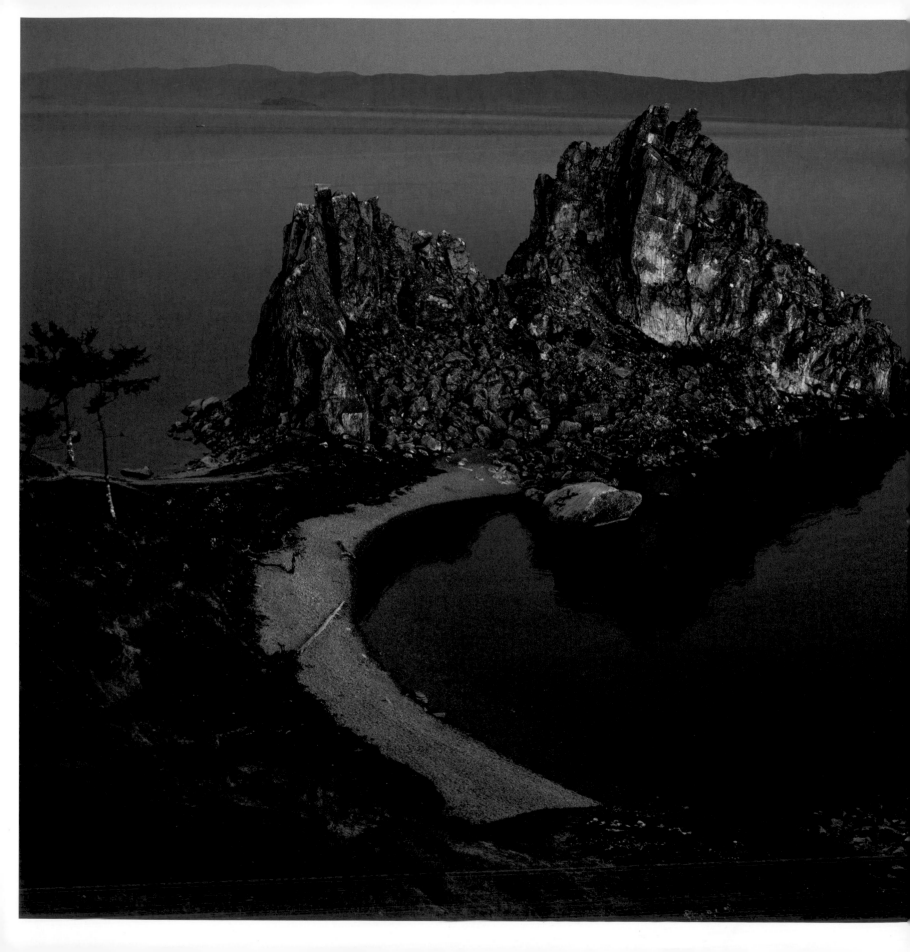

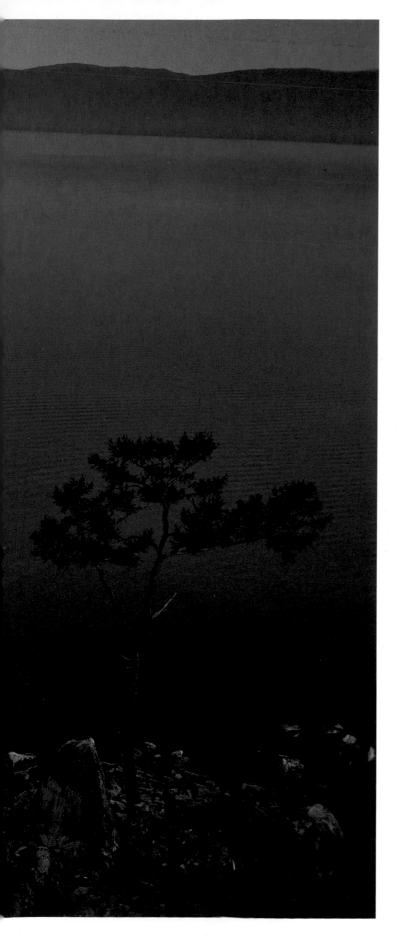

"I like to take
a photograph that has
content and
aesthetic form,
something you haven't
quite seen before,
and for that reason
makes the
viewer curious."

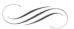

Siberia's Lake Baikal is a mecca for shamans, who believe that spirits inhabit the waters as well as the celebrated Burkhan Rock.

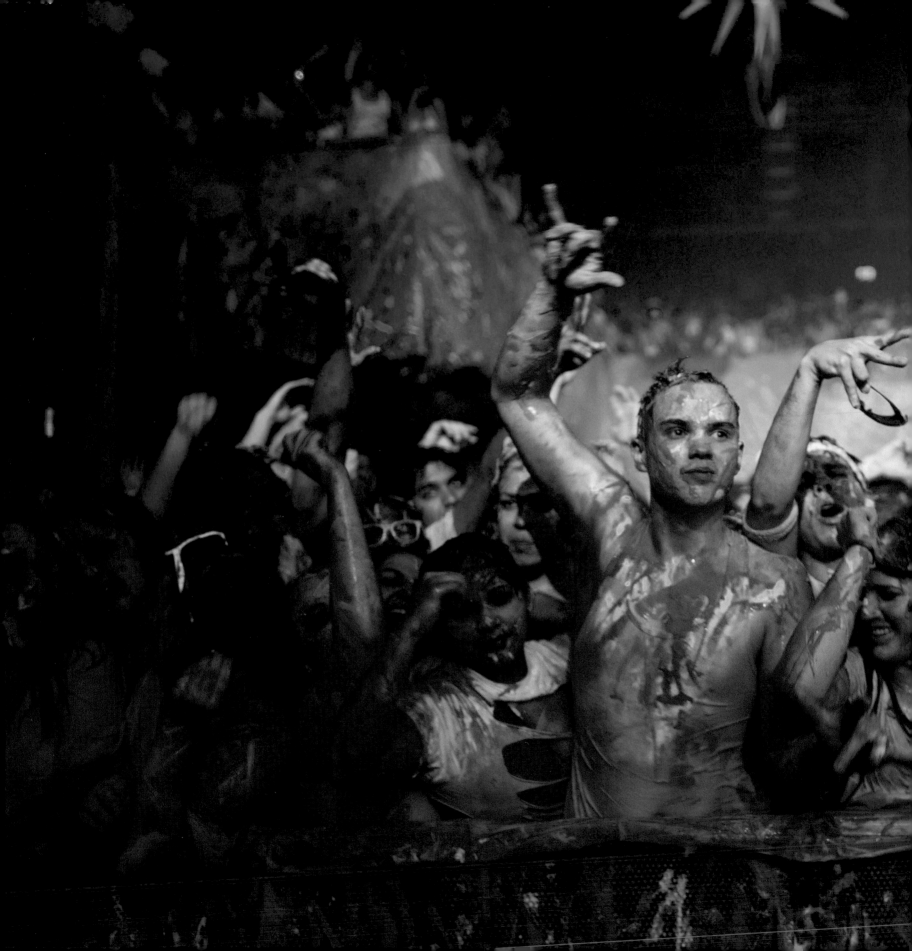

KITRA CAHANA

Envisioning the Future

"At this point, my work is less about self-meditation and more about social responsibility."

In 2013, Kitra Cahana won the ICP Infinity Award for Young Photographer, enhancing her already impressive career as a documentary photographer and multimedia artist. "It's the year of the sponge for me," she says. "I'm trying to take in as much as possible to find the hidden stories that are socially important and need to be told."

As an intern for *National Geographic* in 2009, Cahana was allowed to look through the archives and spent many hours studying the work of other photographers. She was eager to publish her work in the magazine. "I was there for two and a half months and pitched close to 50 stories. None of them got approved," she admits.

Cahana's first feature for the magazine, published in 2011, focused on the teenage brain. To prepare, she immersed herself in a community of teenagers in Austin, Texas. "When I'm in a community, that's my life and those are the people in my life: the subjects. They become my friends," she says. "The trick is to become a 'tabula rasa,' or 'blank slate.'" Cahana arrives without preconceptions, bringing only her camera equipment and a series of questions.

Born in Miami, raised in Sweden and Canada, and educated in Montreal after spending time in Italy and Israel, Cahana is currently and comfortably "living out of a backpack" and ready to work at all times. In 2011, her father—a rabbi—suffered a stroke that left him quadriplegic. Cahana has spent the last year photographing him, experimenting with image and text. "That is my true voice," she says.

Cahana was born in the digital age and embraces technology. She also admires photographers who move their documentary work beyond the traditional realm and mesh it with other mediums. "My hope is to wed photography with more voices beyond my photographic voice, to be an all-in-one journalist, to tell stories that are fully rounded," she says. "I'm getting to a point where I feel a little bit of mastery—that this is a medium through which I am able to convey something."

Preceding pages: *Drenched in fluorescent paint and lit with black light, euphoric teens shine at an Austin, Texas, party.*

Teen Brains ~ 2010-2011

Teenagers have a reputation for being impulsive risktakers. New neuroimaging studies, however, put a positive spin on the teen thought process, suggesting that the adolescent brain undergoes a beneficial adaptive period that prepares teenagers to leave home and survive in the larger world. Cahana's tableaux of Austin, Texas, teens being themselves perceptively illustrate the complex passage.

Downtown neon frames the image of a teenage girl's face reflected in the mirror of her parents' truck.

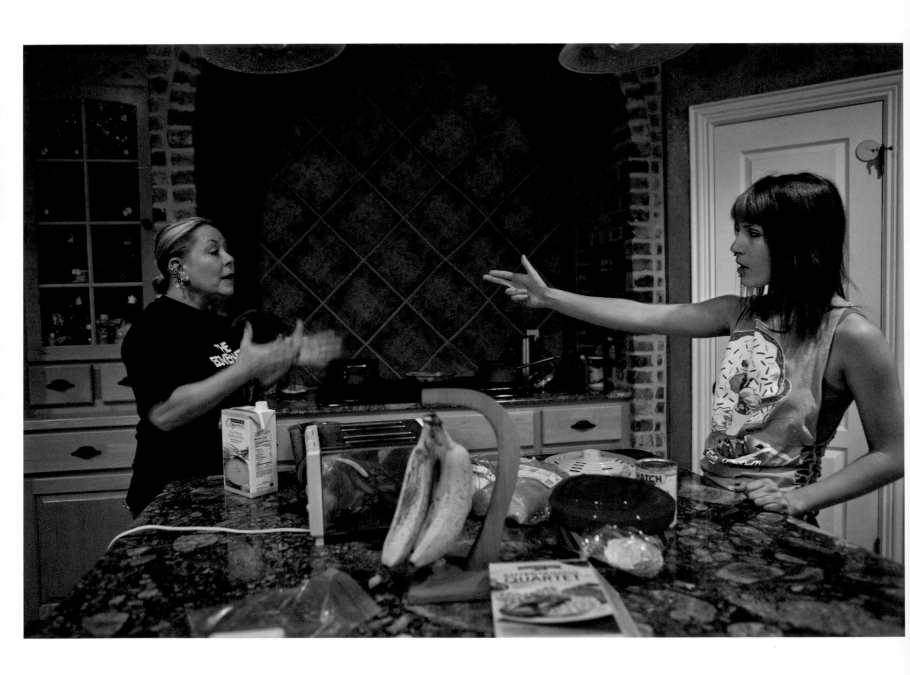

Hearing of her mother's clash with an ill-tempered driver, a sympathetic daughter responds with dark humor.

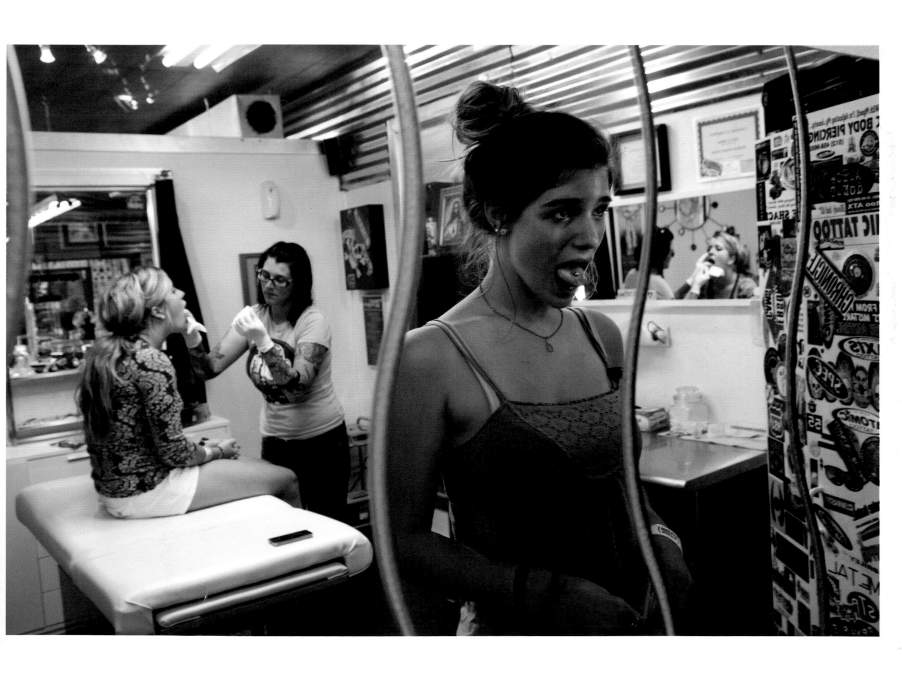

Getting her tongue pierced was "exciting and scary" says a teen who succumbed to pressure from her best friend.

Boys video a friendly boxing match on their cell phones to post on Facebook, a way to generate kudos for the winner.

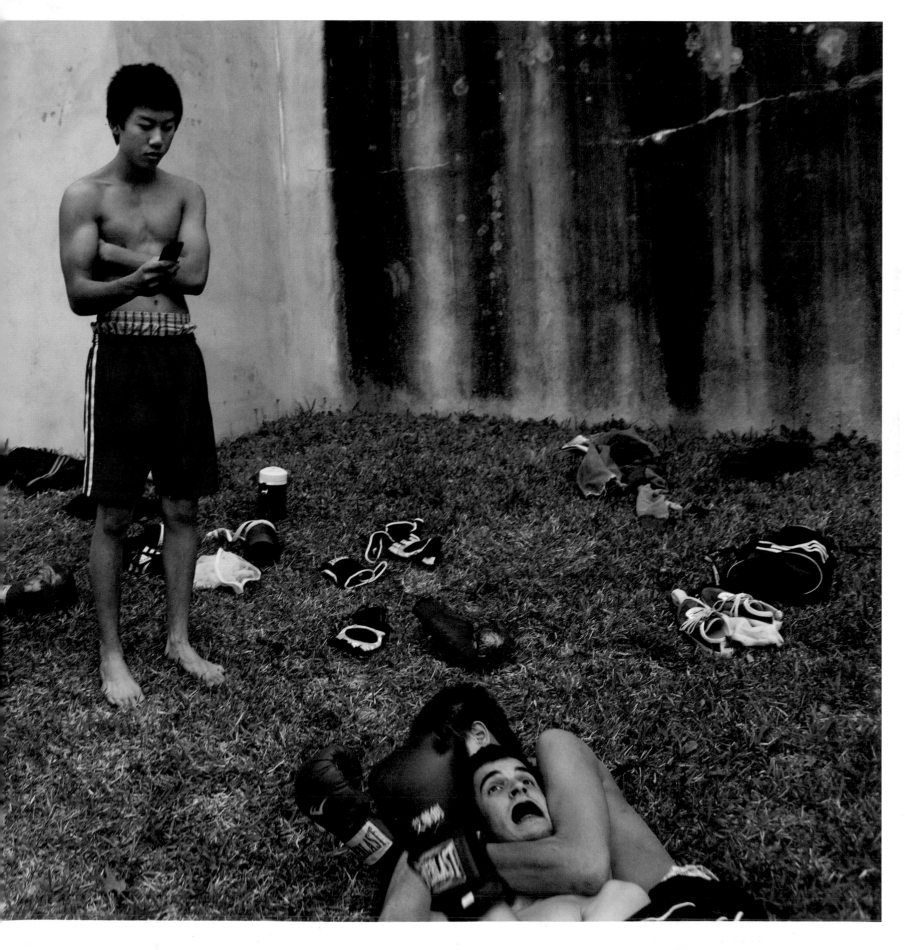

Summon the Spirits ~ 2009

Every October, thousands of pilgrims converge on Sorte Mountain in northwest Venezuela for healing and guidance. According to legend, the spirit of Maria Lionza, a 16th-century Indian girl, resides in the mountainside and has the power to bestow good fortune and cure illness. Blending Catholicism with African and indigenous folklore, practitioners light candles, create shrines, chant, puff on cigars, and perform spine-chilling rituals involving tongue slashing and walking through fire to communicate with dead souls.

Ringed by candles and offerings of liquor, a woman experiences a healing ritual.

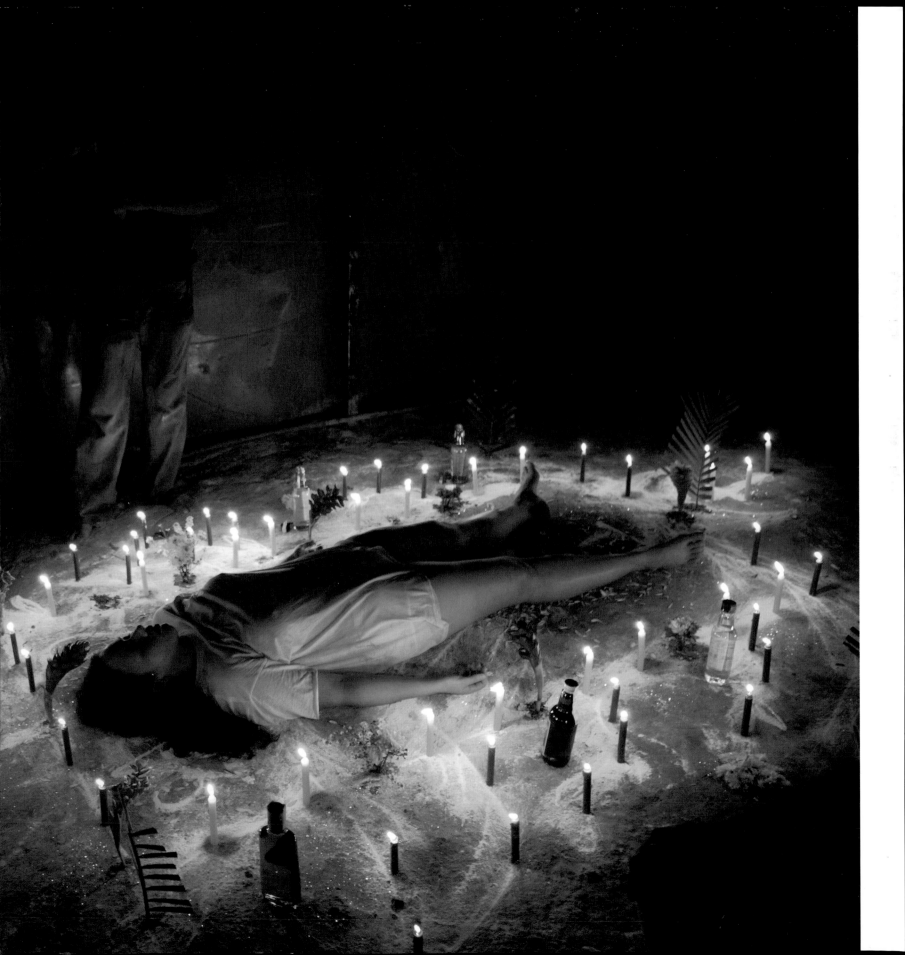

"I try to approach
every story I work on
as though I'm going to write
a thesis about it.
I really embed myself."

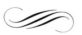

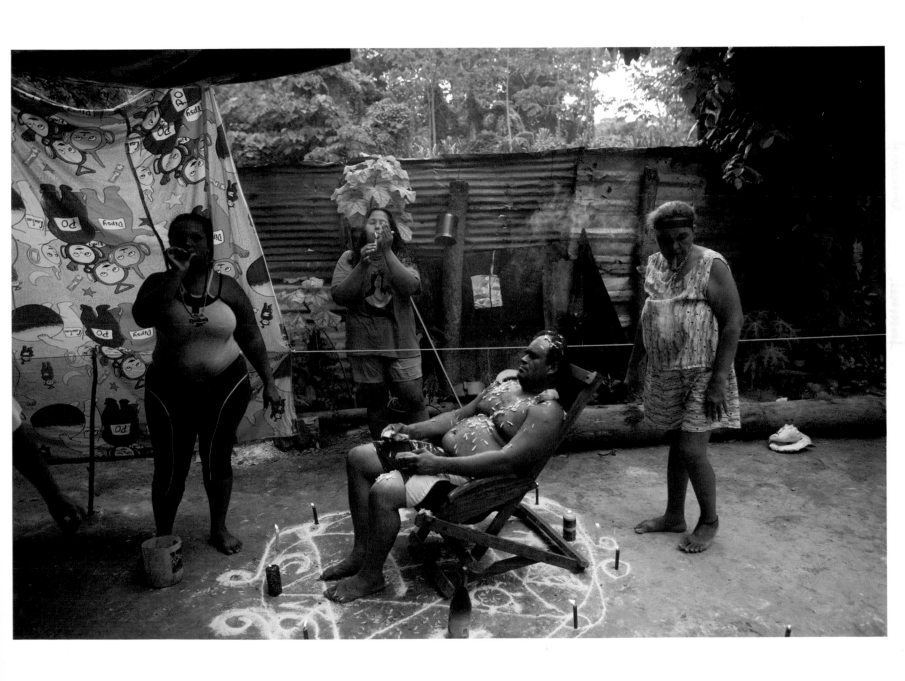

Women blow a haze of cigar smoke to assist a man soliciting a blessing.

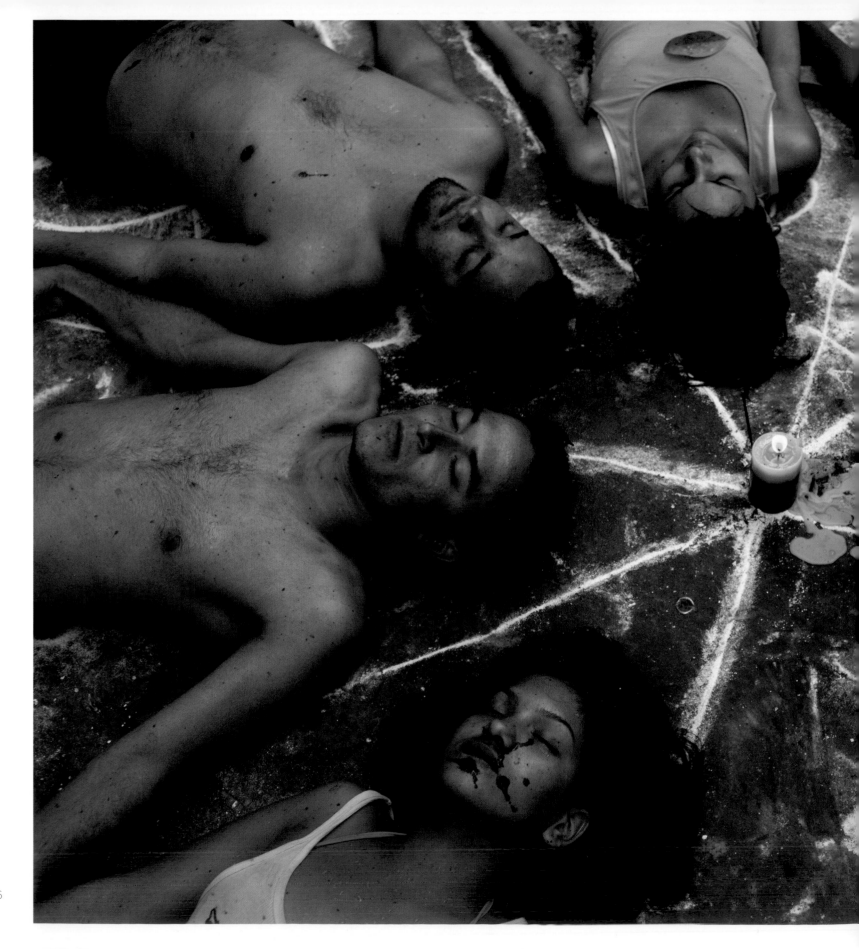

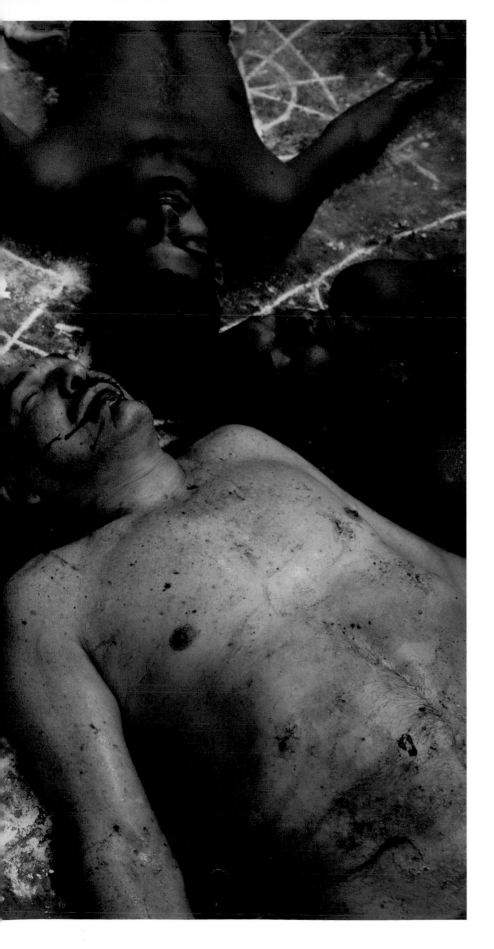

Supplicants, some marked with human blood, repose on sacred chalk drawings.

"I like images that imply something deeper. The greatest ideal of an image is to reference an abstract idea."

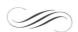

After working himself into a trance, a man leaps through a flaming pyre.

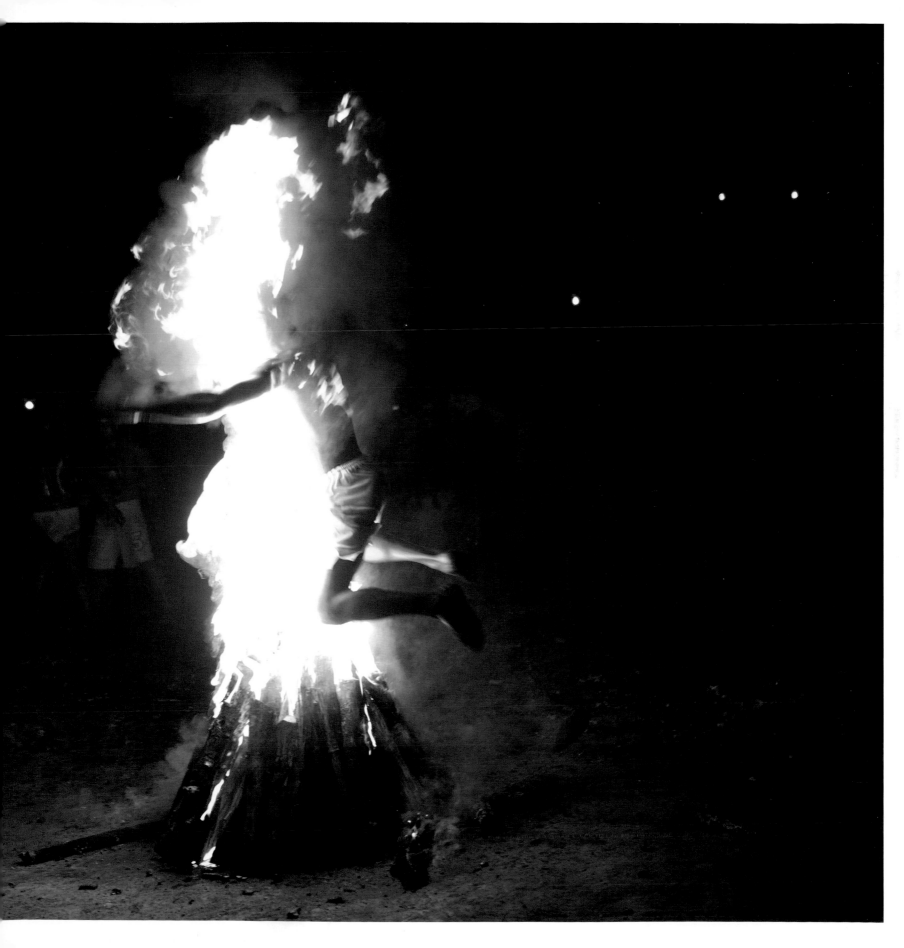

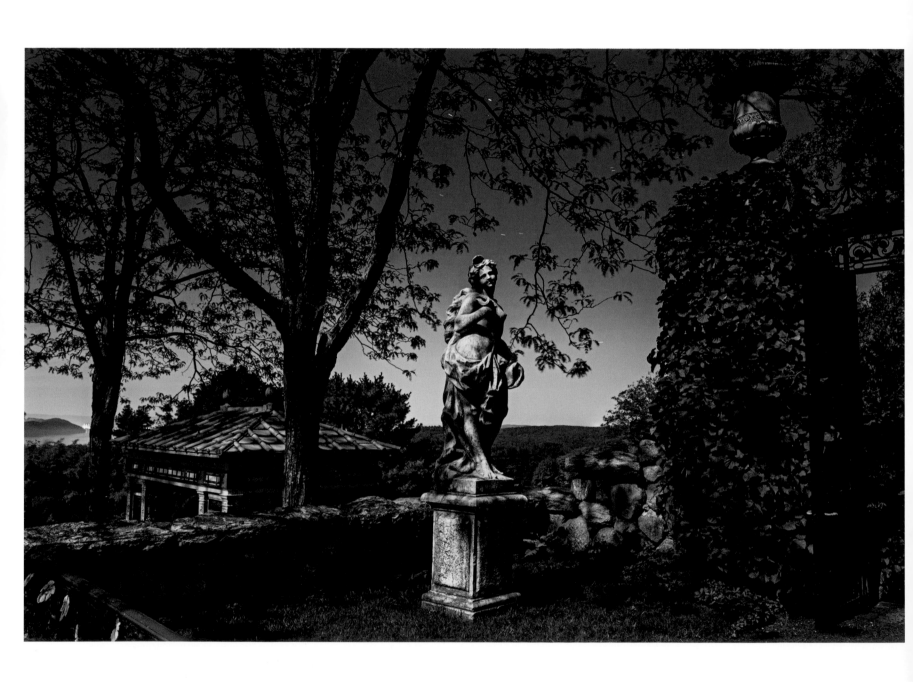

DIANE COOK AND LEN JENSHEL / Tarrytown, New York, 2011
Night's magic and mystery envelop Kykuit gardens on the
Rockefeller estate.

CURATOR'S NOTE

To be a photo editor at *National Geographic* is a privilege like no other. We enter the lives of our photographers through their images. We experience their work in its rawest, freshest form, as they map out a story, frame by frame. We see the photographers when they're wired with excitement over an idea, when they're desolate and seem to have lost their way, when they're utterly on target and piling up revelatory images—sometimes all in the course of one story.

I feel an intense gratitude to our photographers at *National Geographic* for opening the world to us without our having to suffer the hardships of time zone changes, malaria, hostile warlords, or excruciating temperatures. In return, we support their work from idea to publication, doing our best to help create a meaningful narrative. As we distill the images down—from as many as 65,000 frames shot, to 40 or 50 in the final show for the editor—we share the exhilaration of seeing the story begin to take shape. And if we're lucky, we have the chance to build the photographer-editor relationship in story after story. *National Geographic* is one of the few magazines where an editor can work with interns and then partner with them again as experienced professionals 20 years later. We can watch a career—and a way of seeing—evolve over decades.

From the earliest days of the magazine, women have published their work in *National Geographic*. Eliza Scidmore and Harriet Chalmers Adams were among the first in 1907 (Scidmore also may have shot uncredited images from the Stikine River published in January 1899). And yet in the magazine's 125-year history, only four female photographers have claimed the title of staff photographer, as compared to roughly 50 male colleagues. The new millennium has brought a fresh wave of women, as fearless as their predecessors, to *National Geographic*. But of the photographers shooting for us today, still only one-fifth are women. It is my hope that *Women of Vision* will inspire young women to dream of careers as *National Geographic* photographers.

I cannot look at a photograph and tell you whether it was shot by a woman or by a man. But I do know that the women whose work appears in these pages exemplify the kind of storytellers we need as we move deeper into this insatiably media-hungry age: journalists with relentless curiosity who bring us memorable stories full of meaningful insights and surprises. Without exception, they approach their subjects with passion and compassion, so that we—their audience—marvel at the mystery in the everyday and recognize the dearly familiar in the remotest places. Their images live beyond the page and transform the world we know.

I must take a moment to thank Kathryn Keane, Vice President of Exhibitions for National Geographic. *Women of Vision* is her creation. The first spark was hers, and her gracious and inspiring energy has guided our endeavor ever since. She herself is truly a woman of vision.

~ Elizabeth Cheng Krist
National Geographic Senior Photo Editor

Acknowledgments

Many talented people come together for big ambitious projects like this one—each with a special role to play at a special time. Like links in a chain, each is responsible for the strength of the whole. I want to acknowledge our chain gang here. I am perhaps most grateful to the exhibition's curator, NGM Senior Photo Editor, Elizabeth Krist, who embraced this project from the very beginning and whose careful, experienced eye and creative spirit is at the very soul of our success. Assisting her was photographic coordinator Zahira Kahn. Many thanks as well to the profoundly talented staff of the National Geographic Museum, and especially its art director, Alan Parente, who not only designed this beautiful exhibition but also oversaw the development of its multimedia with videographer Steve Pickard. The elegant photographer portraits were shot by the very talented team of Mark Thiessen and Rebecca Hale.

Equal thanks go to the editorial and design staffs of the National Geographic Books division, who produced this extraordinary book. A special nod to the book's editor, Hilary Black; project manager, Gail Spilsbury; photo editor, Susan Blair; special sales director, Bill O'Donnell; intern, Gabriel Dinsmoor; and brilliant designer, Marianne Koszorus, among many others. Together, they have created this elegant and timeless monograph that will live on long after the exhibition ends.

This project would not have happened were it not for the full support—from the start—of NGM Editor in Chief Chris Johns, EVP of Mission Programs Terry Garcia, and EVP and Chief Creative Officer Melina Bellows.

Additional thanks to Ann Curry for lending her voice to this book—and for the important efforts of Debbie Lucci and David Bennett in generating vital support for this exhibition and the book. Our terrific partnership with PNC on this project was the direct result of the vision of their Senior V.P. for Sponsorships, Brian Goerke, and the very talented Sandra Solomon.

Finally and most importantly, my thanks to our remarkable and fearless photographers for doing what they do—and for patiently giving so much of their time to the making of this "girl power" project. We will enjoy recruiting many others along the way as "Women of Vision" travels around the country and the world.

~ Kathryn Keane
Vice President of Exhibitions
National Geographic Museum

Credits

Published by the National Geographic Society

John M. Fahey, *Chairman of the Board and
 Chief Executive Officer*

Declan Moore, *Executive Vice President;
 President, Publishing and Travel*

Melina Gerosa Bellows, *Executive Vice President;
 Chief Creative Officer, Books, Kids, and Family*

Prepared by the Book Division

Hector Sierra, *Senior Vice President and
 General Manager*

Janet Goldstein, *Senior Vice President and
 Editorial Director*

Jonathan Halling, *Design Director, Books and
 Children's Publishing*

Marianne R. Koszorus, *Design Director, Books*

Hilary Black, *Senior Editor*

R. Gary Colbert, *Production Director*

Jennifer A. Thornton, *Director of Managing Editorial*

Susan S. Blair, *Director of Photography*

Meredith C. Wilcox, *Director, Administration and
 Rights Clearance*

Staff for This Book

Gail Spilsbury, *Project Editor, Text Editor*

Elizabeth Cheng Krist, *Senior Photo Editor*

Mark Thiessen and Rebecca Hale, *Portrait
 Photographers*

Marian Holmes, Rena Silverman, *Writers*

Marshall Kiker, *Associate Managing Editor*

Judith Klein, *Production Editor*

Lisa Walker, *Production Project Manager*

Galen Young, *Rights Clearance Specialist*

Katie Olsen, *Production Design Assistant*

Production Services

Phillip L. Schlosser, *Senior Vice President*

Chris Brown, *Vice President, NG Book Manufacturing*

George Bounelis, *Vice President, Production Services*

Nicole Elliott, *Manager*

Rachel Faulise, *Manager*

Robert L. Barr, *Manager*

The National Geographic Society is one of the world's largest nonprofit scientific and educational organizations.
Its mission is to inspire people to care about the planet. Founded in 1888, the Society is member supported and offers a community
for members to get closer to explorers, connect with other members, and help make a difference. The Society reaches
more than 450 million people worldwide each month through *National Geographic* and other magazines; National Geographic
Channel; television documentaries; music; radio; films; books; DVDs; maps; exhibitions; live events; school publishing programs;
interactive media; and merchandise. National Geographic has funded more than 10,000 scientific research, conservation, and
exploration projects, and supports an education program promoting geographic literacy.
For more information, visit www.nationalgeographic.com.

For more information, please call 1-800-NGS LINE
(647-5463) or write to the following address:

National Geographic Society
1145 17th Street N.W.
Washington, D.C. 20036-4688 U.S.A.

For information about special discounts for bulk purchases,
please contact National Geographic Books Special Sales:
ngspecsales@ngs.org

For rights or permissions inquiries, please contact
National Geographic Books Subsidiary Rights:
ngbookrights@ngs.org

ISBN 978-1-4262-1272-7
ISBN 978-1-4262-1323-6 (special edition)

Library of Congress Cataloging-in-Publication Data
Women of vision : National Geographic photographers on assignment / foreword by Ann Curry.
p. cm.
ISBN 978-1-4262-1272-7 (hardcover : alk. paper)
1. Photojournalism. 2. Women photographers--Biography. I. National Geographic Society (U.S.)
TR820.W595 2014
770.82--dc23
2013012585

Printed in Italy
13/EV/1